W9-BFU-425

Giorgione's *Tempest*

Giorgione's *Tempest*

Interpreting the Hidden Subject

Salvatore Settis

Translated by Ellen Bianchini

ND 623 .G5 A763813 1990
Settis, Salvatore.
Giorgione's Tempest

WITHDRAWN

The University of Chicago Press

RITTER LIBRARY
BALDWIN-WALLACE COLLEGE

SALVATORE SETTIS is professor of the history of classical art
and archaeology at the Scuola Normale Superiore in Pisa.

The University of Chicago Press, Chicago 60637
Polity Press, Cambridge
© 1990 by Polity Press
All rights reserved. Published 1990
University of Chicago Press edition 1990
Printed in Great Britain

99 98 97 96 95 94 93 92 91 90 5 4 3 2 1

First Published as La "Tempesta" Interpretata, © 1978 Giulio Einaudi
editore s.p.a., Torino

Library of Congress Cataloging-in-Publication Data

Settis, Salvatore.
 [Tempesta interpretata. English]
 Giorgione's Tempest : interpreting the hidden subject / Salvatore
Settis ; translated by Ellen Bianchini.
 p. cm.
 Translation of: La Tempesta interpretata.
 ISBN 0-226-74893-6
 1. Giorgione, 1477–1511. Tempesta. 2. Giorgione, 1477–1511–
–Criticism and interpretation. I. Title.
ND623.G5A763813 1990
759.5--dc20 89–20507
 CIP

This book is printed on acid-free paper.

Contents

List of Illustrations

Translator's Acknowledgement

I am indebted to several people for their contributions to this translation, but especially to Giles Waterfield, Frances Morris and Martin Caiger-Smith for their help with the technical terms of art and art history, Luca Fontana for his expert counsel over some of the knottier passages, and my husband Franco for his practical advice, endless patience and encouragement.

Preface

This book would perhaps never have been written without a grant from the Alexander von Humboldt Foundation which enabled me to spend an intensive period of study first at the Institutes of Archeology and Art History at Bonn University, and afterwards at the Warburg Institute in London. I am indebted to the Foundation for the generous help and assistance extended to its grant-holders, and must give special thanks to my colleague Nikolaus Himmelmann, whose warm and discreet friendship made my stay in Bonn so enjoyable.

Of the many people who have read all or part of this book I am especially grateful to those who contributed their criticisms and suggestions: Chiara Frugoni, Grazia and Alfredo Stussi, Paola and Aldo G. Gargani, Guido Paduano, Giovanni Previtali, Francesco Del Punta. Marino Berengo and Mario Rosa made many useful suggestions for improving the last chapter; and the book as a whole is profoundly influenced by my friend Carlo Ginzburg and the many discussions we have had together.

This book is dedicated to my parents Rocco Settis and Carmelina Megna: not as dutiful gesture of filial devotion, but as memento of how, precisely at the time of writing the book, I was sustained by the warmth and constancy of their affection.

1

Subject and Not-subject

I

There is a short story by Gabriel García Márquez in which 'a very old man with enormous wings' touches ground near a sleepy South American dwelling. He sticks fast in the muddy yard, only to become further ensnared by the inquisitive neighbours, and lives for some time with the hens in a large cage. His identity is made known to us not only by a description of his physical appearance but also by the title of the story which follows in the collection, though it was written some years before: 'El mar del tiempo perdido', 'The sea of lost time'. This then is magisterial Time, revealer of Truth, reminding men of the brevity of life by periodically brandishing his sickle. But here he has become a kind of enormous scraggy chicken, which nevertheless manages to maintain a gangling sort of dignity. García Márquez has placed him among illiterate, poverty-stricken peasants as an unlikely companion who is therefore all the more likely to provoke utterly reasonable questions. In doing so the author effortlessly shows how the magic genie of symbolism can be released from the lamp: he demonstrates the naked strength of this time-withered image by making it a thing of flesh and blood.

The figure of Time had long exhausted all its admonitory powers and was only to be found in fading frescoes, or prints in dusty frames, or in heraldic books displayed on elegant shelves for the delight of the erudite peruser. While this was the case it was still possible to consider the image as a chance fragment of a gratuitous, inoffensive symbolism, part of the trappings of an intellectual game that was played as an end in itself. Whether it aroused indifference or respect, it still had an appreciable beauty that we could find

words to describe: to the idle rich, painting the picture and then enjoying it are the only two sides of the coin. We might amuse ourselves by guessing who was right about this or that figure, and find out its genealogies and meanings. This was also an intellectual game, far removed from the uncouth (albeit inevitable) noise of Life's cash registers. The techniques of the 'connoisseur', whereby precise formulae are manipulated to comment on a work's beauty, to identify the artist and to fix the price, are certainly more profitable and more directly useful to the antiques market. The reading of the work's meanings is an optional extra, unnecessary for either selling the work or treating it as part of the furniture.

But it is still possible for Time to be delivered from this enigmatic limbo of a rarefied, elitist symbolism and to dwell with some peasants without any wings at all. If the symbol is given flesh and blood we will realize once and for all that it is not a dead image, comprehensible to a few, but has relevance and meaning for all of us; and, like Márquez's peasants, we may question it.

Jorge Luis Borges states in an elegant paradox that oblivion is a heightened form of memory. If this is true, it is perhaps the reason why Homer (in a story by the same author) is unable to bear the immortality to which he is condemned and judiciously forgets how to speak. He turns into a wild, unkempt old man (similar to García Márquez's figure of Time) who will not, or cannot, answer the questions that are put to him. But if only his modern interrogators would not merely discourse on the wearisome tribute of perpetual, unchanging 'classicism', perhaps then Homer could really be roused to speak, in strong, passionate words, of the adventures of Achilles and Ulysses; and perhaps then Father Time could unveil his whole truth before us. If we can perceive the beauty of an object within its meaning and not outside it, within its history and not outside it, and if we can comprehend and not simply admire, attribute and acquire, perhaps then we can really slaughter the 'art' which we have invented and free it from a contrived immortality. Only then will it give sustenance to all.

II

'In every field the decisive step is the reintegration of content into form,' writes Jean Piaget, quoting Claude Lévi-Strauss. In the study of art more than anywhere else the history of form has gradually parted company from the history of content: 'art criticism' elaborates lists of attributions and comments on aesthetic value and is thus *de*

facto opposed to iconology, which attempts to decipher the meaning of inherited images.

From the time that Winckelmann declared his desire to seek 'the essence of art' in the works of classical sculpture, if not before, the cult of and the search for a higher Beauty have become an integral part of bourgeois culture, although Beauty has been described in a hundred different ways and not always with explicitly mystic or metaphysical connotations. Beauty, it was argued, is apparent to varying degrees in statues or pictures, rendering them more or less 'works of art'. During the nineteenth century, art criticism thus developed the distinctive traits of a science of aesthetic pleasure and of the techniques of communicating it to others by translating the experience into words. The great critic was often a collector and a painter, spending part of his time distinguishing artistic from critical intuition – and demonstrating in the process that criticism tends to become, as it were, 'the art of art'.

Taste in bourgeois interior design is visible in the background to this process. This was influenced on the one hand by the grandiose achievements of decorative art, often linked to opportunistic evocations of the past (such as the Gothic revival); and on the other hand, by the proliferation of museums and galleries which, following Napoleon's example, developed in the shadow of the Court and contributed to the development of some European cities as national capitals. The great, regal, public museum, with its representative selection of works of art, and the bourgeois drawing-room with its pictures and knick-knacks together constitute the two poles between which individual taste moves, to exercise and refine its own sensitivity. In both of them statues and pictures are snatched from their original context, in which co-ordinates of meaning were mapped out around them, and are offered to the visitor for their aesthetic value only.

At the same time, the final scenes of a long story are being acted out. For thousands of years artists produced their work almost entirely on commission, and therefore always 'within' the wishes of their patron. Now they work almost entirely on their own initiative. The *patron* has been replaced by the *buyer*, who, in the artist's studio or in a gallery, will evaluate, select, negotiate and acquire a painting that must meet general demands of taste, yet which has been executed without any request or intervention on his part. Between the artist and the buyer the critic stands as a bridge, with a decisive role in creating and altering the conditions and prices of the market.[1] For this reason, the job of critic, which was previously

carried out by the artists themselves (Vasari, Ghiberti. . .) is fundamentally divorced from artistic practice: the 'leaven of criticism' (the expression is the title of an article by E. H. Gombrich) is now being offered as a separate item.

Once the collecting of works of art has become a widespread fashion (with its implicit connotations: the ownership of a work of art as a financial investment, as a status symbol, as a sign of one's favoured cultural camp; its relationship with methods and formulae of 'interior design'), modern and classical art are subject to the same market conditions. The critic is expected not merely to guarantee the evaluation of the picture under the hammer, but to identify its origin. 'Botticelli', 'Botticelli and assistants', 'studio of Botticelli', 'school of Botticelli' are all nuances of attribution (and these are just a few) that are not part of the sterile language of art criticism but correspond to price variations in the market; so commercial demands steer the critic's activities primarily towards identification and aesthetic judgements. The 'connoisseur's' methods and language tend to move in the same direction even when not directly employed for the market, and even when the subject is a painting delivered (for good?) from private hands for a public collection.

At the same time, the views of contemporary artists have also wrought a profound change in the critics' and collectors' relationship with the art of previous centuries: Maurice Denis declares, on the painters' behalf, that a painting (every painting) is firstly a piece of canvas with colours arranged on it in a particular scheme, before it is a horse or a nude. The critics, for their part, have ended by hunting for this 'scheme of colours' in older works. The search for beauty beyond the meaning of an image thus involves, in the first place, attaching greater significance to form; secondly, it means maintaining an indifference to content for the purposes of making an aesthetic judgement. At the same time, a taste for art and aesthetic enjoyment belongs to the dominant class alone and this in itself provides an expedient scale of values where appreciation of the formal qualities of a 'work of art' (and the ability to recognize it as such) is given a position of undisputed priority.

Art criticism has thus produced pages of exquisitely artistic prose which deliberately competes in stylistic effect with the picture it describes, as well as pages of awkwardly-phrased enthusiasm. But in both cases the cost has been a high one: by favouring form, the function of a statue or a painting as bearer of a *message* – be it of political propaganda, religious piety or the glorification of a dynasty – has been completely overshadowed. Technical considerations (for

example, the use of colour), philological research (for example, looking through archives) and 'archeological' research (a tear in the canvas, restoration work) – all of which are enduring features – are seen as 'subsidiary' to the more exalted activity of the critic, options to be taken at his discretion rather than the tools of his trade. The study of meanings has been placed at a still more inferior level: 'an obstacle to the interpretation of the work of art' (Venturi). If we pursue this line of thought we reach the involuntary paradox of Horodisch, who claimed that Picasso's transcription of a sonnet by Góngora could be appreciated for its form only by those who had no knowledge at all of either the Spanish language or the Roman alphabet.[2]

While philological and archival research outline the necessary evidence (and occasionally supply an identification) for a practice of attribution that the 'positive' method of the great dilettante Giovanni Morelli has raised to the status of a science, the great romantic myth of the artist–creator encourages the transformation of lists of attributions into a biographical account. At the same time it promotes a tendency to define the artist's 'personality' through an aesthetic analysis of each of his or her works, that is swiftly reduced to a formula in the drastic antithesis of art and non-art, poetry and non-poetry. So that this kind of criticism, which has been entirely developed, not without some impudence, to describe the exclusive encounter between the artist and the connoisseur, now opens up a dramatic controversy within the artist's own life story.

Other critics, displaying a subtler wit and a more cunning philological understanding, have attempted to develop the analysis of form into an entirely new historical field, completely independent by virtue of its sheer abundance. In this way, thin layers of colour are removed from the canvas or wall and jumbled together to become 'history' that can tell us about the painter's masters, and his youthful voyages to the birthplace of Art. This 'history' can uncover fragments and brushstrokes of the assistants and disciples in his studio, and can show us the troughs and peaks of Art itself, according to the wisdom of the critic. In short, the old model of recounting the artist's life through anecdotes has been renovated by this new research, in which the narration is constituted at times by documentary evidence, but more often by a formal analysis 'inside the painter': if the importance of attributing and evaluating has penetrated this far into the painter's life story then the encounter with the critic actually becomes part of the plot. But seen in these terms, the life of the painter, completely encapsulated within his art,

remains detached from the times and from the society he witnessed; it hangs, as it were, a few inches above the ground, not in a place where wars and religious conflicts and class struggles form the course of history but in a different dimension (a better one?): the 'history of form'.

So a 'work of art', extolled as a highly-prized product of the human spirit, if not as a flash of divine knowledge, is thus degraded to the level of the merely decorative, an object of aesthetic pleasure for the individual (which conceals, justifies and perpetuates the mechanisms of the market). It is certainly not a means of communication between people.

> L'intérieur is the asylum of art. The collector is the true inhabitant of l'intérieur. He takes on the task of transfiguring objects, a Sisyphean task which consists of removing those objects' commercial nature by actually possessing them. But he gives them only the value of being loved, not the value of being useful. The collector is mentally removed to a world not only far away in time and space, but to a better world, where admittedly people are as badly off for necessities as they are for everyday things, but where objects are free from the slavery of utility.[3]

On the other side of the coin, we find that our surrounding urban environment, as never before in man's history, is saturated with still or moving images (television, cinema) that are not in the least decorative but highly charged with meaning. From walls plastered with advertisements to the pages of our newspapers, to cleverly shot photographs of actors and politicians, these images continuously suggest behaviour patterns and, through the most sophisticated techniques, try to persuade us to approve or acquire. It is patently obvious in this world of images that implacably follow us around that the different qualities of style are *always* a function of the best possible articulation of the message, within the relationship of 'artist', patron and public. Even so, the development of techniques of persuasion through advertising images runs parallel to the diminishing content of Art with a capital A, admired and constructed at an entirely formal level. A tragic rift opens up between our daily experience, which takes in thousands of visual messages wholly constructed around *content*, and our recollection of an 'art history' which is only, or especially, a history of *form*.

This same 'artist's art', which may seem to serve the exclusive purposes of interior design and therefore be degraded to a decorative function, cannot tolerate its position of exclusion. 'Provocation', in many different forms, has an ever-increasing hold on contemporary

artists and reveals the desire to give a jolt to a public that for generations has formed a habit of sterile aesthetic pleasure, and to force it to realize that images are as much a means of communication as words.

This type of art criticism has lost the thread between past and present and in doing so has fostered a two-fold mystification. On the one hand, the idea of a 'work of art' as an object of pure aesthetic pleasure has been brought back, generalizing a view of taste that belonged to the great nineteenth-century bourgeois critics and perpetuating the separation of form (higher up in the hierarchy) and content. On the other hand, by accustoming people to a purely formal interpretation of images it has helped to put beyond their reach the processes of constructing an iconographic interpretation, which can thus still keep all its secret powers of suggestion quite intact. In the meantime, modern techniques of persuasion through image-making (which are the historic sequel to these processes) can do their work without interruption, as long as the world of representational art remains in the equivocal innocence of aesthetic contemplation.[4]

III

In the more reactionary and unenlightened quarters of American society in the 1950s, the term 'iconologist' was synonymous with 'intellectual' and both were used in a derogatory sense[5]. It was a symptom of the precise political hue which coloured the hostility felt by the old school historians of style towards the exponents of the new methodology, led in the United States by Erwin Panofsky, and others like him, forced by Nazi persecution to settle in Britain and America.[6]

The controversy over the iconologists has by no means subsided, even if it is hardly ever now expressed in such clear terms, or with such explicit political overtones. Apart from a host of negative allusions and generalizations, the opposition shows itself above all when it suppresses its own rationale while continuing to follow a line of formal criticism. The obvious implication of this stance is that the study of meanings should not be the critic's main preoccupation; though it may sometimes be undertaken as a 'subsidiary' task, its importance is always marginal in comparison to understanding the 'value' of a 'work of art', as such. Gilbert's essay, which we have already mentioned, at least has the merit of setting out the arguments against 'iconologists' and illustrating them

with examples. The debate is opened from the very title with its effective juxtaposition 'On subject and not-subject'. Turning to the Italian Renaissance as the iconologists' favourite field of study, Gilbert attempts to establish the early origin of the picture 'without subject' in landscape painting; but worried as he is to salvage the results of the Panofskian critique, he then declares that the questions of meaning and style are of 'equal and independent weight'. While illustrating this very point, however, as though reacting to over-zealous quest for symbologies, he goes to any length to find specific cases of 'rejection of subject and symbol' by early Renaissance painters.

As other commentators have already remarked,[7] the examples Gilbert uses to illustrate this argument are less than appropriate. The most obvious case is a passage by Paolo Giovio where, in praising the landscapes of Dosso Dossi, the author refers to them as *parerga* (oddments). The validity of this illustration can be dismissed with the simple observation that Giovio certainly took the word *parerga* from Pliny and used it in the same sense – to describe the *details* of the background of a painting. Oddly enough, Gilbert has made the same mistake as Eustace of Thessalonika in the twelfth century when he took a partridge painted by the Greek painter Protogenes to be the main subject of the picture, and thus described the painting as *parergon*. But we know from Strabo that the partridge was only a detail, along with the figure of a Satyr. Pliny's *parerga* refers to the same painter and is used in the same sense.[8]

Another clear case of misinterpretation is the example of the *Flagellation* by Piero della Francesca in Urbino. Gilbert maintains that the religious subject has been pushed into the background in relation to the three mysterious, monumental figures 'without subject', who take up the right half of the painting. But one need only observe that underneath these figures was the much-discussed inscription taken from the liturgy for Good Friday, *Convenerunt in unum*, to realize that Piero intended them to convey a specific meaning, though today it is difficult to understand what it might be.[9] In a third example, the long description of mythological paintings in Sannazaro's *Arcadia* is considered to be an illustration of paintings without subject, for they do not contain a 'precise allegory'.

The way in which Gilbert's terminology leap-frogs from 'subject' to 'allegory' is sufficiently typical to be worth examining more closely, and can be shown in a series of antitheses that emerge from his writing.

Title	Subject	Not-subject
P. 204	subject *and* symbol	[not subject]
P. 204	elaborate iconological content	without symbolic subject
P. 213	precise allegory	[not subject]
P. 205	symbolism	emotive response in the observer
P. 205	symbolic meaning	to produce a religious attitude

First of all, then, 'subject' is identified with 'symbol', 'allegory', 'elaborate iconological content'. Secondly, the observer's response to the painting, as an emotive response or a religious attitude, is classified as 'not-subject'. But it must be fairly clear that 'subject' is not the same as 'allegory' or 'symbol': for example, Sannazaro's imaginary paintings *do* have a subject – they are 'stories' taken from ancient myths, which are actually indicated by name. Moreover, though none of them has a symbolic meaning, the *intention* of Sannazaro's description (similar to the interiors of many early Renaissance *studioli* or 'study rooms') was to create an atmosphere of 'antiquity' for his characters and his readers. An invitation to identify with a mythological or religious painting cannot possibly be classified as 'not-subject'. The emotive response is the meeting point between the patron's request and the artist's offer, and the scholar must seek it out: for it is also the record of a particular religious attitude, or of a particular way of looking at the past – in other words, a fragment of history.

The antithesis of *subject* and *not-subject* is therefore too radical. No historian of style would deny that a *Nativity* is a *Nativity*, and no iconologist would deny the possibility that a myth may not be an allegory. Gilbert is oversimplifying when he defines iconology as the study of symbols and allegories. His point of departure is that iconologists by definition prefer to study paintings that offer a great wealth of meanings; and in counterposing what can only improperly be called two 'schools' of thought – 'historians of style' and 'iconologists' – he deduces an inherent opposition between style and meaning. However, flawed though this line of criticism may be, it unconsciously expresses a fundamental truth: if, on the one hand there are critics who only study style (though they may not deny the existence of subject), and on the other there are critics who only study meaning (though they may not feel obliged to find symbols

and allegories at all costs), the consequence will be that form and content are not only separate but in active opposition, doing great damage not only to the artist's personality but to every individual 'work of art'.

Art historians have an urgent task in acknowledging this schism and analysing its gradual development in the history of art criticism. A complete understanding of a statue or a painting should place the question of style within the framework of careful research on its meaning as a vehicle of communication, and on its ways of expressing that meaning. For form and content (to state an obvious truth) are born at the same time, and style changes in order to yield the best expression of the subject.[10]

Gilbert uses an imprecise terminology in his essay (though this tendency is by no means exclusive to him) where the word 'subject' is used in two different senses: first, it describes the subject that everyone can see – for example, Piero's painting is generally read as a *Flagellation*; secondly, there is the subject of the iconologists, with their ceaseless inquiries into the significance of the three solemn, silent witnesses who *convenerunt in unum*. This is not to deny that a painting can have a title, but on the contrary to maintain that it is both reasonable and useful to attempt to explain its composition in terms of choice of content and not only of style, beyond the elements that Gilbert calls 'surface subjects'. On the other hand, wherever there is a tendency to deny the existence of a subject, or one that it is possible to analyse 'iconologically', there is also a transparent impatience with criticism that veers towards the study of content, and an irritation with content in itself, considered an obstacle to enjoying something that is a pleasing object and *not* a vehicle of communication. And since in some cases nobody can deny the existence of 'elaborate iconological content', these may still be thought of as exceptions whose artistic results are in fact quite independent of the subject. They may indeed show that the artist has had to take the measure of his patron's trivial demands and overcome them in the name of Art, fulfilling the mission of the true artist by creating form in a superior and timeless dimension, where patron and subject are no longer of any importance.

The concept of the artist as a creative individual thus begins to dominate the scene, leaving no room, at the moment of artistic creativity, for any regard to the wishes of the patron or any concessions to the public. Behind this is the idealistic tradition that respects the 'connoisseur's' value judgements and tends to favour form to the extent of omitting content altogether. Research on the

artist's life, his place in society and in history, is acceptable only if it does not interfere with the inner pulse of artistic creativity which is inherently free of all temporal bonds. The 'disassembling' of a painting to analyse how its message is conveyed is permissible when the various elements point to facts of style: for the formal qualities of that message are the only ones worth gathering.

The question of the origins of landscape paintings may be used here as a litmus test, as this genre is considered to be a prime example of not-subject. Here too fondness for theories tends to distort philological argument. For example, the two small landscapes in the Pinacoteca of Sienna, thought to be by Ambrogio Lorenzetti, are declared to be 'a miracle unparalleled in the whole of the Trecento', though it is possible to demonstrate that they were removed from larger *tavole*.[11] The landscape, then, could justifiably take up the whole space of a painting for the person who removed it, but not for the artist who painted it. But it is also clearly true that a landscape is a subject in itself, even where it has no symbolic meaning. As E. H. Gombrich has so skilfully demonstrated,[12] the birth of landscape painting should be sought not in the untrammelled imagination of the artist but in his relationship with a clientele that developed a taste for the exotic backgrounds of foreign painters. Along with the elaborate mythologies of antiquity, craggy mountains, forests and cottages also began to find a place in the minds of the *gentilhuomini*, as well as on the walls of their houses.

IV

In Italy perhaps more than elsewhere the monograph on the artist has increasingly concentrated on biographical detail. After attributing a work to an artist, the next step (regardless of how that attribution was reached) is to fit him into a particular line of criticism that uses more or less verifiable works to trace not the events of his life but its emotional aspects: its specific manifestations of a pictorial sensitivity. Because both the narrative and the research for this kind of biography are centred around the artist's personality, the whole process is removed to a sphere of elitist isolation, where a dubious portrait of the artist's times is governed by artificial hierarchies of formal values.

In the 1960s, and, indeed, apparently right up to the present day, the iconological trends that emerged via Hamburg and Princeton were taken up by some Italian scholars, though the argument gained support more through the success of Panofsky in America than

through a studied consensus on its principles. These scholars used iconology to deduce their own theories for research and exegesis, and attempted to find meaning 'behind' the form of a 'work of art'. The foundation of their argument is the figure drawn by the artist's brush, but as they build upon this with a series of associations the whole structure becomes progressively weaker the further it is removed from the concrete facts of the painting. Finding three different meanings in the same figure is even less use than finding none at all. Worse still is the suggestion that a figure has 'symbolic' value without any evidence to support such an interpretation in any specific context. The historical reconstruction, or philology, of a meaning is thus replaced by a kind of gratuitous attribution of generic symbols of a vague, all-purpose nature, supported *a posteriori* with texts that would never have been called upon directly by the painting.

These overgenerous iconologists have been swift to accommodate new ideas. But in spite of appearances, the hand of the critic-cum-attributor is still writing the rules: without a specific school of methodology discussion of meaning still slides into discussion of the artist as a creator. The familiar pattern of biography–aesthetics––attributions has been able to assimilate iconology without having to change its ways. But it has left research into verifiable meanings behind.

V

So Giorgione started work [at the Fondaco dei Tedeschi]. But he thought only of demonstrating his technique as a painter by representing various figures according to his own fancy. Indeed, there are no scenes to be found there with any order or representing the deeds of any distinguished person, of either the ancient or the modern world. And I for my part have never been able to understand his figures nor, for all my asking, have I ever found anyone who does. In these frescoes one sees, in various attitudes, a man in one place, a woman standing in another, one figure accompanied by the head of a lion, another by an angel in the guise of a cupid; and heaven knows what it all means. Then over the main door which opens into the Merceria there is the seated figure of a woman who has at her feet the head of a dead giant, as if she were meant to be a Judith; she is raising the head with a sword and speaking to a German standing below her. I have not been able to interpret the meaning of this, unless Giorgione meant her to stand for Germania.[13]

Vasari's words bear witness to the difficulties of understanding Giorgione's subjects, even a few decades after his death. They also go a long way to explain why the artist came to be both a favourite subject of study for iconologists and a source of ammunition for the 'not-subject' faction. If his creations were so personal that not even Vasari could understand them, goes the argument, then they could only have been made by an artist who was free from the humiliating impositions of patronage. Hence Justi talks of the 'freedom of Giorgione', and Conti of Giorgione 'the first modern artist'.

But Vasari must have momentarily lost his concentration when he looked at the four façades of the Fondaco. He forgets to tell us that two of these were not the work of Giorgione but of Titian, and that the latter was in fact the painter of the figure 'over the main door that opens into the Merceria'. This figure, moreover, can be explained with absolute certainty as *Judith–Justice* (1). The few things we do know about the decoration of the Fondaco indicate a precise iconographical programme, however disjointed its features

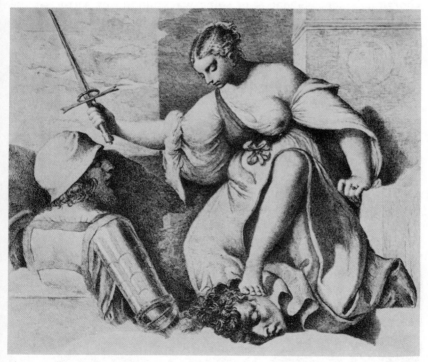

1 A. M. Zanetti, *Judith–Justice*, engraving of the fresco by Titian, at the Fondaco dei Tedeschi, Venice

may seem to be:[14] Venus, Eve and perhaps Adam, a Cavaliere della
Calza, and, in the courtyard, the heads of the ancient emperors.
Even Judith–Justice over the main gate is certainly a repetition of
the figure of Venice–Justice that sits above the gate of the Ducal
Palace that opens into the square (2).

Still, Vasari was but the first of many to emphasize the difficulties
posed by Giorgione's works, claimed by some to have no subject
while others attempt to unravel their mystery. Most mysterious of
all is *The Tempest*, which seems to challenge every attempt at its
decipherment with its endless diversity of interpretations, and to
lend itself freely to the champions of the 'not-subject' school as their
trump card. Indecipherable, they repeat, because there is nothing to
decipher. Is the painting then just a 'little landscape with a storm
and a gypsy', as one contemporary observer described it? Or does
it have a hidden meaning that has been lost in the course of the
centuries? Whatever the answer, whether the painting is a premature
case of 'not-subject' or whether its subject is still to be discovered,
Giorgione's achievement is in some ways unique by virtue of the
fact that it was already obscure to his near-contemporaries, and that
he provoked more attempts at exegesis than any other painter. The
difficulties involved in deciphering the 'montage' and the meaning
of a painting like *The Tempest* make the Giorgione 'casebook'
particularly tempting material.

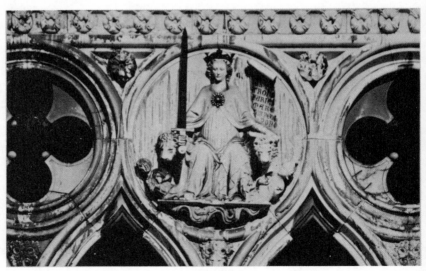

2 *Venice–Justice*

2

The Three Philosophers

I

The Three Philosophers in Vienna (3,4) occupies a special position among the few works that are known to be by Giorgione: for alongside the painting's unchallenged reputation, its subject has given rise to a vast number of interpretations. It was probably painted for a Venetian noble, Taddeo Contarini, for it was in his house that, in 1525, Marcantonio Michiel made the following entry in his *Notizia d'opere di disegno*: 'oil on canvas of three philosophers in a landscape; two standing and one seated who contemplates the sun's rays, with a marvellously imitated rock. The canvas was begun by Giorgio of Castelfranco and finished by Sebastiano Veneziano.'[1] This careful description demonstrates Michiel's purpose in compiling his notes on the possessions of his aristocratic friends, for a work that he never wrote: he wanted to be able to identify the picture by taking down brief details of its appearance. But though he is careful he is also generic, giving us neither the identity of the 'philosophers' nor the object of their 'contemplation'.

The catalogue descriptions of the painting that were taken down with every change of ownership have enabled us to trace its early interpretations.[2] When Lord Basil Fielding, the English ambassador in Venice, bought the entire collection from Bartolomeo della Nave, entry no. 42 in the English translation of the catalogue was described as 'a picture with 3 Astronomers and Geometricians in a landskip who contemplat [*sic*] and measure, of Giorgione of Castelfranco'. Ten years later the collection passed to the Archduke Leopold William.[3] In an inventory of his gallery, drawn up in 1659, no. 128 is entered as 'a landscape with three mathematicians who measure the heights

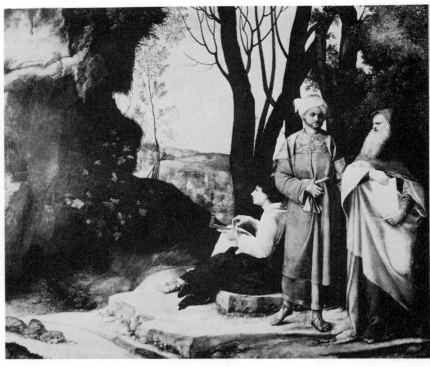

3 Giorgione, *The Three Philosophers*

of the heavens, original by Giorgione'. However, when the painting became part of the imperial collection in Vienna, it was cursorily described in Christian von Mechel's catalogue as 'Giorgione, the three wise men from the East'. The generic descriptions of the previous inventories ('philosophers', astronomers and geometers who contemplate and measure, mathematicians who calculate the height of the heavens) had given way to an exact definition: the three protagonists are the 'wise men from the East', the three Magi. Albrecht Krafft, in his catalogue of 1837, wrote that the painting is known as 'The Fieldmasters from the East' – the oriental flavour persists but the wise men, astronomers and mathematicians have become land-surveyors. In 1881 Eduard von Engerth reinstated Mechel's title, 'The three wise men from the East'. These interpretations, each of which is presented as a statement of fact with no argumentation, emphasize two particular features of the painting: the exotic, 'oriental' dress of the three figures, and their contemplative attitude, though equipped with 'instruments for measuring' the sky or the earth.

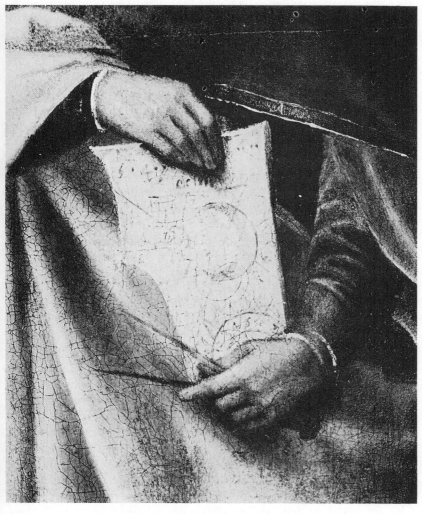

4 Giorgione, *The Three Philosophers* (detail from 3)

Real discussion on the subject of the painting began in 1886, with
a copious work by Carl von Lützow on the imperial gallery in
Vienna.[4] He cites a letter from Hubert Janitschek who saw the
painting as 'the three ages of human wisdom': the older man
represented classical philosophy (probably Aristotle), the central
figure medieval philosophy (probably an Arabic philosopher such as
Averroës or Avicenna), and the young man Renaissance philosophy.
Lützow still entitled the painting 'The three mathematicians', but

his commentary touched on a theme that was to become increasingly popular: that the picture was a personal story which owed most of its charm to the 'lyrical vagueness of its underlying conceit'. The subject, in other words, was either impalpable or else of minor importance. A few years later, however, came Franz Wickhoff's announcement that the subject was a classical legend, firmly in the spirit of the 'classical Renaissance': as in Virgil's *Aeneid*, Evander and Pallas lead Aeneas to the bare rock where the Capitol will stand.[5] Neither Janitschek nor Lützow nor Wickhoff refers to the early interpretations. The field was now open to the talents of the interpreters.

Since that time, all the various attempts (at least fifteen) to establish the subject of *The Three Philosophers* have followed the three directions mapped out at the end of the nineteenth century.[6] Some interpreters, like Wickhoff, looked for a specific story in Giorgione's canvas: Merlin the magician visiting Blaise (Ludwig, 1903), Marcus Aurelius on the Coelian hill, instructed by two philosophers (Schaeffer, 1910), Abraham teaching astronomy to the Egyptians (Pigler, 1935). Others, like Janitschek, saw the painting as an allegory of three phases of life or thought: the three ages of man (Schrey, 1915), the three races of mankind (Brauer, 1957),[7] the three phases of Aristotelian philosophy (Ferriguto, 1933, Francastel, 1960).[8] For some interpreters in this category, the painting was of clearly indentifiable philosophers or astronomers: Pythagoras, Tolomeus and Archimedes (Baldass, 1922); Aristotle, Averroës and Virgil (Parducci, 1935);[9] Regiomontanus, Aristotle and Tolomeus (Wischnitzer-Bernstein, 1945), or even Tolomeus, al-Battani, Copernicus (Nardi, 1955);[10] St Luke, David and St Jerome (Parronchi, 1965).[11] Another interpretation was that of the three phases of hermetic initiation (Hartlaub, 1925 and 1953), and, along the same lines, the 'triple Hermes' in the form of Moses, Zoroaster and Pythagoras (Calvesi, 1970).[12] Thirdly, there were those, like Lützow, who preferred to deny the existence of a definite subject (Baldass, 1953, Venturi, 1958 and Waterhouse, 1974).[13]

It is not my intention to discuss these interpretations, which crowd around Giorgione's canvas in such a tangled maze of scholarly quotations and polemics that it is virtually impossible to get a clear view of the painting. I will instead attempt to unravel the museum history of the canvas, including the attendant philological discoveries and interventions of its more recent life in Vienna.

II

Our point of departure must be *The Sleeping Venus* in Dresden (5), which Michiel described and attributed to Giorgione, 'but the landscape and the Cupid were finished by Titian'. The figure of Cupid recurs in all descriptions of the painting up until 1837, but does not appear on the canvas in its present state. In 1929, however, Carlo Gamba noticed a Cupid in Vienna which must have been copied from the Venus canvas, for it showed an identical landscape in the background (6).[14] He therefore suggested that the two belonged together. The prestige of artists such as Giorgione and Titian soon demanded that this hypothesis be verified and the canvas was subjected to X-ray. The results largely confirmed Gamba's theory, revealing the figure of a Cupid which had been painted over in the seventeenth century. This, then, was the first appearance of X-ray photographs in the arena of interpretation of Giorgione's works.

The X-ray of *The Sleeping Venus* was published in the *Jahrbuch der preussischen Kunstsammlungen*. In the same volume was a claim by Johannes Wilde, in a brief comment on *The Three Philosophers*, that Mechel's interpretation (the Magi) was the most convincing of all that had so far been put forward. One year earlier Louis Hourticq had 'rediscovered' this same interpretation – with no previous

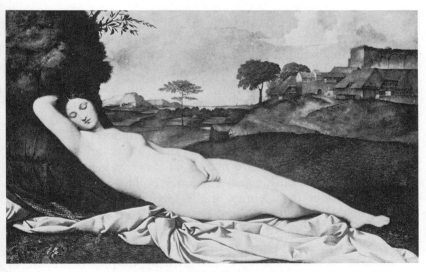

5 Giorgione, *The Sleeping Venus*

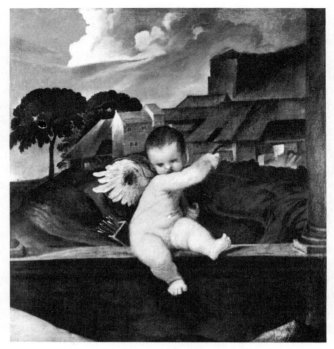

6 Giorgione, *Amorino* (copy)

knowledge of Mechel.[15] This led to the X-raying of *The Three
Philosophers*, supervised by Wilde himself; the results were published
by him the following year.[16] The results, on this occasion, revealed
no features that had been painted over, but an earlier version of the
painting which differed from the final composition in certain details
of the landscape, and especially in the facial expressions of the three
protagonists. The youngest 'philosopher' stares intently, with parted
lips, in an attitude of surprise rather than meditation (7). The eldest
is turned sharply towards the cave and wears an extravagant
'oriental' head-dress; the third man is no longer a generic 'oriental'
(though his dress is unchanged) but a negro. This last detail dispels
any doubts about the identity of the 'philosophers' in the earlier
version: they are the three Magi. First introduced in the fourteenth
century, the Moorish king had become almost obligatory, as had
the age differences between the three men.[17] And the diadem worn
by the elder 'philosopher' had been used by Carpaccio for one of
the kings in his *Adoration* of 1505, now in Lisbon.[18]

7 Giorgione, *The Three Philosophers* (detail from the X-ray)

In 1953 extensive restoration work and the remounting of the
picture occasioned further discoveries: a fig tree and swathe of ivy
trailing down the edge of the cavern, and close by a spring bubbling
up from under the rock. When the painting was removed from its
frame there was evidence that it had been cut away at the sides:
and it was possible to verify the exact measurements of the missing
pieces by a comparison with the sketchy reproduction of the painting
by David Teniers the Younger, in his great picture gallery of the
collection of Archduke Leopold William (8, 9).[19] We are thus able
to reconstruct the earliest composition of *The Three Philosophers*:
the cavern, with its spring, ivy and fig tree, comprises almost half
the painting, supporting the arguments of Wickhoff who was the
first to stress its thematic importance. The first of the Magi holds
a square and compass and gazes into the cave in astonishment; the
other two turn to each other, as though about to speak. The Moor's
right hand is slightly outstretched, and the old man holds a compass
and a scroll bearing astronomical signs (10).

Some more recent interpreters have thought to ignore these
established facts in the painting's history by paying tribute to

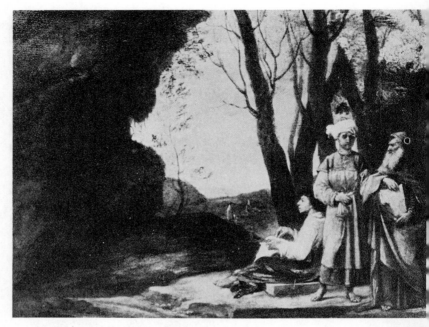

8 David Teniers the Younger, *The Picture Gallery of the Archduke Leopold William* (detail)

Giorgione's development as an artist, allegedly demonstrated in the changes made in the second version of *The Three Philosophers*. The most recent attempts to interpret the subject (Francastel, Calvesi) have excluded the first version altogether without so much as a reference: it is merely the prehistory of a masterpiece, that was altered because it was imperfect and therefore had no part to play in the painting that Giorgione wished to bestow on his patron and on posterity.

But given the new details (spring, ivy, fig tree) that have emerged with X-rays and remounting, it is perhaps worthwhile to attempt a reading of the earlier version which can then be compared with the later composition of *The Three Philosophers*, a familiar feature not only of the great Museum in Vienna, but of every book on Renaissance art.

III

There can no longer be any doubt that the three figures of the earlier version – a younger man 'who contemplates', a Moor and an old

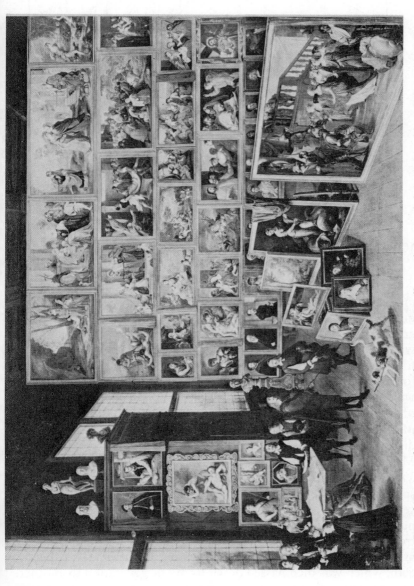

9 David Teniers the Younger, *The Picture Gallery of the Archduke Leopold William* (whole)

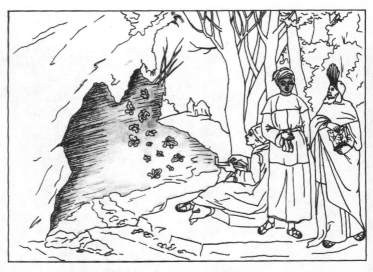

10 Giorgione, *The Three Philosophers* (schematic reconstruction of the
 first version of the painting, drawing by Fulvia Donati)

man who turn towards each other, 'measuring' and talking – were
intended to represent the three Magi. But even when the protagonists
are identified, the iconography of the Vienna canvas is still elusive:
what are the Magi doing in front of the cavern? Wilde has put
forward a convincing answer[20] in which he points out the source
for the scene (one may add: direct or indirect) in a text that was
widely known throughout the Middle Ages and into the beginning
of the sixteenth century: the so-called *Opus imperfectum in
Matthaeum*. It tells of a school of *studiosiores*, with strict rules of
discipline, who watched the skies for signs of the coming of the
Messiah. The chosen spot for their observations was the *Mons
Victorialis*, which was *electis arboribus amoenissimus* [a delightful
spot with choice trees], and had *quandam speluncam in saxo* [a
certain cave in the rock] and pools where the sages could take
purifying baths. This was the grotto where Adam and Eve hid their
treasure after they were cast out from the earthly paradise. They
assured its remembrance in a kind of testament made to their son
Seth, which was then passed down from one generation to another.[21]
The revelation that Christ had come would occur in the place where
Adam and Eve began their earthly life, after the Fall and expulsion
from Eden, and Adam's treasure would be an offering to the Messiah.

All the elements of this imaginary scene are present in the first version of *The Three Philosophers*. The one variation is that there are only three sages. This is the canonical number of the Magi – based solely on the number of gifts in the Gospel (gold, incense and myrrh) but consecrated by iconographic tradition for more than a thousand years. It was also the number established by John of Hildesheim in his famous *Liber de gestis trium regum*, a work that was surprisingly well known and regarded as an authority for its links to the cult of the Magi's relics in Cologne cathedral.[22] It is from this tradition that Giorgione appears to have derived at least the figure of the Moor in the 'first' painting: *Jaspar maior in figura, et ethiops niger* [Caspar, taller in stature, a black-skinned Ethiopian], stands in contrast to Melchior (*senex et canus, barba prolixus et capillis* [an old man with white hair and a long beard], according to a text falsely attributed to Bede).[23] But there are other elements which are clearly derived from the *Opus imperfectum*: the spring, where the sages were purified before embarking on their observations, and the 'choice trees' which Giorgione specifically identifies as ivy and fig. These trees, as Klauner has shown, frequently recur in early Renaissance paintings of the life of Christ, and especially in those of the Nativity and the Passion. In a *Sacra conversazione* by Mariotto Albertinelli, the fig tree is shown on the Virgin's pedestal, while at each side we see Adam and Eve at the moment of the original sin: in a rich and enduring tradition the fig is 'the tree of good and evil'. In other cases, the allusion to the contrast between original sin and redemption may be less direct, as for example in a painting by Moretto, where the Virgin's cloud merges with the fig's branches. Ivy is connected first and foremost to the Nativity. Its significance is especially clear in an engraving by Nicoletto da Modena, in which a great trail of it climbs around a pillar inscribed with the words *'virtus ascendit'*. Ivy and fig, then, refer antithetically to Sin and Salvation: evergreen as ivy, the New Covenant has established the laws that will lead mankind towards God.[24]

Klauner, however, was certainly wide of the mark when she concluded, as though overwhelmed by drawing such a quantity of iconographic comparisons, that the Magi are discovering the birth of Christ *from the ivy and the fig tree*. This runs contrary to both the texts and traditional iconography, as well as to the evidence in the painting. The old man holds a compass and a parchment full of numbers and astrological signs (dominated by the word *celus*) that declare the Messiah's birth.[25] The young man bears a square and compass and more papers – not, we presume, to measure the fig

and ivy. The 'choice trees' are there as emblems, subtle allusions to salvation, but the Magi are portrayed as astrologers, in the rich and widespread tradition of the Christian world.[26] Armed with the instruments of their science, they are there to observe Christ's coming. Behind them, the vivid contrast between a leafy tree and the stark outline of a bare tree restates a theme that was frequent in late medieval art, and which still persisted in the paintings of Jacopo Bellini, Carpaccio and Mantegna: the dead Tree and the living Tree (11). The Tree of Paradise withered after the Fall and the Tree of Life bears the promise of salvation through the Passion of Christ.[27]

The group of the three wise men only occupies half the space of the painting. The other half is completely taken up by the cavern, Michiel's 'marvellously imitated rock' (assuming he was not referring to the rocky steps under the Magi's feet). Let us take Michiel's description a stage further: to the seated philosopher 'who contemplates the rays of the sun'. But the sun is setting far off in the background, while if we look closely at the 'philosopher', he actually appears to be turned towards the cavern; and indeed this is the only position he can be in, if the two halves of the painting are to come together to form a legible whole. No colour print can reproduce the extraordinary light in the painting: the sun has almost disappeared, a faint red on the horizon between two humps of hills, showing us where the west lies; but the steep hollows of the cavern are dimly lit by another light, that seems to emanate from the opposite side.

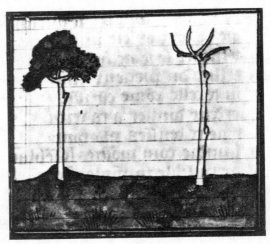

11 *Miniature with Two Trees* (from *Cahiers archéologiques*, XIX, 1969)

Michiel was therefore wrong when he stated that the seated philosopher 'contemplates the rays of the sun'. This double source of light is so intimately bound up with the meaning of the painting that it cannot be the result of later alterations. Even if it were possible to prove that this part of the picture was due to the 'completion' by Sebastiano del Piombo that Michiel recorded, we would still have to concede that the vision of a boundless light suffused through airy towers of cloud, and the sun setting behind blue hills (so similar to the *Tramonto* in the National Gallery in London), is a vision that can only have belonged to Giorgione. How else are we to explain the uniformity of colour of the withered trees, almost like cardboard cut-outs in a backdrop, while the scene is illuminated from a central light in the background that was even more central when the canvas was intact? Baldass, who was perhaps the first to notice the two sources of light, tried to explain it – as Goethe had done before with a Rubens landscape – as an 'artistic necessity' that violated and transcended any 'necessity of natural form'. Michael Auner has found a far more persuasive explanation: the light which comes from the east and shines into the depths of the cavern is the Star of Bethlehem. The painting then represents the very moment when divine revelation cuts across the astrologers' calculations; and thus the noble figures of the three protagonists seem lost in a kind of inner confusion – 'for we have seen his star in the east' (Matt. 2.2.).[28] Thus we see the seated Magus open-mouthed, with eyebrows raised in an attitude of surprise. Giorgione has given him an expression which generally belongs in the iconography of an Annunciation to the shepherds, where there is always one who makes a gesture of astonishment on seeing the angel (or the star, in cases where the scene is combined with the Magi).[29] This character can still be seen today in Neapolitan cribs;[30] and in my native village of Rosarno in Calabria he is called by a peculiarly appropriate name – *u mmagatu da stida*, 'bewitched by the star', the word *mmagatu* containing both 'magus' and 'magic'.

Teniers' painting shows the whole picture as it was in Archduke Leopold William's gallery (8, 9). A comparison with the original painting shows very clearly how the removal of a wide strip of canvas from its left side has altered the nature of the cavern, transforming it into a solid rock. For the cut comes exactly at the point where a fold in the rock face begins to curve outwards, opening up the hollow of the cave. And there the star, in a heaven that is outside the picture, first begins to reflect its soft light. The edge of the rocky outcrop, fringed by grasses and roots darkened by the sun

setting behind, marks a clear separation between the cavern and the night shadows beyond. But though the canvas has undergone such a brutal alteration, we can still make out the subtle luminescence coming from the darkness of the cave. It is this light which picks out the sparse leaves of ivy and fig; it steals over the rough rock, leaving shadows that form a kind of terrible visage (in the top corner of the picture), as though to guard Adam's treasures. It scatters a myriad of reflections over the pebbles at the mouth of the cave (each picked out by a light stroke with the tip of the brush), which join together in the little rivulet of water that flows from the spring. It gives a warm brownish colour to the tuft of grass at the base of the philosophers' stone pedestal – here too Giorgione's astute brush has traced hundreds of tiny points of light.

Brought to this mountain by science and faith, the Magi 'stare intently' into the dark cave, to discover by the first light of the star that the Redeemer is in the world. An imposing protagonist of the painting, the great cavern brings to mind the artificial grottos that were a familiar feature in mystery plays. These artefacts were movable elements of scenery that could readily pass from theatre to painting: Francastel, who has explored this phenomenon, quotes an example from a play of 1508.[31] And, apart from the bare record of surviving texts, it is certainly true that the mystery plays nourished the faith, imagination and memory of their spectators through the centuries, as they still do today. We can almost relive this experience if we stand before the clock in St Mark's Square (built 1496–99) in Ascension week, when the chiming hours bid the Magi to rise and pay homage to Christ. For the rest of the day the figures are concealed inside the clock, but now they take on life and movement and rehearse a sacred drama that is something between living theatre and the immobility of a painting.[32]

In the widely known Play of the Magi, the scene where they discover the star is narrated in a few simple strokes:

Primus magus: Stella fulgore nimio rutilat
Tertius magus: Quae regem regum natum demonstrat
Secundus magus: Quem venturum olim propheta signaverat
Magi: Eamus ergo et inquiramus eum, offerentes ei munera, etc.[33]

First king: The star shines with a great light
Third king: Signifying that the king of kings is born
Second king: Whose coming was foretold by the prophet
Kings: Let us go and seek him, then, bringing him gifts, etc.

The limitations of the set dictated that this scene was followed by the Adoration, omitting the journey of the Magi. But the characters

parts are divided up: the first king sees the star; the third interprets it in, as it were, a purely astrological sense; the second adds a reference to the prophecy of Balaam. In just the same way, the first king of Giorgione's painting discovers the star; the third holds up a set of astrological calculations that interpret it; and we can easily believe that the task of quoting the prophet has fallen to the unmoving, portentous figure of the second king.[34] Standing on three different levels on the rock (which follow a Byzantine formula, perhaps after Mantegna)[35] the three Magi represent the three separate stages of the star's discovery.

IV

The *Mysterium Nativitatis* was not the only place where this scene occurs: and despite the claim that 'a representation of the Magi that does not include their coming before Jesus is otherwise unknown in iconographic tradition',[36] it is in fact possible to find other significant examples of its occurrence. The first is a famous altar piece by Gentile da Fabriano (12), painted in 1423 for the church of Santa Trinita, and now to be found in the Uffizi. This is an elaborate Adoration with three lunettes that show additional scenes with smaller figures, belonging to an earlier time than that of the main subject: we are shown the Magi discovering the star, their journey and their arrival in Jerusalem. As in a mystery play, one space encompasses a series of scenes that must be thought of as temporally and physically quite separate: 'medieval theatre is synoptic. It is as though the whole world is gathered under the eyes of God'.[37] The journey of the Magi from Revelation to Adoration is but the prologue to the Epiphany of Jesus, before whom all the kings of the earth would kneel down.

The same iconography is used in a work of the same period as *The Three Philosophers* by a Veronese painter, Giovan Francesco Caroto. Towards the year 1507 he worked for the 'altar of the Magi in the church of the hospital of S. Cosimo' in Verona, where he painted 'the altar shutters, representing the Circumcision and the Flight into Egypt, with other figures'.[38] Vasari only gave details of the subjects of the right door, but both doors were acquired from a Veronese family by the Uffizi in 1908, and can be seen there today. In the background of the left panel (which has borne the cumbersome label *St Joseph with Two Shepherds* from one catalogue to the next) are the Magi studying the star (13).[39] Clearly, in an 'altar of the Magi', the presence of the latter could not be limited to these tiny figures: the main panel (or relief) must certainly have

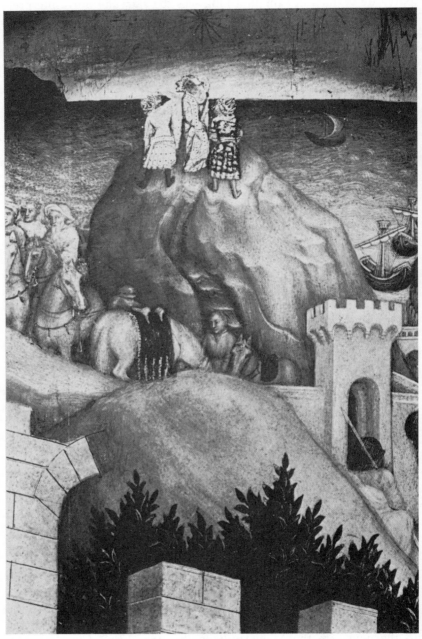

12 Gentile da Fabriano, *Pala di Santa Trinita* (detail)

13 Giovan Francesco Caroto, one of the altar shutters from the Altar of
the Magi in the Ospedale di San Cosimo, Verona

included an Adoration of the Magi, by a different artist, a subject that has close ties with Caroto's panels. When the altar is shut the two 'portals' come together to form one scene: the Circumcision of Christ, whom Mary places on the altar before the priest, while Joseph stands outside the temple, in a rocky landscape that spreads over the two halves. When the altar is opened, the Adoration in the centre becomes the second scene in the story, while the two side panels show the dramatic consequences of the Magi's journey of homage: on the right, the Slaughter of the Innocents, and on the left the Flight into Egypt. So that in opening the panels the observer discovers the true history of this new born child, in that the Slaughter and the Flight prefigure his destiny as a victim. In this sense the first scene, with the Magi in the background, synchronising the sighting of the Star with the circumcision,[40] is comparable to the first act of a mystery play.

As the work of a Veneto artist who was contemporary with Giorgione, Caroto's door has particular importance. But, in a further example, the appearance of the star is clearly isolated from the three other scenes depicting the childhood of Christ, on a monument of such venerable age and resplendent setting that it must have been familiar to every Venetian: the pillars of the ciborium in St Mark's church. Here successive tiers of figures are set in a series of narrow arches. Below are inscriptions, separated by three dots(:), that mark each space as a scene from the life of Christ. In the back left column, the second tier from the bottom shows the scene of the Annunciation to the Magi (three kings and an angel) and to the shepherds (three shepherds and an angel). The remaining arch is occupied by Herod seated on his throne. The Magi group (14) is depicted at the exact moment of their discovery: two Magi are turned towards the third in the centre (thus separating the group from the rest of the composition). The Magus on the right points to the heavens, his counterpart on the left is seated and studies celestial sphere; between them, the third Magus reads a scroll with the prophecy of Balaam. The inscription provides a clear guide to the scene:

:*SCRUTATIO PROPHETIE PRO STELLA*:

The figure of the seated Magus (absent in both Gentile's and Caroto's works) and the group's isolation from the other figures are features which make this scene virtually unique. Its only parallels can be found in Cappadocia,[41] which saw the development of the schema of the three shepherds that was to become so widely diffused: two standing and the third seated, playing a musical instrument. Since

14 Detail from one of the pillars of the ciborium in San Marco, Venice

St Augustine it was popularly believed that the Magi prefigure the
homage of the pagans to the Saviour, while the shepherds prefigure
that of the Jews.[42] But the scene of the Star had already been isolated
from the bringing of gifts in a Carthaginian relief of the fourth or
fifth century (15): two of the Magi stand, gesturing in astonishment,

RITTER LIBRARY
BALDWIN-WALLACE COLLEGE

15 Drawing from a Carthaginian relief

and the third is seated between them, not 'in a highly realistic attitude of disappointment'[43] but meditating upon the meaning of the apparition. The Magi have thus completely taken over the role assigned to the figure of Balaam in early Christian art, who pointed to the star while an inscription ran 'orietur stella ex Iacob' [there shall come a star out of Jacob] (Numbers 24.17).[44] On the pillar in St Mark's Church we find not only that one king is seated while the others are standing, but that one holds a scroll and another an instrument of astrology – both features of Giorgione's painting. It may not be coincidence that the largest church in Venice contains the closest iconographic parallel to the first version of *The Three Philosophers*.

V

It should be noted that in the examples we have just seen, the scenes where the Magi discover the star and compare it with the prophecy of Balaam or with their own knowledge of the skies are all part of a larger cycle. The scene is thus justified as one episode in the story of Christ, and the inscription clarifies the narrative sequence. But in Giorgione's painting the apparition of the star is not an episode but the focal point of the story. Yet though he has selected a crucial moment at the very beginning of the *historia trium regum*, his narrative slant is such that the sequel is not to be forgotten: lost in noble, profound meditation on the prophecy, the Magi seem to know already that Christ is born, though as yet with more astonishment than joy. In the same way as the feeling of an entire canto of the *Divine Comedy* can be fleetingly recalled by listening to the first lines, this moment of suspense evokes the whole story

of the Messiah's birth. For the discovery of the star also embraces the Epiphany, the revelation of the Christ child's divinity.

Facing the three astrologers is the cave, dimly lit by a distant, invisible star. This is the grotto of Adam's treasure, scene of the last episode in the story of the original sin and the first in Christ's life among men. Here Adam had buried the treasure that he wished to be offered to the Redeemer, in the knowledge that his sin would be washed away. Several thousand years of history are thus drawn together into one particular space; and though sin seems to come hard on the heels of salvation, like events in a personal biography, the destiny of mankind is projected into infinity, the temporal dimension of God.

It was for these reasons that Christ was called the *novus Adam*, and Adam's skull (which gave its name to Golgotha – 'the place of the skull') was often to be found in Crucifixions at the foot of the cross. Christ died where Adam was buried, and his Passion crowns and concludes the story that began with Adam's sin. A similar kind of preoccupation gave rise to the legend of the finding of the cross, which Piero della Francesca immortalized beyond the life of all legends: the tree of good and evil, after various incidents, becomes the *lignum crucis*, recovered some time later by St Helen to be venerated by all of Christendom. Thus, in a series of scenes of the life of Christ on Bonnano's doors for the Duomo in Pisa, the panel showing the Epiphany also includes the original sin below the hill with the Magi (16), without any narrative link with the rest of the decoration.[45]

Giorgione, then, has represented the Magi as drawing together the opposing strands of the story of salvation. The fig tree at the mouth of the cave is an allusion to the tree of knowledge, the spring to renewed Grace through baptism, the ivy to the undying strength of redemption. But through its isolation from the rest of the story, the scene has an altered meaning. The Gospels narrate the chronology of Christ's divine origin, with his genealogy and the Annunciation, and his birth; the Epiphany and the coming of the Magi are added only by Matthew, setting the seal on a story that is already sacred. Giorgione's picture is an isolated portrayal of the instant of intense suspense when the first glimmer of the star appeared to man, and told him of the new presence of God in the world – was it revelation or discovery?

In traditional medieval iconography the star *appears* to the Magi with so bright a light that they seem to have no course but to follow it. Sometimes an angel or a voice from heaven is added to guide them, or even the figure of the infant Jesus in the star.[46] In

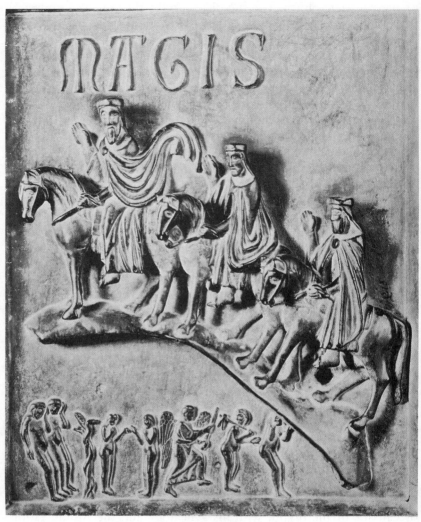

16 Door of San Ranieri, Duomo of Pisa

Giorgione's painting the Magi are *seeking* the star, and as they stare intently into the dark depths of the cavern they discover its first rising. The apparition is immediately interpreted – not by an angel from heaven or the voice of God, but by astrologers, through calculations, observations, books of science and squares and compasses. The divinity of the Christ child is not revealed through a genealogy or an Annunciation but *discovered* by men through

science. The star begins a new age, announcing that Christ has come: but it is man's science that makes that discovery and shows it to the world. In choosing this scene for the story of the Magi, Giorgione has shown man using his own instruments to explore his world, and discovering there the presence of God. The sacred story has taken on a temporal, earthly dimension.

VI

The star of the Magi had long been a subject of dispute among the church Fathers: the question of whether or not the *Philosophi Chaldaeorum* [Philosophers of the Chaldeans] (St Jerome, in Daniel, 2) could have deduced the Redeemer's birth from studying the stars inevitably led to pronouncements on the nature of astrology.[47] The star controversy was revived with the astrological debates of the quattrocento: the opposing sides being exemplified by Giovanni Pico della Mirandola and Marsilio Ficino. In his *Praedicatio de stella Magorum*, given in a Florentine church around Christmas 1487, Ficino examined the predictions of the Magi in great detail, expressing them in the terms of contemporary astrological language.[48] On a previous occasion, in his translation of Iamblichus' treatise *De mysteriis Aegyptorium, Chaldaeorum, Assyriorum*, composed in those years and published in Venice in 1503, he had already stated that 'haberi posse per divinum vaticinium vertitatem certissimam circa stellas' [it is possible to establish most certain truth about the stars through divine predictions] (p. 73). Pico opposed this argument in his *Disputationes adversus astrologiam divinatricem* (1493–4). Here he rejected an astrological interpretation of the Magi story on the grounds that the star was not *perpetua et naturalis*, but *facticia et artificialis*, created by God solely to reveal the birth of Jesus; no specific astrological science was therefore needed to interpret it. Just as the Magi were warned in a dream not to return to Herod (Matt. 2.12), so they had not 'divined' the meaning of the star but had received knowledge through Revelation and Grace.[49]

The sharp divide between Pico and those who believed in the powers of astrology may be said to conceal a common and deeply ingrained tendency. The opposition between astrology and astronomy, which we now consider obvious, was only to be posited at a later stage. At that time, the observation of heavenly phenomena was upheld and defended as part and parcel of the understanding of nature, and only within astrological 'science'. And precisely *within* that science the 'modern' concept of astronomy would gradually

evolve. Even the paramount problem of the stars' influence on human destiny can itself be conceived as a justification of astrology, which in the last analysis is itself a defence of the principle of causality as a key concept for the interpretation of nature.

Unresolved in the troubled and ambiguous arguments used by Ficino, this question fares rather better in the works of Pietro Pomponazzi, particularly in his treatise *De incantationibus* (1520). Here he argues that all strange and prodigious events, though seemingly the result of magic or demonic influences that alter the laws of nature, must instead be referred back to those very same laws: i.e. the influence of the stars that act by mediating the divine will, as secondary causes, by the principle of necessity. In this way the study of astrology allows an explanation of prodigies in terms of natural necessity; it is therefore in opposition to the world of magic and miracles. By proposing a pattern of explanation, imperfect though it may be, in terms of causal links, astrology posits itself as a framework for a scientific understanding of nature. A broader and more articulate astrological science could eventually explain *all* 'magical' phenomena.[50]

There is therefore common ground between Pomponazzi's position and the unswerving rejection of Pico – he does not conceive of celestial 'influences' but only of natural causes perceptible to the senses. Both positions sought to establish scientific knowledge along chains of natural causes, but the path chosen by Pico was to be far richer, directly influencing Kepler and the foundation of the exact sciences.[51] But Pomponazzi too seemed to strain the tenets of medieval Aristotelianism by introducing an iron principle of natural causality into astrology.

In discovering the star and interpreting its meaning with books of science, square and compass, and the prophecy of Balaam, Giorgione's Magi take their stand in the philosophical debates of their own time, arguing, with silent eloquence, the power of man over nature and the stars. As astrologers, they bear witness to their faith in the instruments of science. The ancient legend that was based on a brief reference in St Matthew's Gospel and fostered by a long tradition of religious theatre has found its most sublime expression in Giorgione's painting, for its life and substance are shaped by the astrological debates that animated all the scholars of the time. This imaginary *Ludus Magorum* could well be enacted in the lecture hall of a university.

At about this time there was a growing tendency in the Church to rid itself of the legendary inheritance of the mystery plays. In

1508 the town of Rouen was requested to abolish one of the most famous 'Mysteries of the Nativity' and the order was carried out by the cathedral chapter in 1522. In the same period the Patriarch of Venice forbade the plays in the city's churches, and especially *inter praedicandum*; and in the following decades the Council of Trent sanctioned the complete disappearance of religious theatre.[52]

VII

This, then, is a reading of the first version of *The Three Philosophers*. It is endorsed by the fact that so far no-one has doubted (and it would be difficult to do so) that the three protagonists are the Magi. But can the same be said of Giorgione's painting as he left it, as we see it today?

Once more we are beset by the discordant labourings of various interpreters, to the point where the opinion of those who deny all possibility of understanding the painting begins to seem justified. Then there are those who have set themselves a different task, to seek the meaning 'outside' the scene itself by reconstructing the original site of the painting and then labelling it as 'companion' to another picture. Three scholars have tried this method, on the basis of a reference in Michiel's notes to the ten paintings in Taddeo Contarini's house: three by Giorgione, three by Giovanni Bellini, two by Jacopo Palma il Vecchio, one by Girolamo Romanino and the last by an artist whose name has been lost. Of these, Wickhoff selects a lost painting by Giorgione, *Aeneas in the Underworld*, as companion to *The Three Philosophers*, the interpretation of which is thus offered as Aeneas, Evander and Pallas. Wickhoff makes no reference to the rest of the Contarini collection, nor indeed to the third painting by Giorgione. The latter (also lost) was *The Birth of Paris*, and it was this, in Klauner's opinion, that was the companion to *The Three Philosophers*, though again she does not refer to the third painting. Lastly Waterhouse, without referring to the others at all, takes Bellini's *St Francis Receiving the Stigmata* to be the companion to *The Three Philosophers*. The truth is that it is impossible to gather from Michiel's meagre list whether the paintings hung in one or more rooms. The meaning of the painting is not to be found in one of its 'companions' but in the painting itself, and primarily in the original version.[53]

How then can we explain the transition from the first to the second version? According to Wilde (1932), who published the X-ray photograph, Giorgione removed the most telling features of the

Magi with the intention of changing them to represent the Three Ages of Man, and with this the Three Forms of Contemplative Life (inquiry, meditation and teaching). In erasing a specific subject in favour of another highly symbolic one, he profoundly altered the painting 'in the spirit of classicism'. The first version belongs to the quattrocento, whereas the second approaches the ideals of 'classical art'.[54] Hartlaub also admitted that the Magi are the most likely subject of the first version (1953), but he went on to propose his 'hermetic' interpretation and emphasized that Giorgione's intention in changing the colour of the Moor was to exclude all reference to the Magi. Giorgione, then, altered his subject under the influence of some occult doctrine, such as those practised and diffused by Agrippa of Nettesheim a few years later. Baldass found it hard to confirm that the Magi were the subject even of the first version, which he nevertheless recognized as a story with specific features that were veiled in the second version. This change, in his view, can be explained 'by the wishes of the patron (or may we already speak of the buyer?)'. Klauner, who saw the ivy and fig tree as the key to the whole painting, explained every alteration (including the colour of the Moor) as being made for 'artistic reasons' that did not imply a change of theme. Though her research is carried out within an iconographic framework, this important change in the painting is given a purely formal explanation. Venturi is much clearer than other scholars when he declares that though in the first version 'Giorgione took his inspiration from an apocryphal legend as a pretext for freeing his imagination . . . it is still evident that in his final version he has made sure that the first source of inspiration did not show, transforming his Magi into Philosophers'; 'philosophers in general', but even so 'a simple pretext for Giorgione's art'. By changing his first subject, Giorgione has thus made it contemporary, and has made 'a very important step towards the imaginative autonomy of art'.[55] In the same way, Waterhouse sees *The Three Philosophers* as a generic representation of the 'old order', before the birth of Christ, 'possibly with a side glance at the Magi', but nothing more. Similarly, Calvesi, though initially convinced by Klauner's theory, then went on to construct another 'hermetic' interpretation along the same lines as Hartlaub, without so much as a reference to the first version of the picture.[56]

The heart of the problem is this: if it is true, as no-one has seriously doubted, that the subject of the first version is the Magi waiting for the star (or we could now say, discovering it), is it then possible that Giorgione used a fundamentally different theme for

the second version? How can we understand and reconstruct such a transformation? Above all, is it possible that the meaning of the scene is totally changed when the attitudes of the figures, the details and symbols and the general scheme of the composition have remained the same? In Hartlaub's eyes, the grotto has now become Saturn's cave and the Magi represent the three phases of hermetic initiation. But if Giorgione had wanted to abandon the first theme for the second, what made him leave the essentials of the scene untouched? Why should a painting of such careful construction and rich iconography have been 'adapted' to a completely different theme? The loudest claims that Giorgione was asserting 'art's autonomy of imagination', a free inventor of paintings without subject, come from those scholars, like Venturi, who also see him as bound to his original version, obliged to keep it in spite of a change in theme, unable to create the new subject of the new painting from the beginning. It is hard to believe that canvas was so expensive in Venice.

First, let us go over all the changes between the first and second versions of *The Three Philosophers*. The Moor is of a different origin, though for his interpreters he is still an Oriental, and thus usually considered a philosopher or an Arab astronomer. The old man has lost his diadem of feathers, the exotic sign of his noble birth, and he is no longer turned so sharply towards the cave. The younger man, seated on the ground, is less visibly astonished at his discovery. The cavern retains its imposing presence, with the first light of the star reflected from its dark depths; at its mouth the ivy and fig still grow, the spring still bubbles close by. The philosophers still hold compasses and scroll, and their gaze is still fixed on the revelation in the cave, though it is now less troubled. The subject has not been erased but attenuated or hidden.

This series of changes is better explained by going back to the first version, or rather, by considering the two versions together, and comparing the changes with the most common iconography of the Magi. The first point, as we have already noticed, is the isolation of the scene from a wider narrative context. This would already have been an obstacle to interpretation in the first version, had not the colour of the Moor's skin also revealed the identities of his companions. Moreover, the Magi are not characterized as kings, as they are in the Bible.[57] On the other hand, neither do they have crowns in another work of Giorgione's circle (if not actually by his own hand, as is quite probable): the *Adoration* in the National Gallery. Here too, one king is oriental, not negro (17). Lastly, the

17 Giorgione (attr.), *Adoration of the Magi* (detail)

star, the Magi's traditional guide and companion, is replaced by a light inside the cavern.

A similar change of iconography, where the force of a supernatural event is conveyed by the painting's natural light alone, can be seen in a work by Giovanni Bellini (18). It was painted about twenty years before *The Three Philosophers*, and it too hung on the walls of the Palazzo Contarini. As Millard Meiss has shown,[58] St Francis receives the stigmata not from the usual apparition of a crucifix, with or without cherubim, but from a heavenly light that proceeds from the top of the picture; though protagonist of the scene, it is invisible in a reproduction of the whole painting (19). This detail, along with others such as the omission of Brother Leo, traditional witness of the miracle, makes Bellini's St Francis a work of exquisite and subtle construction. He has dispensed with all superfluous human spectators, and rejected the cherub–crucifix that so often appears in Stigmatizations descending into the scene with almost vulgar overtness like some theatrical device; and lastly he has

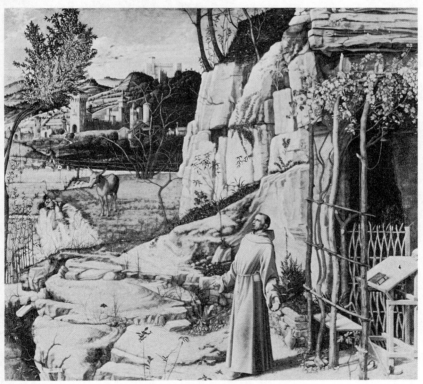

18 Giovanni Bellini, *St Francis* (whole)

19 Giovanni Bellini, *St Francis* (detail)

minimized the representation of the stigmata, conveying St Francis' similarity to Christ not with bleeding wounds but with marks that are almost imperceptible. The inhabitants of Casa Contarini would certainly have known that St Francis resembled Jesus 'not by the martyrdom of the body but by the enkindling of the mind', in the words of the *Fioretti*.[59] In the same years Leonardo had drawn the *Virgin of the Rocks*, seated before a cavern. But he had made a cleft in the background, through which a bright, penetrating light pours in to illuminate the mysterious rocky architecture of gigantic monoliths and distant mountains.[60] The light 'outside' the picture, which lights the foreground, is blended with the light 'inside' the picture, whose source is not revealed.

The first version of *The Three Philosophers*, then, shows that certain aspects of the subject had already been attenuated. In addition

to these, the Magi are guided by instruments and books of astrology rather than the prophecy of Balaam: not kings, but philosophers with compasses and an illegible scrap of parchment, with no star or any other mark to indicate their identity. They challenge every interpretation, with their slightly off-putting solemnity and their air of intently observing or waiting for something, we are not told what. They are almost too human to be Magi, and it is easy to see why a witty genre painter such as David Teniers the Younger (who had already copied the painting in the gallery of Archduke Leopold William) should have been tempted to transform them into peasants in his light-hearted satire (20): the youngest sits eating from a plate on his knees; the old man is given a spade and a sack, and his companion breeches, an unbuttoned shirt, and a gnarled wooden staff.[61] We can see exactly the same process at work in the many attempts at 'Giocondoclasm' provoked by Mona Lisa's smile.[62]

In trivializing the theme of Giorgione's painting to such a degree Teniers not only betrayed its spirit but deliberately ridiculed it as well. The atmosphere of sublime peace, laden with presentiment, that the cavern, the Magi's instruments and the light have evoked, cannot survive when the protagonists are Flemish peasants at their midday meal. But Giorgione's painting invited trivialization: for his

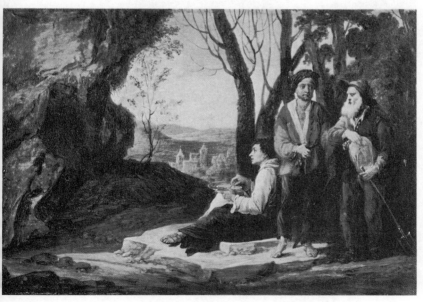

20 David Teniers the Younger, 'Parody' of *The Three Philosophers*

Magi were already more ordinary men than kings, no longer
following a supernatural apparition with some sort of message, but
scholarly interpreters of a phenomenon that was natural, though
beyond the fixed order of things – the appearance of a new star. It
appeared not as a great light in the heavens that showed them both
its meaning and the road they should take; but its light was
discovered in the darkness of a cave, through a man-made science
that was at one with faith in God. The old legend of the Bible is
thus vested with a secular meaning – in much the same way that
the unhallowed figures in the 'Benson' *Holy Family* are rendered
'human' and contemporary (21). But precisely because they are
Joseph, Mary and Jesus, the fact that they have no halos gives them
greater nobility and resonance, marking them as the eternal archetype
of every Christian family. Anyone familiar with the subject would
see in the figures of the Magi not only the sages of history *(quos
enim Graeci philosophos, Persae magos appellant* [for they are called
philosophers by the Greeks and Magi by the Persians]),[63] the first
to receive God's Grace, led by prophecy to pay the first homage of

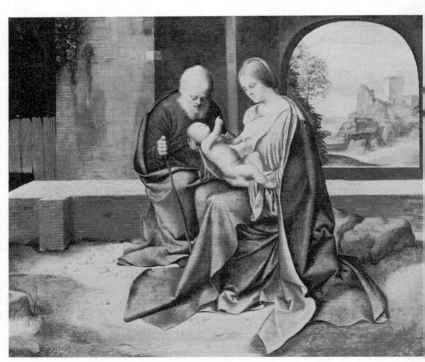

21 Giorgione (attr.), 'Benson' *Holy Family*

the Gentiles to the Saviour; they would also see the human race discovering the plan of salvation through study and observation, and coming to know God through science and philosophy. It is in this sense alone that the traditional subject has been not erased but superseded, placed in a more modern and higher perspective.

3

The Interpreters' Workshop

It might be argued that tracing the 'history of the Giorgione question' will become an abstract discussion of philology or, worse, a mass of scholarship that merely serves to prove the interpreter's assiduous methods and strengthen his interpretation against others. But what makes *The Tempest* unique is above all the history of the numerous attempts at its interpretation, fluctuating between subject and not-subject; and secondly, the way its apparent ambiguity has challenged the iconologist's skills more than any other painting, with results that have only reiterated all the pitfalls and nuances it contains. For these reasons, a survey of all the readings to date (assuming that none has escaped me) is not just an exercise in telling a tale on one page to undo it on the next, where the plot is always the same though the characters change their names. Interpretation does not mean attributing a story to a painting in a random fashion that explains one or two features but leaves the rest to guesswork. Nor should it gratuitously seek to analyse the spirit of the artist's times, supposedly revealed in the work.

Caught in the tug-of-war of subject and not-subject and repeatedly exposed to the iconologist's scrutiny, *The Tempest* is a particularly suitable candidate to pose an awkward question: 'What are the rules of this game?'

Fire and mystery

I see Giorgione approach over a strange shore, though I cannot see his mortal form; I seek him in the mystery of a fiery cloud that

envelopes him. He is more myth than man. No destiny of any poet on this earth is comparable to his. Almost nothing is known about him; some would even deny his existence. His name is not written on any of his works; some would not admit that any belonged to him. Truly, Giorgione in art represents the 'Epiphany of Fire'. He should be called the 'Bringer of Fire', like Prometheus.

The speaker is Stelio Éffrena, the protagonist of *Il Fuoco* by Gabriele D'Annunzio, and *alter ego* of the author.[1] A meeting has been called at the Palazzo Ducale in Venice by this 'other Image-maker'.[2] Giorgione is the centre of attention. The assembled crowd (from which Foscarina appears) is hypnotized by the evocative powers of the poet, who uses the magic of words to mediate between the magic of figurative art and the people. 'Such was the mysterious truce that the revelation of Beauty gave to the lives of the toiling people. It was the highest good of Beauty revealed. It was the victory of Art the Liberator over the misery, anxiety and tedium of their daily round' (p. 59). Art is the evasion of the everyday. Those who can escape the grip of hard facts will soar, like Giorgione, above the banality of life. If it were really possible to doubt Giorgione's existence, D'Annunzio's task in identifying with a nameless, themeless Beauty would be easier. Even so, 'men as deep as he do not know the enormity of the things they express'; their 'measureless power' is born of 'a pure ignorance of the artist' (p. 72). Just as the poet's word lifts the troubled masses from the vulgarity of their daily lives, so the artist, the creator from nothing, paints a sky of Beauty that will enable everyone to reach the dizzy heights of aesthetic enjoyment.

In *Il Fuoco*, written in 1900, D'Annunzio's own identification with Giorgione is mediated through Stelio Éffrena. But it appears in a more direct form in an article written in 1895;[3] on this occasion, D'Annunzio is making a claim for the artistic nature of the art critic:

> Now, what is criticism, if not the art of enjoying art? And what is the duty of the critic, if not to understand the work by intense experience, and then to reconstruct that understanding and that emotion with all the powers of the written word? CRITICA ARTIFEX ADDITUS ARTIFICI. (p. 340)

Thus what really counts is not 'the research of archives, history, iconography, hagiography' (p. 336) but the meeting of the poet–critic and the artist of the past: for example, D'Annunzio is 'led *by nature* to find the true meaning of Giorgione's symbols' in *The Tempest* because, before he has even seen the painting, he conceives a vision in his own mind that draws on an intense experience of the beauty,

colour and charm of Venice, and flashes before him in a blaze of light:

> We saw in that dazzling light the vision of a naked Woman and Child, the mother and her only son, the same bright vision as in the *Tempest*. For the woman and child on the ancient canvas are clearly like a fantastic apparition, one of those intense hallucinations that take on the semblance of reality. The man on the left is separated from the group and stands like one transported by his own vision. He is alone, he does not communicate with the two images as living creatures, nor make any gesture to them. He knows they are untouchable and he is alone. He stands completely still in the empty landscape overhung by the storm, while his desire rises to a great height and bursts through the clouds in a streak of lightning. (p. 348)

This thoroughly D'Annunzian Giorgione, whose painting is of 'the image of masculine strength, of overwhelming passion, of smouldering, voluptuous sadness . . . the overabundance of virile energy, of fertile seed', in fact turns out not to be D'Annunzio's original invention.The 1895 article was a critique of a book published in 1894 by Angelo Conti, art critic and ideological disciple of the 'Image-maker', and model for another character in *Il Fuoco*, Daniele Glauro.[4] As well as giving him the title for the book, Giorgione provides a pretext for a more general crusade in favour of 'artistic' art criticism: feelings and impressions as against the arid precision of historical research. The result of this is that 'the great human enigma that goes by the name of Giorgione' (p. 12) is the perfect subject for Conti: his obscurity is a 'true gift' for it has the power to prevent 'the usual offensive squabblings between the dwarves of erudite literature' (pp. 47–8).

However, Conti too cannot resist the challenge of *The Tempest*'s impenetrability. He interprets it as an idealized celebration of the birth of a child. The thunderbolt that flashes over the quiet human family alludes to the tragedy of paternity, which bequeathes to the child both life and 'the dreadful inheritance of pain' (pp. 54–5). This is an eternal theme, that makes Giorgione a precursor of Goethe: 'three human figures, whom the coming centuries will name Faust, Helen and Euphorion in the final poem'.[5]

This Goethian (and strangely also 'rather Wagnerian')[6] Giorgione passed from Conti to D'Annunzio. But it was by no means the only metamorphosis Giorgione was to undergo at the whim of his critics. An even more 'impure' use of *The Tempest* was made by Josef Strzygowski, an archeologist and art historian who is principally known for the dilemma posed in his most famous work *Orient oder*

Rom, on the origins of early Christian and medieval art.[7] In his last works he elaborated a theory on the purity and strength of 'Nordic' art, as opposed to the decadent art of the south. It was a theory that fitted well with the Nazi cult of the Arian race, and so *The Tempest* was used as a historic record of Indogermanic sensibility (for Giorgione, of course, was a 'Nordic' painter). The subject was unimportant; it was the landscape that carried the main force of the picture, and this was so closely bound to the artist's inner life that it excluded the role of a patron. It was a 'landscape of expression', showing the influence of Persian tradition (!).[8] Once the subject and patron were ruled out Giorgione's 'inspired' work was open to Strzygowski's 'Arian' manipulations. Giorgione was relegated to the limbo of 'mystery', for there he could be shown to justify dubious cultural movements more easily.

Hartlaub's theory likewise takes the 'mystery' of Giorgione as its point of departure, but its outcome is quite different and certainly more auspicious. Hartlaub reiterates the 'mystery of Giorgione' in the very title of his earliest work,[9] and this would be justified if he then went on to spell out the difficulties of understanding the painter's subjects, which were only intelligible to a handful of people, even in Giorgione's lifetime. But his arguments make some theoretical leaps that are less justifiable: for example, the meaning of the word 'mysterious' changes from being 'comprehensible to few' to 'originating in secret societies' and then to 'depicting the secrets of these societies'. The immediate result is that *The Three Philosophers* and *The Tempest* become esoteric paintings of the rites and mysteries of alchemistic–astrological societies in which only the initiated could take part. These types of organizations certainly existed in the Renaissance. But we do not know if they gave rise to their own iconography at this time, and Hartlaub admits that there is no evidence that Giorgione had any contact with them.

To give credibility to his theory of Giorgione 'the initiate', Hartlaub had to deny the existence of a patron. To this end, he took up Justi's formula and asserted 'Giorgione's freedom' in composing his paintings. Wickhoff's interpretations (which Justi accepted) were rejected precisely because they assumed a condition of patronage. Paradoxically, Hartlaub's reading of hidden meanings for the initiated entails in the first place the denial that the paintings mean anything at all, in the conventional sense of the word. The patron is removed, the painter is alone with his inspiration, but the subject remains as inextricable as if it had been commissioned by an 'initiate' patron. The 'mystery' of Giorgione, transformed into a follower of an

alchemistic sect, is a camouflage for the old question of the artist's complete creative freedom and the old irritation with the tiresome presence of a non-artist who can interfere with the creative process: The *Three Philosophers* represent, as we saw in the previous chapter, the three phases of hermetic initiation. The *Tempest* is the condition of the initiate, symbolized by the child in his mother's arms (= school of knowledge) who faces the "trials" (lightning and tempest) near a Temple (broken pillars), under the eyes of his guardian (man on the left).

It is bizarre that by way of evidence and explanation Hartlaub simply reverts to anachronism: the mother as school of knowledge reminds him of the way a university is referred to as an 'alma mater' (but since when? and where? Hartlaub is not worried by this at all). The columns of the temple are likened to a masonic lodge; the trials of the initiate to those of Tamino in *The Magic Flute*. After Conti's 'rather Wagnerian' Giorgione we now have a rather Mozartian Giorgione. And if the whole thing has to be so mysterious, why not choose a rather more fashionable mystery? Hartlaub goes on to add that if the science of initiation to secret societies 'was a recurring theme for Giorgione, which affected his thoughts and feelings, it must constitute what Freud would have called a "complex" in his spiritual life'.[10] The worlds of alchemy and psychoanalysis, it would seem, are only a step away.

Hartlaub's explanation veered too sharply from the initiates of secret societies to Giorgione, with no documentary evidence to support it. Although he began by averring the artist's absolute freedom, he then placed it in a position similar to that bound by a patron by bringing in his sects of alchemists and astrologers. Hartlaub was evidently not convinced by his own reading of *The Tempest* for, as we shall see, he later came up with two more. These differ from each other, but both come within the boundaries of a 'conventional' subject and the usual relationship of patronage.

At about this time another interpretation of the painting was put forward by Arnaldo Ferriguto, an assiduous scholar of Giorgionesque works[11] who disputed Hartlaub's theories. Ferriguto's arguments were based on Paduan Aristotelianism in Giorgione's time. The man ('active, operative factor') and the woman ('inert, passive factor') are the two poles of the human family; the child, with his 'overwhelming greed', is almost animal-like, but he is already worthy to 'rise from the animal to the virile phase, to think and smile and become a man'. The village, ruins and pillars are the transience of human works, while the four elements are displayed all around: air,

water (the river), earth, fire (lightning). The scene is therefore 'Man's happy faith in the fundamental goodness of the elements, inasmuch as the elements comprise the first substance of the body'.

Among the more recent interpretations is that of Günther Tschme-litsch, the essence of which is contained in its title, *Harmonia est discordia concors*.[12] The contrasts between fully-clothed 'soldier' and naked woman, between town and country, storm and serenity, represent discord bringing forth harmony, through the balance of opposites. The characters, however, are still unidentified. There is just one passing thought that the relationship between the man and woman may be an echo of the union of Venus and Mars, which produced Harmony. Tschmelitsch, like Ferriguto, supports his interpretation with a great number of learned quotations from contemporary texts: the result is that his reading is plausible at best as the possible musings of Giorgione's contemporaries on the painting, but not as an explanation of the primary subject. Like Hartlaub, he has 'released' Giorgione from the constrictions of the usual relationship of patronage, and in doing so has cast *The Tempest* into a grey area at the outer limits of 'not-subject'. Here interpretation is not constructed through the analysis of its single details, but simply by the impression given by the whole. It is neither story nor allegory but a doctrine, and its characters and landscape can therefore remain ambiguous.

Maurizio Calvesi rightly pointed out that 'neither Ferriguto nor Hartlaub [nor Tschmelitsch, we could add] built their hypotheses on the firm ground of "subject". That is to say, they did not identify a context that would support the possible meanings of the painting'.[13] This is the gap that Calvesi wished to fill with a new interpretation of *The Tempest* in which the *Discovery of Moses* as *subject* overlays a complex line of hermetic argument.

There are, then, two levels of interpretation: the narration of the Hebrew legend in which the infant Moses is discovered by Bithia, daughter of Pharaoh; she nurses him in the presence of a guardian (the 'soldier'). Another version of the story, however, has Moses as Bithia's *son* (and not, in that case, 'discovered'?) and therefore the Egyptian grandson of Pharaoh, initiate of the mysteries of Osiris. Initiation is represented here by suckling, as Hartlaub had thought; Moses, in Bithia's lap, is also Thotmosis, the hermetic sorcerer and biblical prophet; the 'guardian' of the ceremony standing before her must certainly be Hermes Trismegistus (but also the archangel Gabriel). The tempest, with the lightning darting through the clouds, is the work of Moses the magus and prophet: it brings the drought

to an end, and alludes to the theory of the elements (and especially the power of magic over fire) and signifies both the end of idolatry and the beginning of Grace. For the discovery of Moses prefigures the birth of Jesus, while the four points of the compass turn around the ruins in the middle distance, bringing in the auspicious star of the new religion that will supplant the old.

The painting, then, shows a gradual shift from a Hebrew legend to a Christian theme, through the story of Moses the Egyptian and devotee of Osiris. The ancient wisdom of Egypt and the Bible is invoked around the cradle of the new faith. But the transition from 'concepts' to 'the firm ground of a subject', which Calvesi undertook to make in order to overtake Hartlaub and Ferriguto, has not been fully achieved. The legend of the finding of Moses includes neither the guardian (Hermes/Gabriel) nor the tempest. Explaining their presence inevitably necessitates a swerve of direction from 'subject' to 'concept'. Mercury Trismegistus and a thunderbolt cannot drop inadvertently into the legend of Moses.

Eight years later Calvesi went back along the same road in the opposite direction, from 'subject' to 'concept'. His first *Tempest* as the finding of Moses is replaced by a second *Tempest*, as 'marriage of earth and sky'.[14] The woman is Earth, the child 'that which is born and fed by Earth'; the man is 'a personification of Sky and in particular Mercury'. His staff is a symbol of the male organ, and an attribute of wisdom. The city in the background is inspired by the mosaics of Palestrina.[15] It represents Egypt, fatherland of hermetic teaching and in particular a city founded by Hermes Trismegistos. The ruins are 'the ancient mercurial wisdom that is assimilated by that same nature whose secrets it reveals'. The pillars and the thunderbolt are respectively the 'ascent and descent of liquid, airy humours' and 'fire'. In short, 'the fabulous marriage of earth and sky', taken from the *Dialoghi d'amore* by Leone Ebreo (though the union of Uranus and Gea is found in ancient mythology before Hesiod's *Theogony*, and is therefore a widely known story).

In his quest for precise evidence of the 'hermeticism' of Giorgione revealed in his painting Calvesi turns to Leone Ebreo. The latter was in Venice for a short time at the beginning of the sixteenth century and the dominant ideas and themes of his *Dialoghi d'amore* (published in 1535) are rooted in Platonism. But, adds Calvesi, Giorgione might also have been a converted, practising Catholic of Jewish origin. This would explain why he had so few public commissions; besides, 'Giorgione's musical activity might be an indication of his Judaism'.[16]

All Giorgione's works are thus interpreted in the light of his imaginary Judaism and his direct dependence (also imaginary) on the writings of Leone Ebreo. Although the exegesis is specifically conducted with methods and formulae used by iconologists, it nevertheless reveals that its author has inherited his vision from the critics of style: the painter is unharnessed from his patron, true and consistent with his own self, sole author not only of the colours and composition of the painting but also of its themes and concepts. For example, the supposition that *The Three Philosophers* and the frieze of the 'liberal arts' in Pellizzari's house in Castelfranco were painted at roughly the same time is based on the affinity of their themes:[17] it is as if the subjects of Giorgione's paintings – whether for a gentleman of Castelfranco or for a Contarini in Venice – were simply determined by the direction of his own thoughts, without heeding any suggestions or instructions on the matter. Calvesi's theory, though, is not even in the 'freedom of the artist' mould, for all the 'philosophical' content is attributed to Leone Ebreo, if not actually to a patron. It distorts the old, but very modern, pattern of patron → author of programme → artist (for example Medici→Poliziano→ Botticelli). The patron pays up with no questions on detail, the author makes suggestions that are entirely his own, the artist reads philosophical texts and transfers then on to canvas according to his own inclinations. The three corners of the triangle have moved away from each other into complete isolation; and the tired formula of Giorgione's 'mystery' is replaced by Giorgione's 'hermeticism' that brings in his personal history. The painter of Castelfranco is now Jewish, and the development of his style reflects the troubles of the Jewish community in Venice.[18] We have travelled from a Giorgione whose very existence was questioned by D'Annunzio to a Giorgione about whom we know rather too much, with an unlikely biography embroidered by indulgent iconology.

'Family' and music

The earliest reference to what is now called *The Tempest* is in the *Notizia d'opere di disegno* by Marcantonio Michiel. On a page dated 1530 is a note, made in the house of the Vendramin family in Venice, of 'a canvas of a little landscape with a storm, with a gypsy and a soldier, by Giorgio of Castelfranco'.[19] As Ferriguto has rightly shown, the aim of these brief details (like all Michiel's quick

'sketches') was to reproduce the overall appearance of the characters: 'soldier' because the man leans motionless on his staff, as though sentinel to the whole scene; 'gypsy' because the woman is partially clad and 'rumpled'.[20] In the inventory of the Vendramin collection made in 1569, the 'gypsy' is unchanged, the 'soldier' is now a shepherd, and the tempest is not mentioned at all.[21]

The first reference to the painting after this date was made by Burckhardt, in his *Cicerone* of 1855.[22] *The Tempest* was at that time in Palazzo Manfrin, and had inherited the title of *Giorgione's Family* from a painting by another (and at that time more famous) Giorgione: a canvas with three portraits that had hung in the same gallery until a few years earlier. It appeared under this entry in the catalogues of the Manfrin collection of 1856 and 1872, and similarly in the earliest study of the painting, an article by H. Reinhardt written in 1866 (which included the first lithograph of the painting).[23]

J. A. Crowe and G. B. Cavalcaselle, in their famous *History of Painting in North Italy* (1871), had already questioned this interpretation: 'the landscape . . . seems at one moment a pretext for the figures' but 'there may be a deeper meaning in the scene'.[24] Even so, when in 1878 the *comune* of Castelfranco Veneto commissioned a marble statue of Giorgione, to be erected on a small island in the river that flows around the walls, some people were able to argue that the sculptor Augusto Benvenuti was inspired by the 'soldier' of *The Tempest*, who was thus identified with Giorgione.[25] As Calvesi has shown, the title which the painting acquired almost by accident gave rise to a precise identification: Giorgione, his wife and child, threatened by distant thunder. Conti follows the same line in his reading of the painting as the inheritance of pain (= the tempest) in the human family (see above, p. 50). This view continued to be held by many more interpreters towards the end of the nineteenth century and the beginning of the twentieth,[26] until Wickhoff opened up a new channel of discussion in 1895.

Walter Pater made no reference to *The Tempest* in his famous essay on 'The School of Giorgione' (1877).[27] But he did propose, with graceful eloquence, a key for reading all the painter's work which was to exert a strong influence on subsequent interpretations of the picture. It was at this time that the great task began (led by Crowe and Cavalcaselle) of verifying Giorgione's hand in the numerous pictures that shrewd or ingenuous scholars had attributed to him. Giorgione's catalogue was rapidly reduced, to such an extent that Pater considered the *Concerto* in the Palazzo Pitti to be his only certain work, and preferred to use the term *school* to define his art.

This drastic reduction of verifiable works gave rise to Pater's inspired pages on the painter's musical gifts: the painting's form and content are blended together with the connoisseur's own impressions, and with his exquisite prose; aesthetic emotions excited by the painting are given brilliant, articulate expression, in words that seem to echo the notes of the *Concerto*. According to Pater, Giorgione's followers also had a predilection for the theme of 'music, or the musical intervals of our existence'; and as 'inventor of "genre"' Giorgione, 'in the subordination of mere subject to pictorial design . . . is typical of that aspiration of all the arts towards music . . . to the perfect identification of matter with form'. An aesthetic emotion aroused by the *Concerto* provides the key to understand all of Giorgione's works. And it is in the same essay that we find the famous aphorism 'all arts constantly aspire to the condition of music'. In this, his 'only' painting, Giorgione was supremely inspired by 'a spark of the divine' fire. With this quote from Vasari[28] Pater unwittingly gave the cue to Conti and D'Annunzio that turned Giorgione into 'the Epiphany of Fire'. (A few years later Guillaume Apollinaire declared that 'la flamme est le symbole de la peinture'.[29])

The 'musical' reading of Giorgione's work seems to derive its authority from Vasari's testimony that he 'was exceedingly fond of the lute, playing and singing so divinely that he was frequently invited to musical gatherings and meetings of noble persons'. He was, then, an artist on two counts, imbuing his painting with his experience as lutanist and singer at aristocratic 'gatherings'. Pater's somewhat doubtful reading of Vasari opened up a rich vein of criticism that was worked continuously in various versions, until Bonicatti produced his carefully vague formula:

> The artist practised his two arts indifferently . . . the importance of the historical subject and the descriptive function of the painting was diminished [supposedly demonstrated by Vasari's comments on Giorgione's pictures in the Fondaco dei Tedeschi; see above, p. 12] to make the art of painting closer to the art of music . . . Once the associations which bind an image to a traditional iconography have been broken, the artistic experience moves towards an allegorical content, analogous to music.[30]

Pater's writings invited a purely stylistic, formal reading of Giorgione's works. When, in a deservedly well received book, Lionello Venturi set out to distinguish the artist's works from those of his followers,[31] he too refused to treat the subject of *The Tempest* as a serious question. If a subject existed at all, it was the one stated by Michiel.

'Why was it painted? In Mallarmé's opinion a verse was a pretext to break his silence. If we substitute the idea of "pretext" with that of "necessity" (for "pretext" sounds too cynical for this Venetian visionary) Giorgione's painting will be identified.' Thus 'it is not a case of figures in a landscape, but of a landscape with figures' and 'the subject is nature; man, woman and child are merely elements of nature, though not the principal elements'. Many years later, however, on the subject of Giorgione's *Three Philosophers*, Venturi talks of 'a pretext for his imagination'.[32] As for *The Tempest*, Giorgione had 'no subject in mind', the painting was the fruit of a 'personal fantasy that owes nothing to figurative or literary tradition'.

It would be impossible to list all the critics who have supported this argument. Kenneth Clark may stand for all of them:

> No one knows what [*The Tempest*] represents; . . . I think there is little doubt that it is a free fantasy . . . Part of its incantatory power lies in its defiance of logic, in the strange detachment of the figures, who seem unaware of each other's existence, or of the approaching storm and in the inexplicable character of the ruins in the middle distance, which can never have formed part of a real building.[33]

Sometimes the interpreter's support for the not-subject argument is not declared, calling Pater to mind, with his interpretation based on Giorgione's 'musicality'. Ugo Ojetti does this, for example, in an article published in *Corriere della Sera* just before the outbreak of the Second World War:[34] 'Could it not be that, as with lovely music, everyone will find a different story, depending on their mood at the time?' But on another occasion the same writer in the same newspaper praised the pragmatism of the winner of the Cremona Prize for painting (founded and presided over by Farinacci), and enthusiastically recalled a speech by Cipriano Efisio Oppo, the Fascist delegate and artist of the regime. The latter had declared before Mussolini that 'the subject has been greatly valued in all ages, but only has real worth when it is based on true art'. The example of 'true art' was, of course, the winner of the Prize (Luciano Ricchetti). The themes of the competition that year were: (a) listening to the Duce's speech on the radio; (b) states of mind aroused by Fascism.[35] The subject is acceptable if it eulogizes the regime; but with a painting of the distant past we must enjoy its beauty, let our imaginations go and not ask foolish questions.

The search for a subject

Our survey so far has shown that interpretations fall into two categories: one is the 'familiar', almost anecdotal version, perhaps including a reference to the artist's supposed illegitimacy[36] (as in *The Family of Giorgione*); the other is the rejection of any recognizable subject (as, for example, in Conti's theory). In 1895 Franz Wickhoff came up with a third possibility: exegesis based on a text, on the narration of a specific story. While he was preparing his best known work (the introduction to the *Vienna Genesis* that marked a turning point for studies of Roman art) Wickhoff twice sought out classical sources for Giorgione, in the spirit of the 'Renaissance of Antiquity'.[37]

The Tempest, he suggests, is the illustration of a passage in Statius' *Thebais* (IV.vv.730ff.), which tells how during the expedition against Thebes, Adrastus and his companions went to look for a spring for water for his parched troops. In a wood he meets Hypsipyle, daughter of the King of Lemnos, exiled from the island after she saved her father from the extermination of the male population wrought by the Lemnian women. She nurses Opheltes, son of Lycurgus (though not by her), to whom the unhappy queen is now enslaved. Hypsipyle leaves Opheltes on the grass while she takes Adrastus through the thick wood along the river Langia. Meanwhile, little Opheltes is bitten by a serpent and dies.

This interpretation, supported by some and rejected by others,[38] was joined by the similar theory of Rudolf Schrey, who saw *The Tempest* as 'a free illustration of Ovid's *Metamorphoses* . . . which shows Deucalion and Pyrrha after the flood . . . The waters recede, Deucalion stands apart in thought, but Pyrrha is serene, finding consolation in motherhood.'[39] Schrey put his theory forward in such a hesitant, fleeting fashion that Wickhoff's interpretation remained virtually unchallenged until 1930. At this point Hourticq called into question what he took to be the current theory, and refuted it with sound arguments. Unfortunately he had nothing better to put in its place than an amorous idyll (and even then with little conviction): the broken pillars symbolize the early death of the two lovers. The 'soldier' could be Matteo Costanzo (to whose death the altarpiece in Castelfranco was dedicated), and the 'gypsy' 'une belle et honnête dame', represented by a nymph (but the child? And the lightning?).[40]

In the course of the 1930s another exegesis emerged that partially toppled Wickhoff's interpretation: *The Tempest* as *The Discovery*

of Paris. Federico Hermanin was the first to allude to this possibility, in a passing reference in 1933, while a complete exposition is to be found in an unpublished book by Robert Eisler.[41] The hypothesis was taken up by G. M. Richter in his book on Giorgione,[42] and he seems to have arrived at his conclusions quite independently. It must certainly have been the most convincing, for both Morassi and Hartlaub supported it, the latter thus forsaking his own 'hermetic' interpretation.[43] This theory is obviously based on the influence of the lost *Discovery of Paris* by Giorgione, which is only known through the copy by David Teniers the Younger.[44] The man is the shepherd who finds Paris, the woman is his wife who takes care of him, or else the she-bear that suckled him in human guise (this is Hartlaub's explanation). The lightning and the ruins refer to the burning of Troy.

But Hartlaub was to change his mind again about *The Tempest.* His third exegesis of 1953 explains the painting as the miraculous birth of the philosopher Apollonius of Tyana, as recounted in the *Life* by Philostratus: 'Apollonius was born in a meadow where his mother had gone to pick flowers after a dream. She fell asleep on the grass but was woken by the song of swans and gave birth to Apollonius. At that moment, lightning flashed in the sky, a clear sign of the gods' pleasure.'[45]

Hartlaub's third hypothesis is entirely constructed on the supposition that the thunderbolt is related to the 'gypsy's' recent childbirth, but it takes no account of several elements which, in his previous attempts at reading the picture, he had considered essential – in particular the man and the broken columns. Moreover, though the *Life of Apollonius* was certainly common reading in the 1500s, there is no evidence (or at least Hartlaub does not produce any) that it was an important source for paintings. As far as I know, there is no other *Birth of Apollonius* in iconographical tradition either before or after Giorgione.

One theory that never really found an audience came from a senior civil servant, Luigi Parpagliolo, in 1932. His reflections on *The Tempest* were probably occasioned by the state's recent acquisition of the painting. Siegfried, the palatine count of Treves, entrusted his wife Geneviève to his servant Golo, as he was leaving for war. Golo tried to seduce her and when rejected took his revenge by accusing her of adultery on Siegfried's return. The accusation was aggravated by the birth of Geneviève's son, whom Siegfried refused to recognize as his own. Siegfried ordered Golo to have Geneviève and her child murdered but the two soldiers entrusted

with the task take pity on them and release them in a forest (this is the scene of *The Tempest*). The story ends with the recognition of Geneviève's innocence and the punishment of Golo.[46]

In 1939 P. De Minerbi published a book in which he tried to find an interpretation for both *The Tempest* and the most puzzling of Titian's paintings, *Sacred and Profane Love*.[47] Here he states that *The Tempest* is a narration of the mythical Phoenician origin of the Vendramin family. (This legend is alleged by De Minerbi, but with no supporting texts: its basis is the origin of the Vendramin of Aquileia, and thus of Illyria, and so back to the Phoenicians. Each passage of time carries its own batch of occasionally contradictory testimonies, but as a whole the case is not plausible.) The 'soldier' is the god Baal, the 'gypsy' Astarte with a child at her breast, symbol of her fertility and her descendants. The broken pillars and their pedestal are a votive altar to Baal. The bush in front of the 'gypsy' is sacred to Astarte. 'Both are symbols, Baal of the source and governing force of life, Astarte as common mother and goddess of the earth. Both are the progenitors of the Phoenician race' (p.101). The lightning, ruins and the animal on top of a tower (identified as a chimera) represent presages of death and destruction, in contrast to the heron perched on a roof top, which represents a 'presage of light'. None of these elements 'can be separated from the rest, for the painting is the expression of a part of the supreme will that rules time and space' (p.121). The motif above the gate of the town is the arms of the Carraresi family. The town is thus identified as Carrara, near Padua.

In 1941 Luigi Stefanini presented a new interpretation to the Paduan Academy which enjoyed a certain amount of success, particularly after it was republished as a single volume in 1955.[48] He undoubtedly came very close to the truth in noting the parallels between *The Tempest* and the *Hypnerotomachia Poliphili*, the famous Aldine edition of 1499 which became a 'bible' to all the scholarly and sophisticated Venetians of the time – why not to Giorgione and/or to his patron as well? The scene of *The Tempest* is the 'Garden of Destiny', emblematic of human life, with its contrasting rubble and vegetation, 'life growing among the ruins', that is a recurring theme of the *Poliphilo*. The broken columns allude to the surname of the author (Francesco Colonna) and to his 'unhappy existence, stricken by an unattainable dream of love'. The dome in the distance is the temple of Venus; the mother and child, *Venus genetrix*. The man is Poliphilo himself, pilgrim of love with the traveller's staff. The best title for the painting is therefore *The*

Garden of Destiny. The patron has commissioned the painting in order to 'realize a synthetic image of the emotions he had experienced in reading the book'.

The Giorgione exhibition of 1955 included many comparisons of different attributions made to him, as well as verifications, but no new interpretation. The only addition in that year was a new edition of Stefanini's work of 1941, and Klauner's passing comment, in her important article on *The Three Philosophers*, that *The Tempest* might be the birth of Dionysius.[49] (This interpretation was developed by Baldass and Heinz:[50] the 'gypsy' is Ino with the infant Dionysius, whom Hermes (the 'soldier') has entrusted to her. The lightning is Jove, presiding over the destiny of the divine child.)

Two years after the exhibition Eugenio Battisti put forward a hypothesis that was innovative yet rooted firmly in historical fact. Its basis was a reference to Giorgione's *Mercury and Isis* in the old catalogue of the Manfrin collection.[51] The subject of the painting is Jove's (lightning) love for a nymph. The latter must be Io, daughter of Inachus, sometimes identified with Isis. The woman is Io–Isis, with Epaphus, her son by Jove. The man is Mercury, sent to free her after she had been changed into a heifer and put under the guard of Argos of a thousand eyes.

The painting, then, unites two separate events: the birth of Epaphus, with a thunderbolt above to mark Jove's paternal presence, and the end of the story when Io is freed from her dreadful guardian. Against all this, Calvesi has proved that the *Mercury and Isis* of the Manfrin collection (drawn up in 1856) referred to an altogether different work by Giorgione, painted on wood and of a different size.[52] Battisti's exegesis has therefore remained exclusively his own.

A few years later Galienne Francastel restated the idea that the thunderbolt represented Jove, though she did not say which story the painting referred to. The woman and child are a 'vision' of the man, the spectator of the whole scene.[53] Two other interpretations, neither of which bears a date or a name, are also quoted here: 'St Roch with a follower, curing the plague'[54] and 'Boccaccio's Griselda':[55]

> The Marquis of Saluzzo, obliged by the entreaties of his subjects to take a wife . . . marries the daughter of a peasant. She bears him two children, and he gives her the impression that he has put them to death. Later on, pretending that she has incurred his displeasure and that he has remarried, he arranged for his own daughter to return home and passes her off as his bride, having meanwhile turned his wife out of doors in no more than the shift she is wearing. But finding that she endures it all with patience, he cherishes her all the more

deeply, brings her back to his house, shows her their children who have now grown up and honours her as the Marchioness, causing others to honour her likewise.

It is difficult to identify a scene in Boccaccio's story that could correspond with *The Tempest*. The semi-clad woman could be Griselda in 'no more than her shift', but she should not have a child with her, for her children had been secretly sent to Bologna some years earlier, so that she should believe them dead. This exegesis is therefore rather too approximate.

Equally makeshift is the theory of A. Stange, who read *The Tempest* as a worldly representation of the 'Rest on the flight into Egypt'.[56] For P. Meller, on the other hand, the painting has echoes of Petrarch's Sonnet 91: Escape into private life makes the storms of public life less hurtful. Only the world of poetry and love can give peace and comfort.[57]

Rather more recently, G. Künstler held *The Tempest* to be a 'theological' painting, contrasting sin and salvation, and indirectly depicting the Immaculate Conception. The 'gypsy' is Eve the Sinner (though the only parallel quoted, by Veronese, has a very different iconography), and the lightning the Virgin as Redeemer. The man and the ruins do not figure, and the exegesis smacks of Counter-reformation ahead of its time.[58]

Edgar Wind does not mention *The Tempest* in his accomplished book, *Pagan Mysteries in the Renaissance*, and Giorgione's *Festa Campestre* in the Louvre[59] only receives a brief comment. His *Giorgione's 'Tempest' with Comments on Giorgione's Poetic Allegories*[60] is thus a kind of appendix to the larger work and reflects its themes and arguments. Only the first few pages are concerned with *The Tempest*, despite its position in the title, and Wind's interpretation of the painting is of a pastoral scene in which *Fortitude* and *Charity* are placed in a dramatic scene dominated by *Fortune* – 'the rising tempest put in act the soul' (Pope). The man, characterised by the broken columns, is *Fortitude*, and the woman feeding her child *Charity* and the tempest with lightning *Fortune*.

Wind's interpretation was enthusiastically received by a number of scholars. Since it has recently been strengthened with new iconographic parallels[61] it is in danger of setting a kind of 'iconological orthodoxy', as though the themes of *The Tempest* can regroup with no difficulty, after their dispersal into several different allegories, and be given their true place in a determinate iconographical series. But a male *Fortitude*, beside two broken pillars that do not show how they were broken, is not credible; and the same could

be said for the thunderbolt–*Fortune*.[62] Besides, once the people, the pillars and the lightning are removed from the painting, the rest of its features remain obscure, unless they are relegated to the spacious and comfortable regions of 'genre'. In that case *The Tempest* would be a collage of allegories in a haphazardly composed landscape.

The American art critic Roy McMullen formed the understandable impression, after reading Wind's book, that Marcantonio Michiel was only 'the earliest known practitioner of what might be called *Tempestry*, a form of divination that has been fascinating art experts ever since that time'. Hence the title of his article, 'The Tempesta Puzzle':[63] a riddle that will only be solved by recognizing four levels of meaning in the painting: allegorical (in Wind's definition), narrative ('probably something to do with Zeus and Hermes'), philosophical–lyrical (following Venturi's definition) and lastly musical (Pater). 'The fact that this solution is not really a solution need not bother us overmuch, for after all, a painting is not a puzzle. It's an experience.'

The most interesting aspect of this theory is not so much the kind of *'embrassons-nous'* between the different interpretative arguments, as the hierarchical way in which the four levels are set out. The first two ('allegorical' and 'narrative', or rather, the narration of an allegory through a pagan myth) are attributed to the patron, and 'they stimulate the imagination' of the painter and encourage him 'to improvise' (the *pentimento* revealed by the X-ray is considered proof of this). On a higher level, *The Tempest* is 'a painting that is first and foremost a painting' – that is, it has a meaning but needs no more 'informational content' than a *frottola* in musical notation. The subtle yet vague distinction between 'meaning' and 'information' is an advantage for the painter's brush as he improvises his work, 'thinking and feeling in musical terms'. We must, of course, take it for granted that a puzzle is not an experience, and that music is improvised and contains no information.

O. Logan pronounced,[64] with some independence of mind, that *The Tempest* 'was most probably inspired by Pliny's description of Apelles' painting of lightning'. With this theory he places the painting alongside the 'archeological' reconstructions of paintings of antiquity, such as Botticelli's *Calumnia*, which also brings one of Apelles's works back to life. But the latter was a painstaking reconstruction of every detail in Lucian's description. And it is hard to believe that Apelles's thunderbolt gave rise to Giorgione's entire painting. Nor is it possible to base such a hypothesis, as Logan does, on an identification of *The Tempest* with a painting that was mentioned

only by Ridolfi, including a wet-nurse and a crying infant: for the figures in that case were 'half life-size'.

Nancy De Grummond is very much more methodical in her treatment of the details of the painting. A few years ago she brought out by far the richest and most soundly-constructed interpretation.[65] According to this, the subject of the picture is the legend of St Theodore, a warrior and martyr who was protector of Venice before the arrival of St Mark's relics. He afterwards retained some importance in the devotion and private prayers of the Venetians. The legend told of a dragon which lived outside the city of Euchaita in Asia Minor, and which once a year would demand a human victim. (In another version, the dragon guarded a spring and would attack men and animals.) Christ appeared to St Theodore in a dream, and told him to go and fight the dragon. He reached it just as it received its victim, the son of a poor Christian widow (in another version the widow is St Theodore's mother and is herself the dragon's victim, chosen and captured for her beauty). At the dragon's cave St Theodore charges it to surrender in the name of Christ. (In the second version, St Theodore finds his mother alone, though the cave is guarded by serpents; the dragon then appears and the fight begins.) St Theodore slays the dragon with his lance; alternatively, the dragon's carcass blocks the entrance to the cave, and St Theodore and his mother are trapped for seven days, after which time the archangel Gabriel appears in a cloud of light and sets them free, also changing the spring into a river. After this, St Theodore is imprisoned for his faith; he is given a last chance to save himself by sacrificing to the gods, and he uses the opportunity to set fire to the temple to the Mother of the gods. He was then martyred and his body preserved in a church in Euchaita, which changed its name to Theodoropolis. His relics came to Venice in 1267 and were preserved in the church of the Saviour. In the Byzantine world, he was invoked for his power over storms.

For De Grummond, then, the man in *The Tempest* is St Theodore, the woman with a child is the Christian widow of the legend. The dragon is not shown but the indeterminate creature on a distant tower is a reference to it (some have called it a chimera, others the Lion of St Mark). The snake, half-hidden in a crevice near the lower edge of the painting, is one of the vipers that guarded the dragon's lair (though these only appear in the version of the legend where the woman is St Theodore's mother and would thus be *without* a child). The ruin and broken pillars are the remains of the temple that was burned down by St Theodore; the town is

Euchaita–Theodoropolis, and the dome in the distance belongs to the church of St Theodore in Euchaita, though it is inspired by the new church of San Salvatore in Venice which had just been rebuilt (1506). The storm clouds and the lightning, though absent from the legend (unless they could be considered the 'cloud of light' around the archangel) are an allusion to the saint's power over storms.

The value of this exegesis is that it 'leaves nothing out' of the interpretation and it suggests close links with the Venice of Giorgione's time (St Theodore was the city's propatron saint; the church of San Salvatore, rebuilt in that period, houses his relics). Even so, De Grummond herself has pointed out that Giorgione's painting cannot be an *illustration* of the St Theodore legend, for the absence of the dragon and the usual warlike attributes of the saint cancel out the narrative character of the scene. De Grummond therefore turns to the category of 'attributes of St Theodore' to explain the *montage*. After his victory the saint leans silently on his lance (which is not actually painted as such); near him are the woman and child he has rescued from the hideous monster and the snake that guarded its terrible cave. In the distance a dragon(?) on a tower makes an allusive decoration. Besides these different events of the story, further 'attributes' are discovered which allude to the saint's later life: the burning of the pagan temple, the church where his body was preserved, Venice, the seat of his precious relics. Lightning flashes above him, with a sole function of 'attribute' that recalls the usual invocation of St Theodore by the Byzantine world. Thus the enchanted landscape is peopled with the saint's 'attributes': they radiate from his statuesque figure, scattered around him like votive offerings on an altar.

This highly intelligent interpretation contains a serious problem, namely the precarious balance between the *narration* of the legend (which gives De Grummond the title of the article) and the non-narrative display of the saint's *attributes*. It is difficult, perhaps impossible, to find examples of similar construction, which hovers between a collection of attributes and a story depicting scenes of different events. On top of this, the truly canon attributes are missing, i.e. the dragon and the characterization of St Theodore as a warrior. By way of parallel and proof, De Grummond cites the same paintings that three years earlier Wind had argued as representing *Fortitude* and *Charity* (22, 23). These are clearly of such 'Giorgionesque' character that it is even possible to confirm their direct descendance from the *Tempest* composition. But Wind and De Grummond cannot be right to use them as proof of their

22 *Allegory*

theories. The interpretations of each painting are still far from being
established – this is why the two scholars could use them to argue
opposing theses. Besides, the differences in the essential composition
of the two paintings (not least in the absence of lightning) is such
that both must be cases of fundamental variation, as opposed to
repetition, of the *Tempest* model. Moreover, in the Philadelphia
painting (23), the woman and child can be neither *Charity* nor the
widow rescued by St Theodore: the laurel that climbs along the
leafy tree behind her makes her more akin to Giorgione's *Laura* in
Vienna,[66] and bears the same connotations of conjugal faith (24).
The reason for the absence of the dragon, then, is precisely that the
subject is not the legend of St Theodore. For why, if the dragon was

23 Palma il Vecchio (attr.), *Allegory*

really so unnecessary to recount the legend in *The Tempest*, should it then be discovered as a vague shadow on a distant tower? Why make the subject totally obscure with this omission? Or is it really true, as De Grummond argues, that on its own *The Tempest* is illegible, and can only exist as part of a *predella*, under a panel that included the victorious St Theodore, complete with suit of armour and slain dragon?[67]

The final attempt is to be found in the pages of a daily newspaper.[68] Here Alessandro Parronchi tried out 'A new hypothesis on the subject of Giorgione's masterpiece: the "Tempest" or "Danae in Seriphos".' This is a well-known myth: Jove visited Danae in a shower of gold, after she was imprisoned by her father. Danae gave birth to Perseus and her father nailed them both into a chest and threw them into the sea. It came ashore at Seriphos where Danae and her son are rescued by a shepherd. According to Parronchi, this is the picture described by Pomponio Gaurico (without indicating the artist) of a Danae 'in whom you could see an eager girl staring about her in astonishment. Looking at the sky, you might say that Jove was about to descend from the clouds with the rain. Looking down, you marvel to see the ground sprinkled with pieces of gold. The 'soldier' in Giorgione's painting is therefore the shepherd of Seriphos who rescued Danae. But the painting of Gaurico's description was not 'Danae on Seriphos' but 'Jove visiting Danae in a shower of gold', a subject which does not include the shepherd

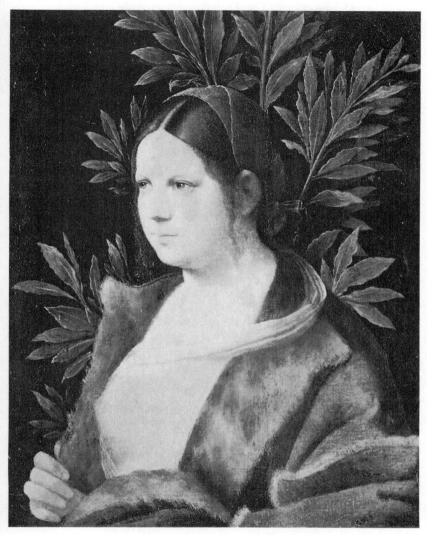

24 Giorgione, *Laura*

or the infant Perseus. And though 'Danae on Seriphos' could include both of them, it would exclude the shower of gold, and, by extension, therefore Gaurico's description.

After such a diverse list of interpretations, nobody will be surprised that *The Tempest* reached the rosy heights of the 'psychology' test in women's magazines. The painting in *Grazia* (14 November 1976)

giocate con Grazia

di Pino Gilioli

Che cosa vedete nella "Tempesta"?...

Nella foto qui accanto vedete riprodotto un famoso capolavoro della pittura; si tratta de «La tempesta», l'opera più conosciuta del Giorgione, uno dei maggiori pittori della scuola veneziana. Questo quadro rappresenta anche un enigma affascinante della storia dell'arte: non si sa, infatti, che cosa volesse rappresentare esattamente il Giorgione nel suo dipinto. Da sempre, gli esperti di storia dell'arte hanno fatto mille congetture sul soggetto misterioso, senza arrivare a nessun risultato concreto. Su questo capolavoro dell'arte noi abbiamo costruito un gioco. Vi invitiamo cioè a scegliere una delle quattro interpretazioni del celebre quadro che pubblichiamo in fondo alla pagina. Che cosa vedete, dunque, ne «La tempesta»? Rispondendo a questa domanda conoscerete i lati più nascosti del vostro carattere. Infatti dopo aver fatto la vostra scelta troverete spiegato nel testo capovolto in fondo alla pagina ciò che essa rivela di voi.

Spiegazioni

(testo stampato capovolto)

1 - Chi ha scelto la prima interpretazione…
2 - La scelta della seconda interpretazione…
3 - …
4 - …

Quattro interpretazioni: sceglietene una

1 - Una povera donna sorpresa all'aperto da un furioso temporale che è appena finito, allatta il suo bambino affamato, cercando invano di nascondersi fra i cespugli sulla riva di un ruscello. Un soldato di ventura che si trova a passare di lì per caso scopre la donna e la fissa con attenzione, meditando di aggredirla e di usarle violenza.

2 - Una zingara sfacciata con un bimbo fra le braccia, cerca di provocare con le sue nudità un timido soldatino che fa la guardia ad un villaggio. Il suo scopo è distrarlo in modo da consentire il passaggio ai suoi compagni che vogliono raggiungere l'abitato per tentare qualche furto. Sta avvicinandosi un grosso temporale.

3 - Una regina durante una passeggiata nella campagna, siede sotto un albero per allattare il futuro erede al trono, mentre il suo regale consorte vigila e guarda con tenerezza la moglie e il figlio che sono minacciati dalla tempesta imminente che si addensa all'orizzonte.

4 - Tutti gli elementi che compongono il quadro (la donna nuda, il neonato, il giovane, il ruscello, le rovine, le mura, gli alberi, e il cielo tempestoso) contribuiscono a rappresentare la natura e la vita con i simboli dell'amore, della gioventù, del tempo che scorre, delle glorie umane che vanno in rovina, mentre i problemi di ogni giorno (rappresentati dalle nubi minacciose) incombono sul futuro.

What do you see in the Tempest? . . .

This is a photo of a famous masterpiece: it is *The Tempest*, the best-known work of one of the greatest painters of the Venetian school, Giorgione. The painting is also a fascinating riddle in art history, for nobody knows exactly what Giorgione meant to say in his painting. Art historians have come up with hundreds of theories on its mysterious subject, without reaching any firm conclusions. We have put together a quiz based on this masterpiece: you are asked to choose one of the painting's four interpretations, which are printed below. What do you see in *The Tempest*? Your answer will enable you to discover the hidden depths of your

personality: once you have chosen, turn to the text printed upside-down at the bottom of the page to find out what your choice can reveal about your character.

Choose one of the four interpretations:

(1) A poor woman, surprised by a violent storm that has just passed overhead, tries vainly to hide among the bushes on the banks of a stream as she nurses her hungry baby. A mercenary soldier, passing by chance, sees the woman and stares at her, planning to attack and physically abuse her.

(2) A barefaced gypsy with a baby in her arms tries to use her naked body to attract a shy young soldier who is guarding a village. She wants to distract him so that her thieving friends can reach the houses.

(3) Whilst walking in the countryside, a queen sits down under a tree to nurse the future heir to the throne. Her royal consort keeps watch over his wife and child, looking at them tenderly as they are threatened by a louring storm that gathers on the horizon.

(4) All the elements in the painting (the naked woman, the baby, the young man, the stream, the ruins, walls, trees and the stormy sky) come together to represent nature and life, as symbols of love, youth, time passing, of the glories of mankind that crumble away while the problems of the present (represented by the threatening clouds) hang over the future.

Explanations

(1) In choosing this first interpretation of a poor woman surprised by a storm you show a good deal of reluctance to face up to reality. Sometimes you instinctively fall into self-pity which is usually completely unjustified. Deep down you are hiding a repressed desire to hurt others which cannot find an outlet.

(2) The choice of the second interpretation, the barefaced gypsy, shows that in general you have a fear of any kind of novelty in life and that you despise your own sex (or have no faith in it?) In your heart of hearts you feel an impossible desire to break free of a life that bores you.

(3) Those choosing the interpretation of the princess and heir to the throne reveal a strong instinct to conform. At the same time, they would like to emerge from their anonymous lives though without having to face up to their current circumstances. They also feel an overbearing need to assert themselves.

(4) Those favouring the fourth interpretation clearly reveal a preference for solutions that will satisfy their imaginations and their liking for physical beauty. Underneath, however, they are hiding a good deal of arrogance which makes them feel different, and intolerant of their surroundings.

was reproduced back to front (25) but the article speaks for itself. Its basis is not so much the problem of finding the *correct* interpretation as the futility of looking at all, and the certainty that a sound explanation does not and cannot exist. So interpreting *The Tempest* can be an amusing game.

An X-ray and a *pentimento*

The X-ray of *The Three Philosophers* was made in 1932. In the same year the Italian state acquired *The Tempest*, and the painting was moved from Prince Giovanelli's collection to the Accademia. In 1939 Maurizio Pelliccioli had this painting X-rayed as well, an event that revealed, among other minor details, one important variant: a female 'bather' in place of the 'soldier' (26).[69] This provided excellent ammunition to the defenders of the not-subject argument, as it seemed to show that Giorgione swapped a nude for a thoughtful young man with a long staff. It is difficult to imagine a story that could admit such an alteration without changing its original meaning. Perhaps it was true that *The Tempest* had no theme; perhaps it was a straightforward landscape that could allow any sort of human figure (with storm clouds, near some broken pillars, and a background of a distant city beyond a bridge). This, at least, was the reconstruction of the first version that Morassi immediately attempted, in which the soldier is replaced by the second, naked, childless 'gypsy' (27).

In his presentation of the X-ray results Morassi maintained that they 'ruled out the concepts of several interpretations'. Having said that, he still thought Eisler's interpretation could stand (Paris nursed by the shepherd's wife), for the figure of the shepherd was secondary to the main subject and could easily be replaced by the wet-nurse's companion. In a final *Nota*, Morassi quotes two more theories held by Ugo Ojetti and Fritz Saxl, which fairly represent the two lines of thought that later critics have followed in their studies of the *Tempest* X-ray.

For Ojetti, the X-ray confirms that Giorgione's painting has no subject. This theory has been put forward by many critics, among whom Venturi voices particular strength of conviction:

> The X-ray shows an earlier version in which Giorgione had painted a woman entering the water, in place of the soldier. If he had had any subject in mind, or had been commissioned to illustrate a subject, he would not have been able to substitute a man for a woman with such ease. The substitution was made for artistic reasons: the

26 Giorgione, *The Tempest* (X-ray of the 'bather')

composition is more balanced by a standing man rather than a woman
going down to the stream. Moreover the presence of the fully-clothed
figure gives an air of mystery to the scene that could not exist in the
painting of two women bathing. Giorgione's subject is therefore the
fruit of his own imagination, owing nothing to figurative or literary
tradition and everything to the gratification of the artist and his friend
Gabriele Vendramin.[70]

Fritz Saxl wrote a letter to Morassi describing his reactions to the
X-ray of the 'first' *Tempest*. Rather than presuming the picture to
be a genre painting, Saxl preferred to suppose that 'the subject
illustrates a story where the nurse and child were the sole protagonists

27 The 'first version' of *The Tempest*, according to Morassi

(the bather might be a nymph) and the man appeared at a later
stage. Giorgione had illustrated Act I in the first version and Act II
in the second, which was the more important of the two'. But, he
concludes, we would need to identify the story in order to prove all
this.[71]

 These interpretations accepted Morassi's reconstruction of the first
version as true. The latter had explicitly stated that the 'bather' is
in the same layer of colour as the 'gypsy' and the two figures had
therefore coexisted on the surface at an earlier stage. All this is
evident from the density of the colour, shown in the X-ray to be

uniform and continuous. *The Tempest*, we should conclude, has two 'gypsies' – as though it were possible to prove beyond all doubt that this was the picture Giorgione intended to paint from the start, though he then changed one detail. But even if it were possible to prove categorically that the 'bather' is in the same layer of colour as the 'gypsy', nobody can prove that at the time of painting the 'gypsy', Giorgione had not already changed his whole 'idea' for the work. Morassi's 'first' *Tempest* would be acceptable only if it were demonstrable – which it certainly is not – that Giorgione painted *first* the 'gypsy' and the landscape, *then* the 'bather', which he finally turned into a 'soldier'. But if the 'bather' was painted first, Giorgione could have already made up his mind to erase her when he painted the 'gypsy'. Morassi's theory is true only in the corner of the painting where the superimposition of two figures was documented by X-ray. It cannot stand as a true reconstruction of the whole work.

The correspondence between the picture's restorer Pelliccioli and Ferriguto is not well known, [72] but it indicates that the 'bather' was painted *before* and instead of the 'gypsy': 'in his sketch of the painting Giorgione drew a woman on the left which he afterwards painted on the right, while over the first woman he painted a male figure.' Another reconstruction of the earlier version of *The Tempest* is therefore a possibility. Battisti followed Saxl's argument with his

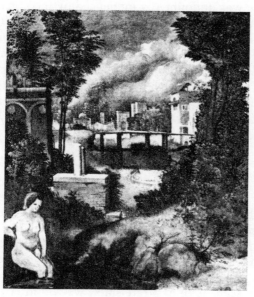

28 The 'first version' of *The Tempest*, according to Battisti

interpretation of an 'Act I' which is Zeus' love for the nymph Io/Isis: 'Jove comes down in a thunderbolt to lie with Io (= Isis)' (28), while the present Tempest shows, as we have already seen, Mercury, Isis and Epaphus.[73]

The Tempest X-ray has provoked endless speculation, but the most widespread reaction has been that though the results increase the difficulties of interpretation, they seem to favour the supporters of the not-subject argument. Fiocco observed, for example, that 'the subject, which is due to the artist's culture or even to taste, does not explain the art or the style of a painting – that is up to the critic to understand as best he can. His uncertainty does not detract from the painting; on the contrary it adds a kind of fascination that is dangerous to question, by scrutinizing Giorgione's intentions with the help of X-ray.'[74] Creighton Gilbert, as usual more specific than most, not only uses the X-ray as proof that the painting has no subject, but even manages to deduce a general principle from it: 'importance for subject is in inverse proportion to possible amount of pentimento'.[75]

This principle is obviously untrue. An Annunciation by Ambrogio Lorenzetti and assistants in the chapel of San Galgano at Montesiepi demonstrates an equally radical pentimento in the contrast between the attitude of the Madonna in sinopia and in fresco. But this change of iconography was undoubtedly influenced by theological concerns: the patron must have preferred a Mary welcoming the heavenly messenger with humility, to the Mary of the first version, who drew back from the archangel in fear.[76] Here, at least, the importance for subject is in direct proportion to the amount of pentimento. But it is impossible to make this statement into a general principle and to apply it unquestioningly to The Tempest. The radical change of iconography from 'bather' to 'soldier' that the X-ray revealed is another obstacle along the interpreter's path.

The rules of the jigsaw

The first rule for putting a jigsaw together is that all the pieces must join up with no gaps in between. The second is that the completed jigsaw must make sense – for example, even if a piece of sky fits perfectly in the middle of a field we must obviously look for a different place for it. And if, when the jigsaw is near completion, we see that the scene is of a 'pirate ship', we will infer that a further

group of pieces showing 'Snow White and the Seven Dwarfs' belongs to a different puzzle altogether.

The Tempest is certainly an extreme case in the history of exegetical disputes over the figurative art of the Renaissance. The painting's modest surface has become a kind of forum for the polemics on methodology that have little to do with the *Tempest* Giorgione painted. For behind the 'subject or not-subject' question the old dispute between the study of meanings and the study of style is still more or less apparent.

Even so, the scholars have found common ground on a number of points: for example, on the great importance of the landscape, and the observer's emotional identification *outside* the painting with the 'soldier' – the spectator/protagonist *inside* the pictorial space (and for this very reason identified by some as Giorgione himself). In the same way, the accumulative effect of the many and varied theories has been to pick out the important elements in the composition of the landscape: the 'soldier', the 'gypsy', the child, lightning, broken pillars, snake, city and lastly the 'bather' of the X-ray. Recognizing the pieces is the first step in fitting the jigsaw together.

The table on pp. 78–9 provides an over-view of the troubled history of *The Tempest*'s exposition. Each interpretation is set out once, under the name of the first person to propose it. The various columns show which 'elements' were identified and how – which pieces of the puzzle were fitted together. The last column shows the suggested subject. The interpretations containing a narrative subject are shown in roman letters, while those containing allegories, symbols or a meaning beyond the narration are shown in italics. The elements included in the table are those which were considered relevant by the interpreters more than once.

It is immediately obvious that some interpretations are noticeably 'thin', sometimes simply through defective formulation in that they ignore too many elements. Though many are developed with remarkable competence, almost all of them ignore one or another of the painting's essential features. For example, Battisti's exegesis is put forward with much subtlety and intelligence as 'an historic interpretation of *The Tempest*' (see above, p. 62) but he does not explain the broken pillars. Stefanini neglects the lightning. The prominence of the pillars and the lightning on the canvas, as well as in a wide consensus among scholars, weakens any interpretation that excludes them.

INTERPRETER	MAN	WOMAN	CHILD	LIGHTNING	PILLARS	SERPENT	CITY	'BATHER' OF X-RAY	SUBJECT
1530 Michiel	soldier	gypsy		tempest					
1569 Vendramin inventory	shepherd	gypsy							
1855 Burckhardt	Giorgione's family								Family of Giorgione
1894 Conti	A human family								
1895 Wickhoff	Adrastus	Hypsipyle	Opheltes			bites Opheltes			Adrastus and Hypsipyle (Statius)
1915 Schrey	Deucalion	Pyrrha	son						Deucalion and Pyrrha (Ovid)
1922 Ferriguto	a family = *humanity*			*fire*	*transience*				*The four elements*
1925 Hartlaub	*guard*	*alma mater*	*initiate*	*trials*	*lodge*				*Allegory of initiation*
1930 Hourticq	Matteo Costanzo	woman he loved			death of the lovers				Lament of the death of Matteo Costanzo and his lover
1932 Parpagliolo	soldier	Geneviève	son						The Story of Siegfried and Geneviève
1935 Eisler	shepherd	his wife	Paris	burning of Troy				nymph (Morassi)	Discovery of Paris
1939 De Minerbi	Baal	Astarte	son	death	death		Carrara	Mythical Phoenician	origin of the Vendramin
1941 Stefanini	Poliphilo	Venus genetrix							Evocation of Poliphilo
1952 Stange									Secular version of the Rest on the Flight to Egypt
1953 Hartlaub		Apollonius' mother	Apollonius	sign from heaven					Birth of Apollonius of Tyana

	Mercury	Ino	Bacchus	Jove				Birth of Bacchus
1955 Klauner	Mercury	Ino	Bacchus	Jove				Birth of Bacchus
1957 Battisti	Mercury	Io–Isis	Epaphus	Jove			Io–Isis	Jove's love for Io
1960 G. Francastel	?	?	?	Jove				One of Jove's loves
1962 Calvesi	Mercury Trismegistus = Archangel Gabriel	Bithia	Moses–Thotmosis	end of the drought	end of paganism			Finding of Moses
1964 Meller	*private life*			*public life*				Illustration of Petrarch, *Canzoniere* XCI
1966 Tschmelitsch								*Harmonia est discordia concors*
1966 Künstler		Eve		Mary				Sin and salvation
1969 Wind	*Strength*	*Charity*	*Charity*	*Fortune*	attribute of Fortitude			*Fortitude, Charity, Fortune*
1970 Calvesi	as 1962 (also Sky)	Earth	that which Earth bears					*Marriage of earth and sky*
1972 De Grummond	St Theodore	the widow	son	*attribute of St Theodore*	pagan temple	viper	Euchaita	Legend of St Theodore
1976 Parronchi	shepherd of Seriphos	Danae	Perseus	Jove				Danae in Seriphos
? (see p. ••)	St Roch							St Roch in healing the pestilent
? (see p. ••)	soldier	Griselda	son					The story of Griselda (from Boccaccio)

Leaving out some of the pieces means disobeying the first rule of the jigsaw. Using explanations that move freely on two different levels in the same pictorial space (narrative and non-narrative) means disobeying the second. This is what De Grummond has done in mixing the 'legend of St Theodore' with the 'attributes' of the saint which have, as it were, slipped away from the narrative level and are dotted about the landscape. The only interpreter to fit all the pieces together (except the 'bather' of the X-ray) was using two different jigsaws, similar though they may be. Interpreting *The Tempest* means providing a well documented explanation for each feature, and fitting all together into one persuasive framework of meaning.

4

Interpreting *The Tempest*

I

It is our duty to worship the image of the mother of God: but how can we recognize her, or distinguish her from other women who look like her? When we look at a picture of a beautiful woman with a baby on her lap, how can we be sure, if there is no inscription (or perhaps there was one but it is now lost), that the subject is not Sarah and Isaac, Rebecca and Jacob, Bathsheba and Solomon, Elizabeth and John, or simply *any* woman with her child? Or, if we turn to the pagan myths that are so often depicted, how can we be sure this woman is not Venus with Aeneas, Alcmene with Hercules or Andromache and Astyanax?

These remarks could be compared to the numerous discussions among semiologists on the 'ambiguity of the sign'. In fact they were made by a Carolingian bishop, Theodulf of Orleans, author of the *Capitulare de imaginibus*,[1] expressing ideas that belong partly to the writer and partly to the imperial court. But we should not interpret Theodulf's words too literally for he is not listing a series of pictorial images but simply giving names lifted from his biblical and pagan cultural heritage: for example, Alcmene is a solemn-sounding classical name and not a specific iconographical model – the traditional iconography of Alcmene is very different from that of the mother of Christ. To the educated Carolingian reader, an evocation of Alcmene would therefore simply have the effect of calling to mind the mother of Hercules, greatest of the classical heroes and returning to favour in Theodulf's time. It would also underline a parallel between the Christian and pagan worlds through two imagined scenes of motherhood. Even so, Theodulf's words could very well

be applied to describe the relationship of ambiguity or similarity between a *Virgo lactans* and another image that the Carolingian bishop could not have known, *Isis lactans*.

In fact, it is usually the case that we instantly recognize a picture of a woman and child as Mary and Jesus. This is not always because their names are written next to them, not because we are directly prompted by their haloes or by the presence of patrons or the faithful in prayer. It is firstly the context of the picture, on an altar or hanging over a bed, that puts us on the right track. But this is not the only factor. The picture might be hung on the crowded wall of a gallery, between a landscape and a portrait, and still we will not hesitate in reading it correctly, even though in principle it could be any 'mother and child' if there are no haloes. We recognize the Virgin and Child above all by means of the many different images of this scene we have already experienced, which are deeply embedded in our memory and form, as it were, a single type. It is visual experience itself, repeated over and over again but always receptive, that tells us the title of the picture. It is not idle to ask ourselves what the common elements of so many variations of expression might be: rather it reminds us of Parmenides' problematic question to Socrates. Observing that no two men are alike, he asked whether an abstract idea of 'man' (or fire, or water) could exist. The unearthly world of ideas, inhabited by archetypal man may not exist. But there is in our collective and individual memory a figurative code made up of iconographic models and types that are recognizable because they are experienced and recorded. By the same token they compose an articulate language.

But that memory can be lost: and when this happens an image that was created for a public that could understand it becomes incomprehensible to observers who are alien to that particular figurative culture. This can give rise to absurd and fantastic interpretations. It was in this way that a relief in the left wall of St Mark's Church in Venice was interpreted as 'Ceres in search of her daughter Proserpina, bearing two flaming torches' (29). An analogous image on the façade of the cathedral at Fidenza was thought to be 'Bertha at her spinning wheel', and a third on the floor of the cathedral at Taranto 'a clown'. These are among the many readings we can attempt: for jesters and clowns certainly populated medieval squares and Ceres certainly sought her daughter far and wide. But the interpretation of an image cannot be mastered by imagining or suggesting possible stories that have been figuratively translated into that or a hundred other iconographic schemata: it is rather the history of its traditions that must be recovered, for this

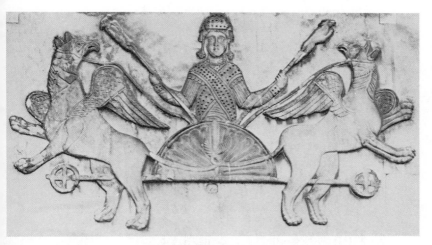

29 Ascension of Alexander, Byzantine relief

alone can have any value as proof of an interpretation. If these three images are placed side by side with all the others that depict the same theme, the question of their meaning no longer hinges on the single monuments but on the iconographic schema. This in turn can reveal a great deal when it recurs in an explicit context, e.g. the illustration of a text in a manuscript, or an added inscription (30). Only then does it become clear that all these images (and not only those where an inscription leaves no room for doubt) portray the same scene: the flight of Alexander the Great on a chariot drawn by two griffins, with bait on the tips of his two lances which serves to drive them on. In this way we can explain every detail, whereas griffins would be unlikely companions for Ceres, Bertha and a clown.[2] The reconstitution of the iconographical series allows us to recover a fragment of our lost memory.

II

In the last chapter we looked at the many ingenious interpretations that have been constructed around *The Tempest*: they are all *possible* interpretations, some more so than others, and there are others still that we could try. For a man, woman and child in a landscape are subjects that recur *ad infinitum* in stories, whether or not illuminated by the sudden glare of a streak of lightning. But nobody so far has placed Giorgione's picture in sequence with others in which the same iconographic schema recurs. The implication of this is that all

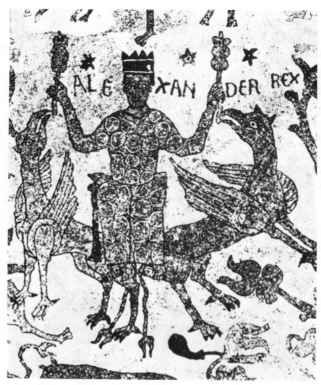

30 Pantaleone, the Ascension of Alexander, mosaic in the cathedral of
Ottranto

the interpretations we have seen have an unexpressed theory in
common, even those which refer to parallel images of the 'same'
story but of a different *schema*: that Giorgione was the first artist
to invent this scene – whether a free composition with no precise
theme, or the illustration of a story with imagery that is new and
utterly unique in iconographic tradition, or lastly perhaps a graceful
and sophisticated assembly of variously symbolic figures. In this
interpretative tradition we find not just admiration for the artist's
lyric intuition in ignoring all formal models, for nobody would
attempt to diminish the beauty of Leonardo's *Last Supper* by arguing
that the scene had been painted many times before; but the lack of
parallels has opened up a paradise of conjecture to iconologists,
while for the 'historians of style' it has made Giorgione the first
'modern' painter, freely inventing his pictures without the interference
of a patron or of a specified subject.

There is, however, an image in iconographic tradition before Giorgione which may be superimposed on *The Tempest*: a bas-relief by Giovanni Antonio Amadeo (1447–1522), in which the disposition of the figures and the overall schema are entirely similar to those of the Venetian canvas (31). On the right, in both scenes, sits a naked woman with a baby on her lap; on the left a man stands in an attitude not of any particular task but rather of one listening with rapt attention. The background, in both cases, is one of houses and trees. The man and woman, in both cases, are turned towards the centre, and the only difference is the object of their attention: in the relief the solemn figure of an old man whose flowing robes indicate his celestial provenance: in the painting, a streak of lightning that pierces the clouds, high above the broad landscape.

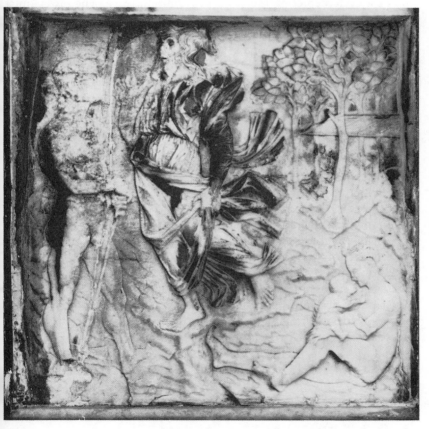

31 Giovanni Antonio Amadeo, God warning Adam and Eve, relief in the Cappella Colleoni in upper Bergamo

The general schematic similarity is so strong that it is worth exploring this avenue a little further. If we imagine for a moment that Giorgione's lightning is either the prelude to or the aftermath of Amadeo's celestial apparition, it becomes almost its iconographic 'equivalent' (i.e. there are two different 'signifiers' for the same 'meaning'). In this case the two scenes would correspond completely. This and other, minor differences between *The Tempest* and the bas-relief will be analysed and justified point by point – an exercise that is only worthwhile if we are sure Amadeo's figures cannot elude a watertight interpretation and that our efforts will not be another of many attempts to explain *obscurum per obscurius*.

The context of the relief provides an easy means of identifying the subject: the façade of the Colleoni chapel in upper Bergamo, one of a cycle depicting the story of Adam and Eve. The latter must therefore be the human protagonists of the scene. Its appearance in the Colleoni chapel also gives us a precise date: around 1472–3, a few years before Giorgione's birth (*c*.1477).[3] Amadeo has taken various key events in Genesis and has portrayed in succession the Eating of the Apple, the Expulsion from Eden (with God officiating rather than the more usual angel with drawn sword), and lastly God appearing between Adam and Eve, turning to Adam with his hand raised in admonition. The story then continues with Cain and Abel. The scene depicted in our bas-relief is not related in Genesis, where the Fall and its consequences end with the Expulsion, the closure of Eden and the Cherubim guarding its gates (Genesis, 3.23–4). It is a scene which recurs in this form infrequently in iconographic tradition. Moreover, its appearance a generation before Giorgione, in the Venetian Republic, and its close affinity to *The Tempest* invite us to investigate this scene first of all on its own terms, as Amadeo has rendered it. This should be done before making any comparison with Giorgione's painting – not because the Bergamo relief must necessarily be assumed to be its source, but because both, in their very similarities, may go back to the same iconographic tradition that was alive in the Veneto between the end of the fifteenth century and the beginning of the sixteenth.

III

Amadeo's narration of the story of Adam and Eve resembles other quattrocento cycles from Genesis, following roughly the same lines of narrative. This can be illustrated with the best-known example, the bas-reliefs of Jacopo della Quercia for the portal of San Petronio in Bologna (1435–8). Here the Fall is followed by the expulsion,

performed by the Angel rather than God; lastly, instead of the scene that we are investigating, we find the Work of Adam and Eve as the consequence of the Fall (32). The destiny of the human race is thus set out from the very beginning through the division of work between man and woman: for man, manual labour to secure the survival of mankind: 'in the sweat of thy face shalt thou eat thy bread' (Genesis, 3.19); for woman, the bearing and bringing up of children: 'in sorrow shalt thou bring forth children' (Genesis, 3.16).

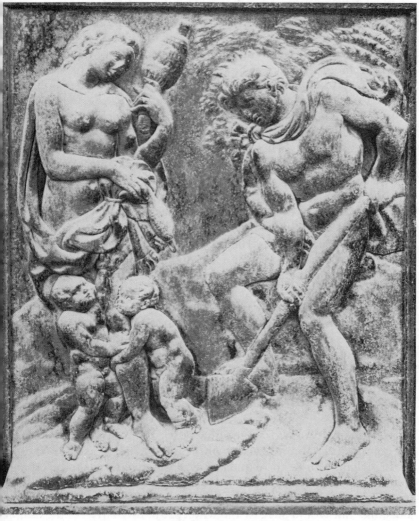

32 Jacopo della Quercia, Adam and Eve, relief in San Petronio, Bologna

Compared with other cycles of this period (e.g. Ghiberti's 'Door of Paradise' made for the Baptistry in Florence) and even with iconographic tradition recurrent in any age, the Bergamo relief represents an exception: for in place of the Work of Adam and Eve we find God and Adam in a dramatic meeting, in the presence of Eve with the first of her sons.

Adam and Eve's story is certainly one of the best known and most frequently depicted of all ages: origin and root of human history, cause of man's fall into a state of sin and – *felix culpa* – of Christ's incarnation and the redemption of human nature. It is a story so famous and so often invoked, in sermons, frescoes and popular tradition as much as in academic inquiry, that it could, and still can, be summoned up simply by calling to mind its most dramatic moment: the original sin, which marked the change of destiny for Adam and Eve (Genesis, 3.1–6). This scene took on a formula in the first centuries of Christianity which has never ceased to be repeated and which still evokes the whole history for all of us. However, iconographic tradition has also portrayed to a greater or lesser extent the scenes succeeding the original sin, following the narrative of the third chapter of Genesis: the Shame of Adam and Eve (Genesis, 3.7, 'and they knew that they were naked'), God's reproof (Genesis, 3.9–13, 'Where art thou, Adam?'), the curse of the serpent, man and woman, in which each is shown an irrevocable destiny (Genesis, 3.14–19), the giving of garments (Genesis, 3.23–4) and lastly the expulsion 'from the Garden of Eden' – *de paradiso voluptatis* (Genesis, 3.23–4). Occasionally the giving of tools to Adam and Eve is added to these events, a scene which is not present in the Bible but which makes God's curse more explicit: Eve is given a distaff and spindle and is thus joined to Adam in work. Again, after the expulsion, the scene of Adam and Eve's work is, as we saw in Jacopo della Quercia's relief, a representation of the *effects* of God's curse, with the progenitors' destiny being played out, after the gates of Eden have closed behind them. It is also a representation of *our* destiny.[4]

It is rare for all these scenes to be depicted in their entire narrative sequence: one or more events in the story would normally be portrayed singly or woven together, depending on the demands of the composition and the wishes of the patron and artist. A portrayal of the original sin or the expulsion was not always felt to be enough to evoke the whole story: sometimes each successive episode had to be condensed and included, even in a restricted space, through allusions that would suggest the whole. A particularly good example

of this can be found in the famous relief in Autun (33): Eve lies gracefully across the entire length of the stone, which originally served as a lintel. Her left hand reaches backwards to take the forbidden fruit, behind which we can see the Serpent. But she is already overcome with shame and tries to hide her nakedness behind a bush; at the same time her right hand is on her cheek, in a gesture of sorrow that was one of the canonic features of expulsion imagery.[5] In this way Adam and Eve's original sin, shame and expulsion are artfully synthesized into a single figure, according to a principle of composition that we can call *iconographic contraction*.

At the opposite end of the scale, an equally famous example demonstrates how the same story can be drawn out in a series of separate scenes. The bronze doors of the cathedral of Hildesheim were cast in 1015 by Bishop Bernward, who personally supervised their iconographic programme. They display the juxtaposition of the stories of Eve and Mary, two protagonists of stories that were chosen to instruct the faithful in sin and salvation (34).[6] The left side comprises eight panels which go, from top to bottom, through the chapters of Genesis, but beginning with the Creation of Eve, followed by her presentation to Adam, the original sin, their shame and the curse (joined together, as is often the case, to form one scene), their expulsion and the first scenes of man's life outside Eden: Adam's work, the offering of Cain and Abel to God, and the killing of Abel. On the right hand side, we have a synthesis of the

33 Gisleberto, Eve, from the north portal of the cathedral of Autun

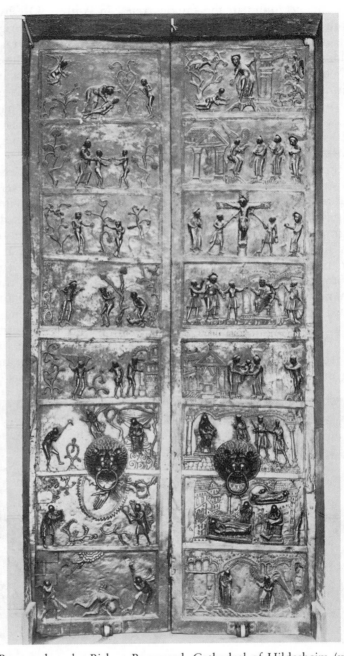

34 Bronze door by Bishop Bernward, Cathedral of Hildesheim (whole)

Gospel narrative, beginning at the bottom with the Annunciation, followed by the Nativity, the Adoration of the Magi, the Presentation at the Temple, Christ before Pilate, the Crucifixion, the women at the empty tomb and the meeting of the risen Christ with Mary Magdalen.

So the two halves of the Hildesheim door tell two parallel stories, one beginning with Eve, the other with Mary. The juxtaposition of the tree of knowledge with the Cross in the third row from the top, alludes to a legend in which the cross was made with the wood from the tree. In the third row from the bottom the Adoration of the Magi is coupled with the work of Adam and Eve: for example, in the distribution of decoration, the presence of the two lion-headed door knockers underlines their thematic importance. Mary and Eve in their motherhood are symmetrically disposed, and depicted according to an identical iconographic scheme: but while one receives the homage of the three kings, the other listens with Adam to the angel's warnings (35). This composition is an older link in the same iconographic chain as the relief of San Petronio, and in some ways as the one in the Colleoni chapel. Adam is tilling the earth, Eve nursing Cain. It is a scene full of dramatic tension, not only because

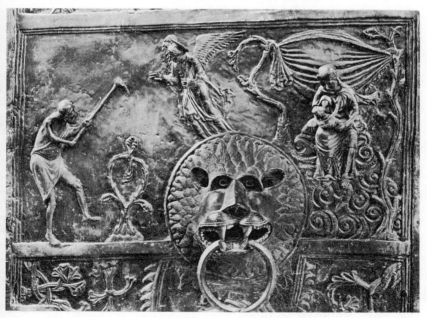

35 Bronze door by Bishop Bernward, Cathedral of Hildesheim (detail)

it shows the fate of man after his joyful state in Eden, but also because little Cain, apparently so harmless in Eve's maternal embrace, will become the protagonist of the two lower panels, guilty of the first crime to be committed on earth.

The panel showing Adam's work follows the expulsion from Eden, but it does not represent a truly successive scene: between the two we must imagine the whole period in which Eve conceived and bore Cain. In order to narrate the fulfilment of God's curse, Adam could be portrayed intent on earning his bread by the sweat of his brow just after the expulsion; but Eve had to be pictured as a mother. As a result, the figure of the angel is extraneous to the Bible narrative, for he seems to be there to remind Adam and Eve of their sin and their tasks in the world, and to repeat the curse that God has cast on man, woman and the serpent two panels back. The scenes of the curse and of work are therefore shown as being complementary: and, as in the Bible, the motherhood of Eve counterbalances the work of Adam. These scenes are drawn as complementary and symmetrical on the doors of Hildesheim and in all western iconographic tradition; they also seem readily susceptible to superimposition and contraction.

This is what has happened in Amadeo's panel: in the centre, God admonishes Adam and Eve, turned towards Adam; but Eve already has Cain in her arms, whom she has 'brought forth in sorrow', and Adam holds a spade with which he 'will earn his bread in the sweat of his brow'. The scene of the curse has thus been moved to a time after the expulsion from Eden, in order to demonstrate its fulfilment; or rather, the effects of the curse are shown with a representational device that resembles the rhetorical figure of prolepsis or *anticipatio*.[7] In combining two distinct but complementary scenes Amadeo has placed God, rather than the angel, between Adam and Eve, and in this sense follows a particularly Venetian tradition that is closely linked to biblical illustrations of Byzantine origin (36, 37).[8] The 'proleptic' Eve with her child in her lap is a recurring model: a famous Carolingian manuscript, the Bible of Moutier Grandval (38), provides a close iconographic parallel to the 'gypsy' of *The Tempest*. Adam stands listening to God, just as in the scenes of the curse. But as in those of his work, he holds a tool that he is not actually using. This iconographic schema, combining two different scenes in the figure of Adam, only occurs very rarely. One example is in a fresco in the chapter house of the monastery of Sigena (twelfth and thirteenth centuries) in Spain: here Adam and Eve watch the angel who 'teaches' them how to till the soil.[9]

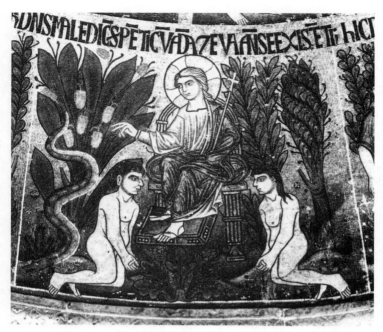

36 Ceiling mosaics from the atrium of San Marco, Venice

More frequent is the scene of Adam and Eve 'at rest' from their labours, alone and meditating on their changed fortunes. Adam has a tool in his hand, Eve has one or two children. In some cycles this scene follows the expulsion, for example, on a Florentine chest of c.1440 (39), and in prints by Cristoforo Robetta made in the same century or at the beginning of the next (40, 41). Or it may recur as an isolated theme, as in a drawing based on Bachiacca and known as *Educazione d'amore* (42).[10] In the Bergamo relief the figures can be characterized as 'at rest' and meditative but between them looms the warning figure of the Eternal Father.

Amadeo has joined two moments of narrative into one scene (possibly copying a specific model) and though this is a standard technique the results stand apart from a widely established tradition. Like so many artists before him, he *contracts* two distinct iconographic schemas into one for the purpose of a narrative sequence which, as at Hildesheim, proceeds with the killing of Abel. Little Cain on Eve's lap is not therefore simply a symbol of the pains of motherhood: he is also the first man to commit a crime that will send him to eternal damnation. The solemn figure of God has his

37 Mosaics from the dome of the Baptistry in Florence (detail)

right hand raised in warning, to decree the destiny of mankind and to threaten endless torment.

IV

The iconographic schema of Giorgione's *Tempest* is virtually identical to that of the Bergamo relief. The most important difference is the 'tempest' with lightning in place of the figure of God, but a few other variants may be noted as well. The relationship between the three protagonists in the relief differs from that of their counterparts in the painting, as does the use of space: in the relief the characters take up almost the whole scene, leaving just a small corner for the rocky background with its two trees and distant roof. In the painting, on the other hand, the human figures are surrounded by a rich landscape which features a base with two broken pillars, a river with a wooden bridge, a distant city with towers and a domed building, trees, clouds and a streak of lightning. In front of the woman, and partly hiding her, is a ragged bush growing from a crevice in the ground; just below it, a tiny snake slithers into a hole.

38 Miniature from the Bible of Moutier-Grandval

39 Florentine chest

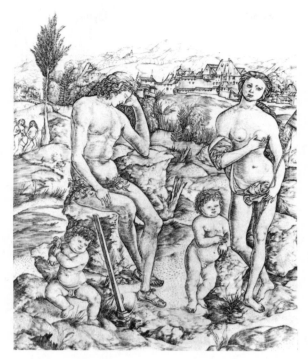

40 Cristoforo Robetta, engraving of Adam and Eve

All these differences (except one) can only point to a single explanation: Giorgione made a fundamental change to the relationship between the characters and to the background, transforming the latter into a broad landscape, liberally scattered with details in order to enrich the iconography of the story and give him a chance to display his judgement and finesse as a painter. The details may or may not add to or amplify the elements of the relief, just as they may or may not have a particular importance for the story. The exception that eludes this explanation is Giorgione's thunderbolt in place of Amadeo's solemn figure of God, breaking into the centre of the relief with its terrible warning.

The idea that the thunderbolt represented the presence of Jove had already been mooted by some interpreters, as we saw in the preceding chapter (Klauner, followed by Battisti and Francastel). A few years ago Götz Pochat led the way down what is probably the right road of interpretation (though at the same time he supported

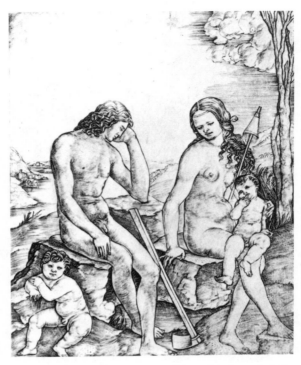

41 Cristoforo Robetta, engraving of Adam and Eve

Edgar Wind's line of argument) with essays on the wealth of literature on *emblems*, where the thunderbolt is the 'image' of God.[11]

The *Emblematum liber* by Andrea Alciati, written in 1521 and published ten years later, opened a way into a whole body of literature that was to occupy the minds of many writers, in both Latin and the vernacular, right up to the eighteenth century, with far-reaching repercussions for poetry and the figurative arts.[12] Alciati was also the first to develop the emblem as a literary genre by establishing a formula of three fixed parts: a *pictura*, accompanied by an *inscriptio* that suggested its meaning in the obscure, contracted language of a 'motto', and lastly a *subscriptio* in rhyme that provided a detailed explanation of the connection between the motto and the image.[13] Long before Alciati, however, scholars had been collecting and examining the meanings of images in the light of a lost science: hieroglyphic script. Every effort was made, through the power of divination and a painstaking reconstruction of the past, to recover the lost knowledge of this writing.

42 Adam and Eve, drawings taken from Bachiacca

The mysterious signs on the ancient obelisks and Egyptian statues that were familiar sights in Rome had long been a source of popular fascination. In 1419 Cristoforo Buondelmonte brought a unique manuscript to Florence from the island of Andros: a treatise on hieroglyphics, written in Greek and attributed to Horapollo. In a

partial reconstruction of an authentic tradition, that shows no knowledge of the syllabic nature of hieroglyphic script, Horapollo provided a 'symbolic' explanation for approximately two hundred signs, whereby each was treated as a separate image, and not, as we now know to be correct, as characters that combine to form a true script. The treatise was acclaimed by scholars as the revelation of a mystery: Horapollo was read with a fierce conviction, transcribed, studied and translated into Latin and then into the vernacular. General principles for the composition of a 'hieroglyph' were deduced from his writing, and his two hundred signs were increased by several hundred more.[14]

'Omnis mundi creatura |Quasi liber et pictura| Nobis est et speculum' [Every creature of the world is like a book or a picture to us, or a mirror of ourselves], wrote Alain de l'Île in the twelfth century,[15] affirming that messages from God could be communicated through animals, plants and natural phenomena. This 'allegorical' vision of the natural world was the fruit of the numerous *Bestiaries* and *Lapidaries* of the Middle Ages; the discovery of Horapollo lent it a new credibility, with all the authority of an ancient and mysterious science. A tract that deciphered the signs of a long-forgotten script was now adopted to unravel God's messages to the world.

Over the centuries the *Bestiaries* had established a wholly Christian interpretation of the world, in which, with the help of the Bible, every animal reflected an element of the story of salvation. Horapollo's text showed how images could represent 'time', 'a year', 'the king', 'the wedding', 'the Nile in flood', 'safety', 'lust', 'ignorance', and 'death', providing the means to translate every human experience and argument into hieroglyphics. The learning and development of this writing became a privileged pastime for scholars, for it enabled them to communicate with each other through 'hieroglyphics' without any possibility of being understood by the less educated. Horapollo's revelations of the secrets of ancient Egyptian priests had furnished the clerics of the new age with their own secret language.

Studies of Horapollo, and the new science of hieroglyphics that they generated, reached a peak in Venice and Padua in the last decades of the fifteenth century and the beginning of the sixteenth.[16] The *Hypnerotomachia Poliphili* by Francesco Colonna appeared at the highest point of this evolution, and was published, with magnificent illustrations by Aldo Manuzio, in 1499. It immediately became, and remains to this day, one of the most celebrated and influential books in European culture. Every object and every

encounter in Poliphilo's waking dream instantly turns into a hieroglyphic and is given a clear graphic translation by his painter. The text in turn provides (for the literate) a learned exposition, in a language that deliberately obscures the Italian with pedantries and Latinisms. The stern admonition to Poliphilo lingers on every page: 'Now ruminate these arguments in your mind': a clear echo of the *ruminatio Scripturae* that was a traditional exercise in spiritual nourishment for monks in the Middle Ages.[17] Hieroglyphics, like the Scriptures, were a subject for reading, meditation and assimilation through a 'digestive' process of internal discussion. A renewed familiarity with the ancients was developed through the standards of the old culture. The inheritance of the Bible was joined to the discovery of antiquity, just as an early fifteenth-century Venetian miniature shows Venus with Cupid surrounded by four gods who take on a pose appropriate to a *Sacra conversazione* (43).[18] Christian

43 'Sacra conversazione' of pagan divinities, miniature from ms. Marc. It. Z64 (4824), fol. 233r.

tradition and the rediscovery of antiquity were joined together by a strength of conviction that with Horapollo's book, the key to a lost world of symbols had been found. In this sense the authority of the Bible sealed the truth of the language of 'hieroglyphics'.

Only a few years after the *Hypnerotomachia*, the Aldine press published the original text of Horapollo's *editio princeps* (1505) which was translated in 1517 by Filippo Fasanini. Also living in Venice at that time was Fra' Urbano da Belluno (1443–1523), a former companion of Francesco Colonna at Treviso. Urbano ran a school that became the centre of a circle of scholars of hieroglyphics.[19] Here Horapollo's science was constantly expanded with new Greek and Latin texts and with the vast heritage of biblical and ecclesiastical culture of the Middle Ages. The most significant fruit of this tradition was the famous work by Urbano's nephew, Pierio Valeriano (1477–*c*.1558), the *Hieroglyphica, sive de sacris Aegyptorium, aliarumque gentium litteris commentarii*, first published in Basle in 1556 though it was well known in Venice long before then. The author begins by declaring the 'sacred' nature of his science, using the words of Psalm 78.2 for his own ends: 'I will open my mouth in a parable: I will utter dark sayings of old',[20] meaning that God expressed his wish to speak to men through an ancient science, through hieroglyphics and allegories ('hieroglyphice sermonem faciam, et allegorice vetusta rerum proferam monumenta' [I will make a speech with hieroglyphs, I will speak of ancient monuments in an allegory]). Discovering the meaning of these things, then, was to discover the true nature of the human and divine world.

The objects and signs of the present and ancient worlds were thus seen as so many messages from God that the new science could decipher with an explanation of their symbolism. Pierio must have acquired his interest in this subject in his uncle's erudite and prestigious circle. His longest work, however, was a belated and systematic codification of this vision, for long before it was written the same ideas had been expressed in a short treatise published in Rome in 1517: the *De Fulminum significatione*, whose contents found their way into one of the chapters of the *Hieroglyphica*.[21] Here the thunderbolt is interpreted at some length with a series of meanings that all proceed from the initial statement: 'everyone knows that the thunderbolt is the *supremi Iovis gestamen*, the attribute of God'. The *Hypnerotomachia* was already dated as the year 1462 'after the descent of great Jove'. The Christian God had joined forces with those of the pagans, and both could speak through thunder. So that when, in a statement taken from Horapollo's text,

we read that lightning signifies 'vocem procul auditam' [a voice heard from afar] that echoes 'longe lateque per inmensa terrarum spatia' [far and wide over an immense region of the earth], we must conclude that this terrible, omnipotent voice can only belong to God. The words of the Psalmist (Psalm 77.18), 'the voice of thy thunder was in the heaven' are a 'hieroglyph' of the voice of God, which speaks to the troubled, awestruck world through the Gospel. The thunderbolts of other passages in the Bible (e.g. Psalm 18.1, 'he shot out lightnings') are also interpreted, with Jerome and Eucherius quoted for supporting evidence, as divine words from the heavens that spread over the world with incomparable light. Thus too Psalm 77.18, 'the lightnings lightened the world'.

There is little need to show how these interpretations were assimilated by the minds and work of artists and their patrons. One example will suffice, in the story of how in 1507 one of Venice's illustrious guests, Albrecht Dürer, bought a sampler of the *Hypnerotomachia* (now in Munich) for a ducat. A few years later he illustrated a Latin translation of Horapollo, procured by his friend Willibald Pirkheimer, for the Emperor Maximilian. The original is lost but a copy of it, with copies of Dürer's drawings, is preserved in a manuscript in Vienna, and was published in 1915. The hieroglyphic of lightning and thunder is illustrated on fol.38v: 'how the Egyptians depicted a voice that came from afar' (44).[22]

44　Copy of an illustration by A. Dürer for the Latin version of Horapollo

The tradition of exegesis that fused together Horapollo and the Bible afterwards became widespread in the wealth of books of *Emblems*. This can be illustrated by a single example from the *Mondo simbolico* by Filippo Picinelli, where lightning is the symbol of 'divine condemnation', 'of travail sent by God', of 'Christ the Judge, Rex tremendae maiestatis', of 'God's punishment of sinners', and 'the wrath of God'.[23]

V

There can be no doubt that the ruin in the foreground of *The Tempest*, between the man and the woman, has the same conceptual history as the lightning: the science of hieroglyphics and the growing use of emblems that novelty value and the prestige of its followers had made into a cult in Venice. For it is utterly unfeasible as the real remains of an old building, with its two close columns, hemmed in on either side by the river or the wood. This 'relic' was purpose-built; it is not a fragment of a construction destroyed by time, or the portrait of imaginary archeological remains but the deliberate construction of a ruin with clear emblematic meaning, 'the broken pillars'.

Assiduous study of the Bible had passed on at least two extracts from the Scriptures where columns played an important role, and these provided easy clues to those in search of emblems. The first was Kings III, 7.15 which describes the columns of the portico of Solomon's temple, and the second pair of columns were those demolished by Samson, killing both the Philistines and himself (Judges 16.29). These and other passages pointed to a fundamental, rather obvious, meaning ascribed to the column: solidity and strength, that in the first passage is sealed by God, and in the second is overthrown by Samson's miraculous powers. This is the line that the books of emblems tend to follow, with countless variations.[24] But the broken columns of *The Tempest* cannot communicate this idea of 'solidity'; nor can they be connected with the iconography of *Fortitudo*, as Wind proposed, for we are not told who broke them.

The menacing presence of the thunderbolt is more suggestive of a passage in book II of Seneca's *Naturales quaestiones*, devoted entirely to the phenomenon of lightning. Jove, writes Seneca, 'fulmina e nubibus mittit . . . columnas, arbores petit' [sends lightning from clouds . . . strikes columns and trees] (II, 42,1). Though there is no specific meaning that can be attached to this text, it nevertheless gave

rise to a symbolic interpretation in an emblem that Giovanni Ferro attributes to Cesare Turetini, and Picinelli to Henry III of France (1574–89): a column with lightning above, and the motto 'Firma ne fulmine tacta'. Threatened by lightning but unharmed, the column represents a strength that can only surrender to the will of God. This symbology was turned on its head in the *Symbola christiana*, published in 1677, by the elector of the Rhineland Palatinate Charles Ludwig, under the pseudonym Philotheus: here the thunderbolt shatters the column and the motto is 'resistendo frangor' (45). The pious elector has made the haughty declaration of peerless strength into a symbol of the dreadful fate of the proud. But the meaning of the column, broken or intact, is still one of spiritual fortitude.[25]

Some time before this, thunderbolt and pillar had been joined together to give a different meaning. The medal by Antonio Marescotti of Ferrara was coined shortly after 1448 for a Bolognese knight, Galeazzo Marescotti, possibly of the same family; on the

45 Emblem of Philotheus (from the *Symbola christiana*)

reverse side is a pillar broken in a storm with the inscription 'MAI PIÙ – 'NEVER MORE' (46). The key to interpreting this image is Galeazzo himself, whose portrait appears on the right side: one of his poems is a lament for the recent death of his beloved Camilla Malvezzi 'the valiant Lady who was the steady pillar of my life'. It has been shown that the medal alludes to the death of Camilla; the broken pillar is here 'life cut short by death'.[26]

In *The Tempest* the relationship between the broken pillars and the lightning is not so immediately obvious. There are no visible fragments from the pillars on the ground. Like the human figures on either side of it, this 'emblem' is dominated by the lightning that hovers over the whole scene, but its narrative context has melted into the surrounding landscape. The pillars may be broken as a consequence of the storm but they are offered to the observer as 'broken pillars' and must be read as such. Poliphilo's dream abounds with them: pillars that are 'fragmentate et interrupte' 'per vorace tempo et putre antiquitate et negligencia' [fragmented and broken

46 Antonio Marescotti, medal

up by voracious time and rotten antiquity and neglect] are especially
prevalent in the cemetery of those who died for love (47).[27] As well
as expressing a generic 'sense of ruin' that was later to inspire many
landscape artists,[28] this passage links the broken pillars directly with
the 'bodies turning to dust' of the dead and buried. For the first
time the broken pillar has become a graveyard decoration. Or
perhaps not for the first time: Cicero told how he recognized the
lost and forgotten tomb of Archimedes near Syracuse by its little
pillar, inscribed with words and signs (*Tusc. Disp.* v 64ff). As in
Poliphilo's dream, it was not built as a broken pillar but here on
the tomb it nevertheless becomes a symbol of the transience of
human life and of our physical death. This was how Jean Mercier

47 Poliphilo standing before a landscape of ruins (from the
Hypnerotomachia Poliphili)

presented it in his 'archeological' reconstruction of Archimedes' tomb, in his book of emblems (48). This too was the meaning of the broken column in Vredeman de Vries' engraving of 1577, and in many emblem books.[29] The traditional use of the upright, unbroken pillar to represent 'the tree of life' led naturally to its meaning, when broken, of 'life cut short by death'. It appeared in sepulchral art at least as early as 1568 and from then on became widespread, particularly from the eighteenth century to the present day.[30]

In his *Libro dei disegni*, now in the Louvre, Jacopo Bellini drew a broad landscape with symbolically broken columns, one on the top of a hill and four on a base, near St Jerome in meditation. Together with the carcasses and rubble on a distant shore, these represented the 'death of paganism' (fol. 18b)(49). On the following page (19a) the column in the foreground is not broken but lies waiting to be hoisted onto its base, where it will bear a statue of a pagan deity that a sculptor is finishing off nearby (50): the glorious sacrifice of the true God is thus juxtaposed with the fleeting triumph of an ancient godhead. Yet the sense of this detail, which is so central to the whole scene of the procession to Calvary, could be inverted: if the scalpel hammering at the statue, which lies prostrate

48 Reconstruction of Archimedes' tomb at Syracuse, in the emblem book of Jean Mercier

49 Jacopo Bellini, *St Jerome* (from the *Libro dei disegni* in the Louvre)

50 Jacopo Bellini, *The Road to Calvary* (from the *Libro dei disegni* in the Louvre)

on the ground like a corpse, is a prefiguration of the Cruxification, then the recumbent pillar could equally represent the death of Jesus. In the same way, the broken column in the scene in a lazar house (fol. 70a), which lies in the same line of perspective as the three corpses (51), is certainly an anticipation of the death of the pestilent man seated upon it.[31]

The 'death of paganism' was represented in another way by Domenico Ghirlandaio (as Aby Warburg has amply demonstrated) in the Nativity painted for the Sassetti chapel in Santa Trinita, where the figure of Jesus is placed at the foot of a crumbling Roman sarcophagus, decorated with inscriptions and garlands. The end of the old religion is thus presented as a direct consequence of the birth of Christ. The same meaning is expressed by the broken pillars that are a familiar ornament to the Adorations of the Magi and the Adorations of the Shepherds by another great Venetian, Jacopo Bassano. These are generally placed (almost echoing *The*

51 Jacopo Bellini, *A Scene in the Lazar House* (from the *Libro dei disegni* in the Louvre)

Tempest) in the left half of the painting, near the Virgin and Child
and St Joseph, and behind the other characters: just as in Giorgione's
painting (52). On another occasion the broken pillar could represent
the death of a person, as in the two *predellae* of Civezzano near
Trento, where it is placed in the background of the scene depicting
the murder of St John and St Catherine's martyrdom.[32] The pillars
of *The Tempest* are hieroglyphs, in just the same way as the
thunderbolt. They are not built on a tomb but nevertheless may be
taken to represent death.

For centuries the Fathers of the Church and the spiritual leaders
had taught that death was God's chosen means to free the soul from
the bonds of the flesh so that it could return to eternal life. It was
a concept based entirely on the existence of the soul; the sensibilities
of the new age began to replace it with a more secular interest in
the death of the body, in the grotesque and terrifying phenomenon
of physical decomposition. Alberto Tenenti has shown how this
fascination, which found its fullest expression in the taste for the
theatre of the macabre, was connected with a new sense that earthly
life was not simply a preparation for, or the antithesis of, heaven,
but was worth living on its own merits. Thus the beginning of Book
III of St Augustine's *City of God*, which speaks of death as 'the
wages of sin' (in the footsteps of St Paul, Romans V.12), is illustrated

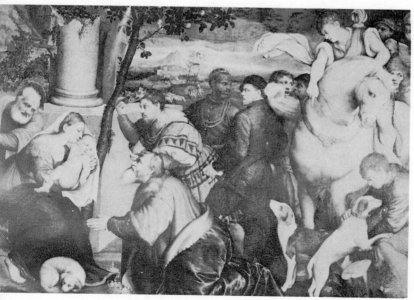

52 Jacopo Bassano, *Adoration of the Magi*

by miniatures showing the original sin next to a decomposing corpse (53). As desire for life became stronger, the death of the body was portrayed as the first consequence of sin.[33]

The *City of God* was one of the most frequently published books in Venice in the last twenty-five years of the fifteenth century.[34] For an illustration of how the theme of death as the first consequence of original sin had such resonance in Venice at that time, we can turn to a work by Marcantonio Sabellico (1436–1506). He was a well known teacher in Venice, from 1473 until his death, and among his pupils was Pierio Valeriano. In his book of 'notable facts', a collection of Christian and pagan deeds that serve to illustrate certain fundamental concepts, Sabellico makes frequent references to the Fall: Adam (referred to as the Protoplast) and Eve are an example of God's curse, expelled from the garden of delights and who 'added the necessity of death'. Death must always be considered as punishment for sin.[35]

In the glare of lightning, God's terrible 'vox a longe' [voice from afar] decrees a destiny of toil and pain to man and womankind; the 'hieroglyph' of the broken columns adds that henceforth death will cut short the lives of all men. A richer, fuller sense of earthly life has numbered death among the consequences of Adam's sin.

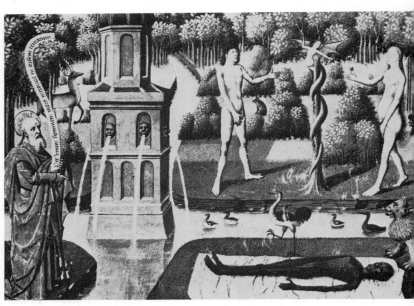

53 The original sin and death, miniature

VI

There is a further *exemplum* in Sabellico's book which finds a direct echo in *The Tempest*: on his way to the Parthian war, Crassus is about to step onto a bridge when 'tempestas subito coorta est cum tonitruis et fulminibus' [a storm arose with thunder and lightning] that prevented him from making the crossing. 'No voice' could have expressed the gods' wishes more clearly: the thunder and lightning are the very 'voice from afar' that Horapollo had taught.

In Giorgione's painting, a bridge lying directly beneath the storm clouds connects the space occupied by Adam, Eve and the ruin with a city. We can see its turrets, columns and trees, and a white bird perched on a roof top, but no sign of any human presence. This distant, deserted city can be none other than Eden, the *civitas, Hierusalem libera* of old tradition.[36] God wisely placed Adam and Eve 'within sight of the Lord's city', reinforcing the admonition to sin no more,[37] for there was now no possibility of returning within the chosen walls. The gate of Paradise, as a conventional feature of scenes of the expulsion, is thus often portrayed as a complex piece of architecture, and sometimes as the gate of an entire city. There are examples of this in a miniature of the twelfth-century *Liber floridus* (54), or the *Mappa mundi* by Andreas Walsperger (1448), both of which belong to a rich medieval tradition that was alive in the fifteenth and sixteenth centuries. One of Cristofano Robetta's prints illustrates this point, showing Eden as an unpeopled city, beyond a bridge over a far river (40), just as in *The Tempest*.[38]

On this side of the uncrossable bridge leading to the city that has shut its gates to man forever, the two figures of Adam and Eve are turned towards the 'emblem' of death, decreed by God's menacing thunderbolt. Adam leans, not on the short-handled spade of his Bergamo counterpart, but on a singularly long staff: various interpreters have agreed that this could be a soldier's lance, a traveller's wand or simply a generic tool. The allusion to the manual labour prescribed in the biblical text is underplayed, almost fleeting. For this Adam is an elegant Venetian, and seems lost in thought more for the death that has entered the world, than for the toil that will make men sweat in their brow for evermore. The medieval tradition portraying Adam at work (as at Hildesheim, for example) has evolved to show Adam at rest, with Eve as mother at his side (as, for example, on the Florentine chest and in the prints by Robetta and drawing by Bachiacca, (39–42, see above, pp. 96–7). Adam,

54 The terrestrial paradise, miniature from the *Liber Floridus*

then, expresses meditation on the destiny of man. In Amadeo's relief, God is turned to Adam: for it is to Adam above all that the divine decree is directed, establishing the laws that will govern men's lives outside Eden. With this image the onlooker is invited to identify emotionally with Adam, an invitation that is in tune with the artist's closer attention to his male public. The woman–mother is entirely taken up with the care of her child, while the man pauses in his work to reflect on the fate of all mankind. It would be unrealistic to expect *The Tempest* to express anything other than the male 'point of view', and, moving in closer, the prompt to identify with Adam is strengthened by his contemporary dress. The handsome clothes belong to a Venetian gentleman, not to a peasant or a fisherman, and are appropriate with the attenuated image of the tool: in the hands of this meditative, or resting, figure, the staff must allude to manual labour. Neither spade nor hoe, it has a point at one end but so hidden in the grass that it is only visible on a close and careful examination. Noble in dress and in bearing, this

courtly Adam meditates not so much on toil as on the life of men after the Fall and the closure of Eden; and on the warnings from heaven, the fate of womankind and death.

Eve is seated opposite him a white wrap that barely covers her. The baby in her lap and her own nakedness indicate recent childbirth, a familiar schema in earlier art. The slender bush that grows out in front of her cannot be a simple decoration in this painting of such deliberate construction: its compositional importance has already been noted by other interpreters, particularly Ferriguto, who have tried in vain to establish its meaning. A comparison with the Eve of Autun (33) can furnish the answer: she too hid her nakedness behind a little bush that was, and still is in *The Tempest*, one of Eve's recurring 'attributes'.[39] It provides an iconographic 'clue', all the more important for being so delicate, to the story Giorgione wished to portray.

As in the Bible, Adam and Eve are not alone as the targets of divine malediction: the tiny snake in the foreground, wriggling into a crevice in the rock directly under the figure of Eve, belongs to this scene as well (55): 'Because thou hast done this thou art cursed above all cattle and above every beast of the field: upon thy belly shalt thou go, and dust shalt thou eat all the days of thy life. I will

55 Giorgione, the serpent (detail from *The Tempest*)

put enmity between thee and the woman, and between thy seed and her seed; it shall bruise thy head and thou shalt bruise his heel' (Genesis 3.14–15). God's curse on Adam, Eve and the serpent recurs in the illustrative traditions of the Octateuchs,[40] and in one especially important example the presence of God is indicated by a light descending from the sky (56). This tradition is probably the origin of an illustrated fifteenth-century Bible from Padua, translated into the vernacular, as well as of the mosaics in St Mark's Church. On other occasions the serpent is quite as visible as the protagonists; in *The Tempest* it is almost imperceptible, as it vanishes into a crack in the earth, yet can hardly be included as mere ornament. The act of hiding and blending with the earth shows that God's curse is already fulfilled. At the same time, it inhibits a too-easy reading.[41] (It may not be by chance that Eve's heel lies above the serpent, prefiguring the fulfilment of punishment that God has predicted, the victory of the woman and the redemption of mankind). Also in the Octateuchs there is a customary picture of the river of Paradise, divided into four streams, as in Genesis 2.10–14. The river of the *Tempest*, like that of the Robetta prints (40, 41), is a clear stream that encircles the city like a moat, and enlivens the landscape. It is, in the words of the Psalmist quoted by St Ambrose to describe the *civitas* of Eden, the river 'the streams whereof shall make glad the city of God' (Psalm 45.5).

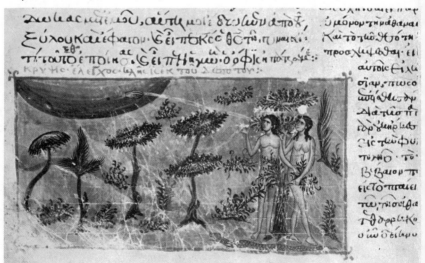

56 God cursing Adam, Eve and the serpent, miniature from ms. Vat. gr. 746, fol. 41*v*

This is the river of the 'bather' whom the X-rays revealed, under the figure of Adam: not a companion to the 'gypsy' but a female figure painted at an earlier stage instead of the present one. It is not necessary to deduce, as Saxl and Battisti did (see above, ch. 3, section IV), that there was an older *Tempest* showing a kind of 'Act I' of a story that was then completed in definitive version. Nor, like Ojetti and Venturi, that the *pentimento* shows that Giorgione's painting has no subject. Nor even, as could well be supposed, that a change of theme took place between the first and second version. There is a fourth explanation that seems more convincing: the 'bather' was painted at an earlier stage, *instead of* the present Eve with child and for this very reason can be identified as Eve herself, in a different composition of the painting that Giorgione had abandoned in the course of his work. The same theme could have been represented through a different disposition of the characters, and a different iconographic schema. For according to an entire tradition in the Middle Ages, starting with the Apocrypha, the bathing of Eve was an important event in the story of the Progenitors. In the *Vita Adae et Evae* it was a bath of purification after the Fall, in which Eve bathed in the Tigris (one of the rivers of Paradise) for thirty-seven days, while Adam bathed in the Jordan for forty days. Other texts tell how Eve bathed alone, after the birth of Cain 'et concipiens perperit Cain super vituperabiles aquas' [and conceived and gave birth to Cain upon shameful waters].[42] Naturally, both these versions were translated into images, rare though they may be.[43] In the first example, the emphasis is on the guilt of both Progenitors, and if we really want to look for an older 'idea' of *The Tempest* we must imagine that it showed the bathing of Adam as well. In the second example, the immersion of Eve by herself, and its allusion to recent childbirth, becomes a kind of 'iconographic equivalent' of the Eve with her child, another formula to express the motherhood that God has prescribed as her destiny. In either case, far from shifting *The Tempest* to the realms of 'not-subject', the 'bather' of the X-ray can be included in the same line of interpretation.

VII

The pensive Eve of *The Tempest* hardly seems aware of little Cain, as he sits on the edge of her white wrap and begins to suckle. Her gaze is directed rather towards the spectator, and expresses not melancholy but self-knowledge and inner turmoil. Even so, the fact

that she is turned towards the centre of the composition renders her symmetrical with the figure of Adam; and the way that her gaze reaches out of the painting is a further invitation to identify with her companion, while he turns his eyes towards the shadows.

Both figures are placed in a 'moral landscape' that sums up their past history and points to the future of mankind. In the background lies the *civitas*, the *paradisus voluptatis*, bristling with towers and columns and walls and inaccessible beyond a bridge that no human being can now cross, across the river of Eden. Upon the city and the bridge flickers the distant lightning, rending the clouds, the 'voice from afar' that repeats the decree of punishment to man and the serpent. Thus Adam leans on his staff, rooted to the spot; Eve nurses the infant Cain, barely covering her maternal nakedness behind a bush. Between them, two broken pillars are an emblem of the death that has now entered man's life, with the sweat of labour and the pains of childbirth. The lone, innocent presence of quiet little Cain is an anticipation of his fratricide, and the way that humanity must tread, down the *via dolorosa* of sin and divine punishment. Almost invisible in the foreground, a snake disappears into the ground. The cause of temptation and sin, and therefore also the object of God's curse, the serpent is condemned to being struck by the woman's heel: thus the harsh words also hold out the promise of the incarnation of the Word and of salvation.

Representations of Adam and Eve had always been governed by two principles: *contraction*, as in the relief in Autun, and *dilution*, as we saw at Hildesheim. In *The Tempest* these principles are used in a new way. Long-standing iconographic convention had portrayed the divine curse alongside its consequences: the reliefs in the Colleoni chapel are by no means the last example of this practice. Thus the birth of Cain was 'brought forward', and two chronologically distinct moments were combined into one (as with prolepsis). In Giorgione's painting this tradition fuses with another: Adam and Eve at rest (as in the Robetta prints, for example), in which Adam holds a tool and Eve is shown with one or two children, both in a meditative pose, with no sign of God's presence. Giorgione has not made a choice between these two iconographies ('The curse and its consequences'; 'Adam and Eve at rest'): Adam and Eve are 'at rest', and brooding over the consequences of their trespass (particularly death, represented by an emblem), and the thunderbolt is a discreet evocation of the curse. If it is true to say that the Bergamo relief illustrates not one biblical scene but two together, then we can also say that *The Tempest* seems to relate a 'historically' specific scene,

immediately after the birth of Cain. The voice of God, represented by the lightning, is less prominent in the background of the scene. As a result, the story regains its 'historical' truth, placed in a dimension beyond the rigid framework of a point-by-point narrative. It is as though lightning and the voice of nature aroused by the tempest would always remind men of God's warning curse.

As in the case of *The Three Philosophers*, the scene would immediately become comprehensible if it were one of a series of paintings (such as in the Colleoni Chapel or Robetta's series of prints) that depicted the Fall, the expulsion, and then this silent meditation on the voice of God, and on their (and our) destiny. We would see clearly that the scene is based on an imaginary, unseen 'dilution' of the story in which the features of its successive events are 'contracted' and woven into the 'moral' landscape: the serpent (guilt), the bush (shame), lightning (the curse), Adam (work), Eve (birth), the pillars (death), and Cain (crime and damnation). By 'reducing' God to a dart of lightning and the serpent to an almost invisible presence, and by representing Death with the emblem of broken pillars and crime with the still-innocent Cain, Giorgione avoided turning his painting into a mass of narrative moments. He displays his rare intelligence in evaluating the importance of each 'element' of the work (which we have dismantled) against the portrayal of a single moment that could be said to embrace all the past and all the future.

Only an observer familiar with this complex process of composition, who could place the scene in a narrative sequence like the one in Bergamo, would have been able to understand the subject of *The Tempest* and assign the correct meaning to each feature. As he leant over to examine Giorgione's canvas more closely, he would have recognized himself in the contemporary figure of Adam; and joined him in meditation on sin and death.

VIII

The original sin and its consequences were already evident in the decoration of secular buildings in Venice, with an example as celebrated in Giorgione's time as it is now: the sculptures on the façade of the Palazzo Ducale. The thirty-six capitals and the three large groups of sculptures of this famous monument display one of the most interesting programmes of profane iconography of the fourteenth and fifteenth centuries. Nevertheless, it would be true to say that art historians have only studied it from a stylistic point of

view. In his recent book Edoardo Arslan gives a summary of its copious history of attributions, but cannot quote any iconographic study later than 1857.[44] It is not possible to give a full discussion of the whole programme here: it shows an orderly narrative that unfolds a complete vision of the world. The virtues and vices, childhood and work, the ages and nations, emperors and sages, are all shown with a wealth of sacred and profane examples, and gathered around the majestic figure of Venezia–Iustitia (figure 1). At either end of the series are the Judgement of Solomon and the Inebriation of Noah, with the archangels Gabriel and Raphael above. In the corner between the pier and the Piazzetta ('the prow of human life')[45] the capital of the portico shows the seven planets with the zodiac and on its eighth side is the creation of Man, immediately below the great sculpture of the original sin (57). The capital of the loggia shows the four winds, with the archangel Michael standing above them with drawn sword. The whole story of sin and punishment is thus presented as the corner stone at the foundation of the passions and virtues that constitute the alternating patterns of men's lives. This part of the decoration dates from the fourteenth century; but the consistency of the iconographic programme that was continued in the fifteenth demonstrates that the following century shared a similar vision of the world and a vigorous interest in these themes.

Nearly a hundred years later the figures of Adam and Eve were chosen to adorn the 'Foscari arch' inside the Palazzo Ducale. The sculptor was Antonio Rizzo, who later went on to decorate the Scala dei Giganti with a series of 'emblematic' reliefs that came from the same world of hieroglyphics as that of the *Hypnerotomachia*.[46] Adam and Eve appear again in a similar, wonderfully 'classical', triumphal arch, alongside the tomb of the Doge Andrea Vendramin in San Zanipolo. These statues were made around 1493 by Tullio Lombardo, who worked with Giorgione a few years afterwards in the Palazzo Loredan (later Vendramin Calergi) on the Grand Canal.[47] The Bible story had already found a place on the entirely profane façade of the Colleoni chapel in Bergamo (begun in 1471–3). This began with the creation of Adam and ended with the sacrifice of Isaac, prefiguring the Crucifixion, and was adorned with candelabras and columns of a bizarre, classicizing style, and jumbled up with busts of Roman emperors and the Labours of Hercules. The personal *virtus* of the *condottiero* Colleoni and his Herculean strength are set against the story of salvation and his certain entry to paradise. The Labours of Hercules provide the decorative theme

Figure 1 Plan of the exterior decoration of the Palazzo Ducale in Venice, showing the iconography of the capitals
Source: A. N. Didron and W. Burges, 'Iconographie du Palais Ducal di Venice', in *Annales archéologiques*, XVII, 1857.

for another tomb in San Zanipolo, of the Doge Pietro Mocenigo, made in 1481 by Tullio's father Pietro.[48] And another Eve (and therefore certainly another Adam) adorns the façade of the Fondaco dei Tedeschi, painted in 1508 by Giorgione together with Titian.[49]

Adam and Eve, then, had twice been the subject of secular decoration in the Palazzo Ducale, as well on the tombs of a Doge and a Venetian *condottiero*, and in both cases were used to express

57 The original sin (Venice, Palazzo Ducale)

the condition of man. It is easy then to suppose that they could
enter the house of a noble Venetian to inspire his personal piety,
and meditations on his moral condition, with a theme richly
suggestive of the past. We can look for proof of this in the *Notizie
d'opere di disegno* by Marcantonio Michiel, who compiled a list

over a period of years of the works of art that he found in the aristocratic houses of Venice and its states. The earliest notes were made in the house of Francesco Zio and its date (1512 or 1521) gives us a good idea of the kind of furnishings to be found in a Venetian *palazzo* soon after Giorgione painted the *Tempest*. Among Zio's collection Michiel lists a chalice of rock crystal decorated with stories from the Old Testament, the work of Cristoforo Romano. The chalice is presumed lost so we cannot say whether, or indeed how, Adam and Eve were depicted. This is no idle curiosity, for Romano was a pupil and close friend of Amadeo.[50] Also in the collection were two canvasses by Palma il Vecchio, 'Christ and the Adultress' (perhaps the one now in the Pinacoteca Capitolina) and 'Adam and Eve', probably now in Brunswick.[51] The theme of original sin is treated here with the traditional iconography, but the size of the canvas (2.02m × 1.52m) indicate that the work must have held a prominent position on the walls of the house.

The *Tempest* hung in the house of Gabriele Vendramin, nephew of the Doge Andrea. Next to its entry in Michiel's list is another work by Giorgione 'the dead Christ in the sepulchre, with an angel supporting him'.[52] Unfortunately the paintings here, as in the majority of the houses noted by Michiel, are not divided into their respective rooms, and as a result we have no idea of the connections they had to each other. The one exception to this is the house of Andrea Odoni, where in an 'upstairs room' the works listed are 'numerous bronze statuettes' and four paintings. These were 'two half-length figures of a girl and an old woman behind her' by Palma il Vecchio (lost); the famous portrait by Lotto of the master of the house surrounded by his antiques, now at Hampton Court; a Virgin and Child with St Joseph and a saint 'in a landscape' by Titian, probably the canvas in the National Gallery or one of its variants; and lastly a 'large nude' by Savoldo that hung above the bed, which can be identified with a painting now in the Galleria Borghese.[53]

There were, then, in Andrea Odoni's bedroom, two such diverse subjects as a 'nude' and the Virgin and Child, with St Joseph and a saint; and Odoni's own portrait as an antiquarian hung in amongst the other paintings to bear witness to the utterly personal nature of the choice of decoration for the room. As in the mind of the collector himself, sacred and profane were fused together.

In another collection listed by Michiel the collector enters the pictorial space more directly. In Titian's 'Baptism of Christ' in the house of Giovanni Ram (now in the Museo Capitolino) the patron

appears with his homonymous saint but not as an adoring devotee standing to one side of the scene: standing 'with his back to the spectator' it seems as though he too is about to plunge into the Jordan, as a participant in the sacred rite (58). The strange scene in the background must certainly have made sense to him, if not to us: a woman who flees in terror, while vultures gather round a

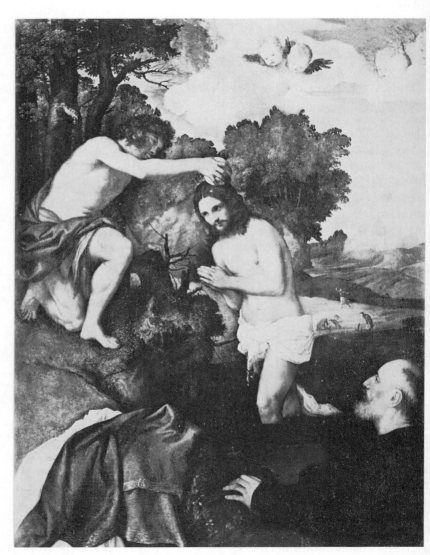

58 Titian, *The Baptism of Christ*

carcass.[54] It is another example of how the patron's own faith, and his personal ideas and preoccupations, as well as his relationship with the painter, had renovated a traditional theme and brought it into a contemporary dimension.

In *The Tempest*, too, an old theme is brought into the present through Adam's entirely modern dress. It is a repetition of the ideas expressed in the decoration in the Palazzo Ducale, or in the tomb of the Doge Andrea, that sin and judgement have marked the destiny of the whole of mankind with travail, pain and death; but the idea is voiced more loudly and the style is completely personal.

Hanging in the house of Gabriele Vendramin among the other paintings, including the portrait of its patron, *The Tempest* eluded too immediate a reading. If, on the one hand, its iconographic schema was quite recognizable, only by comparison with Amadeo's relief, on the other hand the subject had nevertheless been 'attenuated', particularly by the absence of the figure of God. The lightning that replaces the 'voice from afar' so efficiently had already rendered the painting too distant and mysterious for Michiel to understand. But the subject is not so deeply hidden that we cannot trace its genesis and meaning, as we have shown here. The riddle is precisely in the contrast between the 'hidden subject' and the key to its discovery.

5

The Hidden Subject

Quae plus latent, plus placent [There is greater pleasure to be had in
things that are more closely concealed]

St Bernard[1]

I

There is a painting by Palma il Vecchio in the Städelches Kunstinstitut
in Frankfurt, for which we have no contemporary information,
though experts date it at about 1510. At a first reading it appears
to be a scene of unequivocal tranquillity: two nymphs in a rustic
landscape, sitting on the banks of a stream (59). But shortly after
the first publication on the painting, which singled it out for
attention, Swarzenski was able to find a more precise identity for
its subject: the protagonists are the nymph Callisto and Jove, who
has disguised himself as Diana in order to seduce her.[2] Though
Ovid's account of the story was already well established in
iconographic tradition in the Middle Ages, it is not immediately
apparent in this painting. But there is a third, more secret path of
interpretation to explore: which of the two nymphs is Callisto and
which 'Jove'? Rubens's equally famous painting of the same story,
painted a hundred years later, leaves no room for doubt on this
issue (60): the seductive posture of one of the nymphs, and an
accompanying eagle, clearly identify her as the disguised Jove.[3]

Here then, for the first time, the story of the seduction of Callisto
has been removed from the manuscripts and prints of Ovid's
Metamorphoses to occupy the entire surface of a painting not as
'illustration' but as 'subject'. As such, it is hard to imagine that it

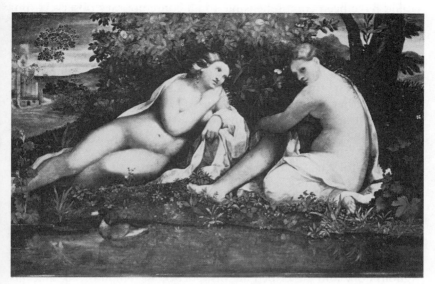

59 Palma il Vecchio, *The Seduction of Callisto*

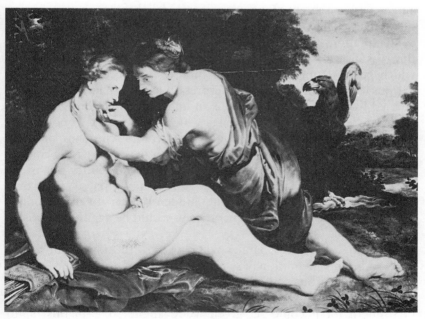

60 Rubens, *The Seduction of Callisto*

would have been comprehensible to all contemporary observers. But the painting by Palma il Vecchio contains a further element of mystery: anyone who knows Ovid may recognize Jove and Callisto and thus lift the first veil, but the second veil – recognizing beyond doubt which figure is the nymph and which the god–seducer – is more difficult to see through. The canvas has a mesmerizing ambiguity that seems designed to provoke debate and discussion, as can be witnessed even now in Frankfurt: the label accompanying the painting answers the first but not the second question, and I myself saw three visitors stand and argue as to who was Jove and who Callisto. The controversy on the subject is an essential part of the artist's intentions.

This taste for cryptic images that would excite discussion among their observers is borne out in a specific testimony by the humanist Giovanni Aurelio Augurelli of Rimini, who lived between Padua, Treviso and Venice in 1500. In describing Giuliano de' Medici's banner for the Florentine joust of 1475 (the same joust that Agnolo Poliziano described in his poem), he emphasized that his pleasure in admiring it was largely due to guessing its secret meaning. 'Multi multa ferunt, eadem sententia nulli est: pulchrius est pictis istud imaginibus' [Everyone has a different opinion and nobody agrees with anybody else. This is more delightful than the pictures themselves].[4] The image is not then just an object of aesthetic contemplation, nor does it simply present a theme to its observers. But it is also a stimulus to discussion of the very image it presents, which passes from the picture to the eyes of the observer, to their various learned and ingenious interpretations, to the hidden intentions devised by artist and patron, like an image in an elegant game with mirrors. Certainly, those paintings which were meant to be seen by the general public (such as those destined for churches or other public places) cannot have been included in the aristocratic concept of a painting as an object of sophisticated hermeneutics nor in the elitist delight in the inexplicit which only the 'initiated' few could understand. It is the nature of the 'hidden subject' to please only a few, for to come into more general view would be against the wishes of the patron.

Giuliano de' Medici's banner was woven with motifs that belong to Gombrich's definition of 'private heraldry',[5] emblems not of family tradition but of individual feeling. Giuliano had thus chosen a heap of blazing logs 'to signify that his burning love was unequalled in strength for it could set green wood alight'. It is in this highly personal context that we must consider works like the *Seduction of Callisto* in Frankfurt. For the subtlety of invention and the obstacles

to unravelling their mystery were a means to enable the cultured nobleman to express his tastes, and to display both his knowledge and his vision of the world to himself and his friends. Thus, in filling their grand houses with paintings of such subtle conceit and execution, the most erudite of the rich Venetians were projecting an eloquent, discreet and above all deliberate image of themselves.

Born of a taste for attenuated or concealed meanings, these paintings are akin to the art of the 'device'. In his *Dialogo dell'imprese militari et amorose* Paolo Giovio laid down the principle 'that it be not obscure that it neede a Sibilla to enterprete it' but yet 'not so apparent that every rusticke [*plebeo*] may understand it'. In other words it should only be grasped by 'a sharp wit and a rich invention'.[6] This principle was already in force long before Giovio's codification: the deliberate exclusion of the *plebei* from the pleasures of the educated class played a natural and fundamental part in finding the balance between subtlety and accessibility.

In choosing a painting as a vehicle for expressing personal feelings, 'inventiveness' must have been severely hampered by the inescapable weight of authority represented by previous iconographic tradition. The transformation of an 'interior' subject into something less comprehensible entailed searching out an unusual iconography, and also perhaps attenuating its meaning by eliminating or toning down its essential features. In some ways, this procedure was the opposite of the artist's normal practice, which was directed towards a wider public. His saints and gods would be given attributes by which they could be easily recognized; but, as we have seen, Palma il Vecchio did not place an eagle next to his Jove, as Rubens was later to do.

Even more complex and difficult was the task of fitting a religious theme into this 'closed' and private use of art. The mythical subject matter of remote pagan antiquity had been brought near by the widespread resurgence of scholarship and a keen spirit of enquiry. It comprised a massive wealth of material that could be quarried from manuscripts and mutilated sarcophagi and moulded at will. The only obligation was to reproduce the polished, shining shell of antiquity – complete with primordial nudes of heroes and centaurs, with arches, candelabras, temples and tubas – as if to encompass the unrepeatable space of that world, which every imitation made all the more unrepeatable. By framing a myth within an 'archeology' reconstituted by the sheer effort of ingenuity, that myth was truly made one's own.

But to a painter in the time of Palma il Vecchio and Giorgione, a Christian subject would have had a different weight. In the course of centuries of rich and varied tradition (which remained firmly

under the influence and the criticisms of the Church), different iconographic trends and strategies had been explored and were governed on one hand by theological orthodoxy and on the other by the education of the Christian public. In the *Catholicon*, a treatise written by Giovanni da Genova at the end of the thirteenth century (and published in Venice in 1497), three reasons are given for placing a picture in a church: to teach the uneducated, to remind the congregation of the mysteries of the incarnation and the lives of the saints, and to arouse feelings of devotion, which was done more effectively by pictures than by words. The same principles are repeated by the Dominican friar Michele da Carcano in a sermon that was published in Venice in 1492.[7] The codification of iconography for religious subjects must have been that much more forceful for being accepted as serving the true Christian faith. Equally, it was that much more difficult to dare to choose a Christian theme as a way of expressing personal thoughts.

II

His [Andrea Schiavone's] works were not then held in high esteem, as those of Gio. Bellini were, the City [of Venice] still being of the old opinion that only those devout and diligent figures were to be appreciated. Besides Giorgione, Palma il Vecchio and Titian attained a greater delicacy, so that their things were used as ornament of public places and of private houses as well.

This passage from Carlo Ridolfi's *Maraviglie dell'arte*[8] restores a vivid picture of how the styles of Giorgione, Palma il Vecchio and Titian related to their patronage. The purpose of the 'greater delicacy' of their works was certainly their use as 'decoration of private houses'. This new wave is counterposed by the old liking for the 'devout and diligent' figures of a prolific painter of religious subjects, Giovanni Bellini.

The contrast, however, may not be as clear-cut as it appears: at the end of his long life Bellini translated his 'devout and diligent' style into a language of greater subtlety. The clearest example of this is the famous *Sacred Allegory* in the Uffizi (61). The interpretation of this painting is disputed, but some light may be shed on its peculiar composition by comparing it with the *Altarpiece of St Job* in the Accademia (62), which we know to be an earlier work. It immediately becomes clear that the Uffizi *Allegory* is a new arrangement of the 'sacra conversazione': the latter is the traditional

61 Giovanni Bellini, *Sacred Allegory*

frontal view of the Virgin enthroned under a canopy in the centre, flanked by six saints and with three angels seated on the steps at her feet. In the Uffizi painting the obvious frontality of a religious image has been restructured through the perspective box and turned through 90°. The Virgin's throne is thus situated on the far left of the picture, still under a lofty canopy; the saints still number six but only two remain on each side of the throne, while the others are placed here and there. In the centre we find not angels but four *putti*, one of whom may be the child Jesus who is no longer on Mary's lap, and who shakes fruit from a little tree which the others gather up. Already in the Triptych in the Frari the angel musicians were changed into winged children who hopped down the steps of the throne. The fact that the two saints (Job and Sebastian) are the same as in the altarpiece in the Accademia is clear evidence of the 'sacra conversazione' nature of the *Allegory*. But its composition has been radically altered by turning it through 90° and giving it an external setting. The landscape is animated by a host of details: the symbolic scene performed by the children around the tree in its tub, which in turn is placed in the centre of a cross marked out on the floor – perhaps the fruit represents the fruit of the passion of Christ; the receding figure of the 'Arab', the distant meeting of two people, close to a traveller with a donkey and a shepherd with sheep and goats, a centaur near a hermit's cave. The severe architecture of an

62 Giovanni Bellini, *Pala di San Giobbe*

interior has given way to a landscape which retains all of its solemnity.

Whatever the significance of the painting's individual details, it is immediately apparent that it can only be classified as one of Bellini's 'profane paintings',[9] despite the recognizably 'sacred' character of his figures. Unlike the *St Job* altarpiece, this picture could never have stood on the altar of a church. And though the purchaser of the *Sacred Allegory* is unknown, both its dimensions (73 cm × 119 cm) and its subject indicate that it can only have been made to adorn a 'private house', a record of a personal piety that was as unintelligible to the majority of observers then as it is today. The sacred subject has been wholly assimilated and is reworked into a framework of private devotion.

Giovanni Bellini was not the inventor of this mode of composition. In the notebooks of his father Jacopo (in the Louvre) there is a Nativity that is turned to show a lateral view and set in a landscape in the same way. On another page of the same book is an Adoration of the Magi where the subject is hardly recognizable, lost in an immense landscape and a throng of figures.[10] Such an Adoration could certainly never have found its way to the altar of a church, and for the same reason had to stay in the sketchbook. But this was no longer the case by the time of Giovanni Bellini and the *Sacred Allegory*: drawings which earlier had merely been artistic experiments in the uninhibited pages of a sketchbook could now be translated into a more institutionalized form, and take on the colour and shape of a painting. But a painting of this kind must be imagined in the house of a nobleman and not in a church.

At the end of his life, then, Giorgione could display a greater daring when he introduced a similar compositional schema into a religious painting: he conceived for the altarpiece of San Giovanni Crisostomo in Venice (which after his death was entirely carried out by Sebastiano del Piombo) a 'sacra conversazione' turned round through 90°(63).[11] It was a model that became universal after Titian adopted it in the *Madonna dei Pesaro* in S. Maria dei Frari (64), painted between 1519 and 1526.[12] The lateral composition had now made its way from Bellini's 'delicate' and profane *Allegoria* to the altars of Venetian churches and was repeatedly used throughout the sixteenth century; nevertheless it continued to arouse the bewildered disapproval of those clergy who kept a close eye on the 'efficacy' of sacred images in the education of the faithful. In his *Discorso intorno alle immagini sacre e profane* (published in Bologna in 1582) Cardinal Gabriele Paleotti deplores the 'ill-proportions' of

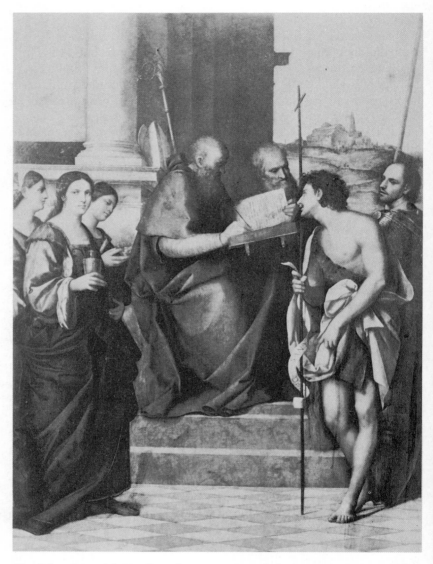

63 Sebastiano del Piombo, altarpiece painted from an idea by Giorgione
for the church of San Giovanni Crisostomo in Venice

compositions where 'the painter does not apportion space to his
subjects according to their status and dignity, and places figures
which should be in the centre at the sides'.[13]

But 'turning' a 'sacra conversazione' round to its side was not
Giovanni Bellini's only means of attenuating the subject of a religious

64 Titian, *Pala dei Pesaro*

painting destined for a gentleman's abode: he had another strategy, the results of which may also never have held pride of place on the altar. His *St Francis* in the Frick Collection (18,19) – which Titian quoted almost exactly in the Pesaro altarpiece – reveals the same desire to tone down the subject but the means are profoundly

different. The saint's stigmata are almost erased, and the fiery presence of the Lord is reduced to a kind of dawn light in one corner of the painting; lastly, he dispenses completely with the requisite figure of Brother Leo that contemporary iconography had led to expect, in the role of witness to a miracle who could testify to the Christian people and thus render that miracle incontestable. Bellini's St Francis stands alone before a God who is the painting's whole light; he demonstrates not a well expounded miracle but a privileged contact with Christ, in his passion and love, with no other witness than himself.

The new taste of the clientele at this time (probably around 1490–1500) already required 'greater delicacy' from artists in tackling religious subjects that were destined to be the 'decoration of private houses', covering them with a veil of subtlety and allusion and lifting private devotion to a level of greater sophistication. Perhaps for the same reason Giorgione's paintings, as Taddeo Albano noted when he wrote to Isabella d'Este a few days after the artist's death, 'cannot be sold at any price, for those who had them made wished to enjoy them for themselves alone'.[14]

III

With *The Three Philosophers* in Vienna, Giorgione (and his patron) challenged the wits of his observers first by selecting a single event from the whole story of the Magi and then further by choosing one that was very rarely portrayed. But even this was not enough for, as the X-ray shows, he changed the colour of the black king and thus obscured not just an interpretation of the scene but the identity of the characters. According to one scholar (G. M. Richter), the Moor's colour was altered because Giorgione had changed his mind and he wanted to make it clear that the philosophers were *not* the Magi. Another scholar (C. Gilbert) held that since the figure of the Moorish King was rare in Italian tradition, Giorgione eliminated him because he wanted to make it clear that the three philosophers *were* the Magi.[15] His intention was more probably that *only a few* observers should be able to identify the three Magi as protagonists, to recognize the story and understand the real meaning of the painting. Just as only the Magi were able to discern the light in the depths of the cave and interpret it correctly, recognizing the sign of God's presence in the world, so only Giorgione's patron and the most 'ingenious' of his friends would be able to perceive the painting's hidden subject. For us, the more hurried and careless observers of today, this was revealed by an X-ray.

This *pentimento* has handed down an impression of the two different stages of conception, where the subject is hidden even deeper in the final version than in the first. With *The Tempest* we can just make out a single fragment of the 'first version' and even that is surrounded by uncertainty. Nevertheless, the painting as it now is follows the same principles as *The Three Philosophers*: a choice of unusual iconography followed by attenuation of the subject by replacing the too-explicit figure of God with a thunderbolt. The serpent is hardly visible, like the light from the Magi's grotto. The earthly paradise in the background could be taken for any other city, and the broken columns for some sort of ruin. And Adam and Eve for a 'soldier' and a 'gypsy'. Lending itself readily to any interpretation and the 'opinions of many people', the painting would have been admired by Augurelli and those like him who delighted in art that strove for a code of iconographic ambiguity, and served the private learning of the few people who could understand it.

Though the general culture had begun to breathe a secular air, nourished by its assimilation of classical antiquity, still tradition and personal sentiment could demand a religious painting to decorate a private house. But a painting that repeated the same familiar schema of pictures for the interiors of churches would have been cumbersome to someone who delighted in strange mythologies and who adopted the symbols and allegories of the classics to reflect his own state. If a 'perceptive and inventive' gentleman wished to express a part of his personal feelings through a painting, the danger of placing himself on a level with the uneducated class could only be overcome by veiling and obscuring the subject, as Giovanni Bellini did with the *Stigmata of St Francis* and the *Sacred Allegory* and, more radically, Giorgione with *The Three Philosophers* and *The Tempest*.

Artists, then, had to avoid incurring the displeasure of the learned client, for a religious painting could associate him with the ignorant masses. This was achievable by 'secularizing' the subject to some degree, a process which is perhaps most clearly exemplified by the use of natural light to represent supernatural events: the bright but barely perceptible rays that dazzle St Francis and imprint the stigmata on his body; the reflection of the predicted star under the intent gaze of the Magi–astrologers; the thunderbolt of *The Tempest* which darts through the clouds with a distant and inescapable force like the voice of God. But in *The Three Philosophers* the supernatural meaning of the natural light of the star is revealed by man through his own means – astrology and the exegesis of prophecy; whereas in *The Tempest* the meaning of the natural phenomenon (lightning

representing God) is mediated through entirely profane elements: lightning–Jove and the wisdom of Horapollo.

Thus, for most people, the painting becomes less intelligible (*St Francis* and *The Three Philosophers*) or utterly unintelligible (*The Tempest*). The religious theme is divested of the story which had given it a place in the heritage of the Church, and is rearranged in an entirely new dimension: an elitist and personal sense of refined, solitary *private piety*. The artist thus preserves the traditions and culture embodied in a religious painting in an altered state, which has assimilated the private world of his patron. And it is his ability to select a theme and pursue it to the end that gives the subject its special importance. By adapting the painting to the taste of one man, and camouflaging its meaning from general view, the painter isolates it from the large mass of religious subjects and shifts it to the realm of an individual, inner experience. Hanging on the walls of 'private houses' even religious paintings could carry personal, and topical, references.

IV

Michiel saw three paintings by Giorgione in the house of Gerolamo Marcello: a portrait of the head of the household, a St Jerome reading (now lost), and his *Sleeping Venus*, now in Dresden (5).[16] The relationship of the portrait of Gerolamo Marcello to the painting of his eponymous saint is very close, all the more in that, like the portrait, St Jerome was drawn *insino al cinto* – 'down to his belt' (i.e. half-length). Similarly, in the house of Gabriele Vendramin there was a portrait of Antonio Siciliano and of St Antony, both by a 'master from the west', meaning 'Flemish'. And in the house of Giovanni Ram was Titian's famous painting (58) where, next to St John baptizing Jesus, is a figure 'with his back to the spectator': his patron, who bore the name 'John'.[17] His hands are not joined in prayer, as the unbroken tradition of devotional and consecrational figures required; he stands as though facing a stage, with the left hand placed on the same rock where Christ has cast his robe, no longer worshipping but an active onlooker to the sacred event.

Nor was the *Sleeping Venus* in Marcello's house simply a 'mythological' painting, and even less 'just a pretext for painting a nude'.[18] Ignoring the complex interpretations invited by its vivid colours and the novelty of its theme, we can trace allusions in the painting that are rather more personal. No-one familiar with the *Aeneid* could be unaware that Venus was the mother of the Julian race and of Augustus: and the Marcello family of Venice prided

themselves on being of Augustan stock, through the emperor's nephew Marcellus. The blood-tie which joined family history to the noblest episodes of a revered antiquity was made explicit in the funeral oration for Jacopo Marcello, delivered to the Venetian senate by his son Pietro. At that time Gerolamo, nephew of Pietro, was ten years old.[19] Thus, thanks to Giorgione's pictorial skill, even a well-known mythological figure was endowed not only with a new significance but an enriching, personal reference that brought her firmly into the present. In the house of the young Marcello Venus and St Jerome have the same function: they bear memories of the past and hopes or guarantees for the future.

The emotional identification of patron with painting is at its strongest in Giorgione's self-portrait, described in the 1528 inventory of the Grimani collection as 'a portrait of Giorgione by his hand for David and Goliath'. The overall appearance of this painting (though turned to back to front) was handed down through an engraving by Wenzel Hollar (1650)(65), with an inscription that tied up with Vasari's reference to a self-portrait by Giorgione in the house of the Grimani family (1568). The canvas in the Herzog Anton Ulrich Museum (66) is most probably original, as C. Müller Hofstede maintains,[20] even though the lower part with Goliath's head has been removed, just as Coriolano had removed it in the engraving for the Vasarian edition of 1658. After it left the small circle of Venetian nobles who could perceive its meaning, the portrait lost its most characteristic feature. For in this painting, which we might imagine Giorgione painted for himself, he has assumed the same attitudes as his aristocratic clients and (if Vasari is to be believed) friends.[21] A self-portrait as David was certainly no masquerade and much more than a pleasing joke. In his identification with a biblical character Giorgione must have wished to give an image of himself that was veiled by allusion to the Scriptures, yet clear enough to an observer of wit and 'inventiveness'.

A few years earlier, in 1501, Michelangelo had written a proud hendecasyllable next to his preparatory drawing for his bronze *David*, 'David with the sling and I with a bow', followed by his signature 'Michelagniol'. It was an identification that went well beyond the intentions of his patron Pierre de Rohan[22] and the artist's heroic sense of his youthful strength was destined to remain among the pages of his personal notes. Giorgione, unlike Michelangelo, dared to identify himself with David in a painting, with Goliath's head as 'hieroglyph' of victory attained. The decapitated head of Holofernes at the feet of Judith—Justice in the frescoes of the Fondaco dei Tedeschi was the work of Titian, as we have already seen, but

65 Giorgione, *Self-portrait* (engraved copy by Wenzel Hollar)

Giorgione also used this motif in his famous *Judith* of Leningrad. The illustrated inventory of Andrea Vendramin's gallery[23] includes a David and Goliath by Giorgione and we may surmise that he painted more than one.

The Brunswick portrait, however, does not reveal a hero exulting in his great victory. Giorgione appears the young victor, like David, but in the grip of a deep melancholy. He seems to draw his head sharply up and back as though to avoid the sight of the gruesome trophy of his exploits. It is perhaps impossible to venture further into Giorgione's intentions without the original documents or texts to help us. But his self-projection in the figure of David was not

66 Giorgione (?), *Self-portrait*

only a way of suggesting a model of comparison with himself and his own capacities; he was also bringing the figure of a young man of royal destiny out from the Bible story and the silent images of medieval painters and into the heart of sixteenth-century Venice. The use of his own appearance fulfilled the task of restoring complete reality to a worn-out theme.

V

The contract which commissioned *The Tempest* (if it ever existed at all) is now lost, but Ferriguto was very probably right when he identified the patron as Gabriele Vendramin, in whose house Michiel saw the painting in 1530. Like Gerolamo Marcello and Taddeo Contarini, Vendramin belonged to the Venetian nobility, and was just slightly younger than Giorgione (he was twenty-six in 1510).

Ferriguto must have been on the right track when he connected these three names to Vasari's testimony of Giorgione 'playing and singing so divinely that he was frequently invited to musical gatherings and meetings of noble persons'.[24] It was certainly not his own whim that Giorgione wished to mix with 'noble persons' through his music and song: this is demonstrated by an unusual Concerto by Lorenzo Costa, painted just before 1500. Here the singers, including the painter, pay homage to a gathering of the younger members of the Bentivoglio family, all sons of Giovanni II the lord of Bologna and each, like Costa himself, indicated by name.[25] For Lorenzo Costa, as for Giorgione, taking part in the 'music recitals', the exclusive entertainments of the aristocracy, was a natural consequence of the painter's relationship of familiarity with his customers.

In the *Venetia città nobilissima, et singolare* by Francesco Sansovino there is a more precise record of the part played by Gabriele Vendramin as the centre of one of these 'gatherings': Palazzo Vendramin, he reported, 'was once the meeting place of all the flower of the city. For here had lived Gabriele, who so loved painting and sculpture and architecture that he had many ornaments and he collected many works by the most famous artists of the day . . . by Giorgione of Castelfranco, Giovanni Bellini, Titian and Michelangelo and others which are preserved by his heirs'.[26] At the age of thirty-three Gabriele Vendramin must have earned his epithet '*el grando*' ('the great'), as recorded by Marin Sanudo in his *Diarii*,[27] not so much for the high offices he held as for the nobility of his dogal family, the wealth of his flourishing trade activities, and the magnificence of his private life. Alternating between his business as merchant with an assiduous attention to the collection of art and antiques, his life seems to have been lost among the great crowd of nobility of a long-dead republic; but we can retrieve it through another image left to us by one of the last Dogi in 1752,

Marco Foscarini. In a portrait of the glories of the *Serenissima* he named Gabriele Vendramin as one 'of those many Venetians who gave medals from their own museums to Vico and Goltz, when they were collecting a great quantity to be exhibited'.[28] Indeed, in 1555 Enea Vico cited Vendramin among the Venetian *'anticarii'*, or antique collectors, and later Hubrecht Goltz recorded the 'heirs of Gabriele Vendramin' among the 'owners of venerable antiques'.[29]

One of the scenes in *I Marmi* by Anton Francesco Doni is set in Palazzo Vendramin for much the same reasons, and is the only page where the author's eccentricity gives way to unreserved respect:

> Messer Gabriele Vendramin was a Venetian gentleman of true courtesy, natural nobility and admirable intelligence, manners and goodness. When on one occasion I visited his marvellous collection, among which were divine drawings that his generosity had bought with great expense, and care and ingenuity, we went together to look at his rare antiques. And among other objects he showed me a Lion with a Cupid on its back and we talked at length of the pleasing invention of the piece and we praised it for demonstrating that Love can conquer men's fierce and terrible nature.[30]

The great collector displayed a surefooted taste in his collections of sketchbooks (especially of Jacopo Bellini) as well as of paintings and he would renew and increase his pleasure in his collection by discussing the true meanings of the 'inventions' of the marbles and paintings. The 'work of art', in this 'meeting-place of the flower of the city' is not just an object of aesthetic contemplation: interpreting its meaning is an essential part of the pleasure of possessing it.

We have a picture of Gabriele Vendramin at the age of sixty-three in Titian's magnificent painting in the National Gallery in London (67).[31] Here the grand old man, surrounded by his family, rests his left hand on an altar – repeating the gesture of Giovanni Ram in the *Baptism*. The cross before which the family kneels is the same as the one that appears in the *Miracle of the Cross* by Gentile Bellini in the Accademia in Venice (68). It contains the relics of Christ's cross and may still be seen today in the Scuola of San Giovanni Evangelista. The swimmer in the centre of the painting who holds the cross before him is Andrea Vendramin: as Guardian Grande of the School, he alone had the miraculous power to salvage the cross from the bottom of the canal where it had fallen. This miracle occurred between 1370 and 1382, and was recalled by Gentile Bellini in 1500, when Gabriele Vendramin was sixteen years old.[32] The two paintings by Bellini and Titian, one painted near the beginning

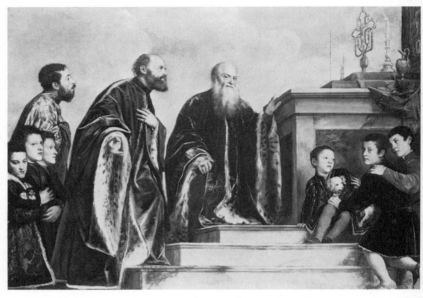

67 Titian, *The Vendramin Family*

and the other towards the end of Vendramin's life, thus constitute
a double reflection of family piety, and at the same time introduce
the relics of the Holy Cross into family history. The evocation of
an ancient sign of divine favour was a reminder to themselves, and
to others, of the greatness of their lineage, and equally a further
entreaty to God for his blessing.

 The items in Gabriele Vendramin's collection lead us to the more
possessive and individualistic elements of his character. Michiel gave
an incomplete list of these items, as they were in 1530: books of
drawing, statues, paintings, among which was the 'little landscape
with a storm . . .'. An art collector himself, though less refined,[33]
Michiel and his hurried list are not the best means to convey an
idea of Gabriele Vendramin's taste. For this we must turn to his
will, drawn up on 3 January 1548, four years before his death (apart
from a codicil that was added *in extremis* on 15 March 1552, two
days before he died, and witnessed by Titian and *Guglielmo quondam
Giovanni depentor*, 'William, son of the late messer Zuane, painter'.
Here he exhorted his heirs, the six sons of his brother Andrea, that

 in the course of your lives you should follow those three things
 through which you can glorify your family and your country. The

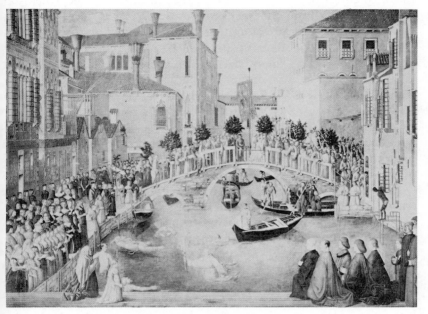

68 Gentile Bellini, *The Miracle of the Cross*

first is that you master navigation and that you put all your mind to
the study and mastery of naval warfare; the second is that you do
not abandon the study of letters; the third is that you take up the
trading of merchandise and never leave debts unpaid.

He went on to state that 'he had in one of his own chambers and
outside that chamber many pictures in oil and gouache on wood
and canvas, all by the hands of excellent men, that were of great
worth and should be highly valued'. And he continues:

> I will not hesitate to say that all these things are so pleasing and so
> dear to me, for their rare quality, and for the many hard years that
> I toiled to acquire them, and mostly because they have been the things
> that have given a little rest and quiet to my soul from the many
> labours of body and mind that I suffered in the affairs of the family;
> and for this reason I beseech and pray those who will inherit the
> aforesaid things that they will use them with such care that they do
> not perish . . . that they may not be sold, nor lent neither in whole
> nor in part under any form.[34]

'So pleasing and so dear' were Gabriele Vendramin's paintings and
so spiritually bound to them was he, as to a haven of peace amidst

the wranglings of 'family business', that his wish to keep them all together in his 'little chamber' was evidently taken most seriously by his heirs. Despite pressure to sell from a potential buyer such as Albert V, Duke of Bavaria (to which Luca Vendramin initially agreed), the brothers finally decided to 'block' the collection, and a detailed inventory was drawn up between 1567 and 1569 by a commission of artists (including Tintoretto, Sansovino, Tommaso da Lugano, Alessandro Vittoria and Titian's son, Orazio Vecellio): *The Tempest* ('another painting of a gypsy and a shepherd in a landscape with a bridge, in a walnut frame with intagli and gilt paternosters') is listed in the *camera per notar* – in Gabriele Vendramin's study.[35]

Bearing in mind the portrait of the old gentleman, painted by his friend Titian in the same year as his will, where he so clearly expresses both the 'labours' of old age and an air of unequivocal authority (69), we will not be surprised to learn that his grandchildren were obedient to his wishes. Sixty years later Vincenzo Scamozzi told how 'the study of the Chiarissimo Sig. Gabriele Vendramin is *still sealed, until there is one in the family who will come and take delight in it*'.[36] None of his immediate heirs, then, sought to find 'a little rest and quiet to his soul' in the paintings; and nobody saw *The Tempest* again till at least 1612, and perhaps much later.

VI

In the group of paintings we have been discussing, and in many more of the same period, the barriers that separate the fluid lives of men and the static pictorial space seem to dissolve: in the case of Gerolamo (Jerome) Marcello, by juxtaposing himself with his own saint and by fostering a privileged contact with the glories of ancient Rome through Virgil and Venus; in the case of the Vendramin family, by consecrating, through the evocation of a public miracle, the mark of God's especial blessing on the family; by entering, as Giovanni Ram does, into the pictorial space, to stand near the Baptist, no longer offerent but actor in the sacred scene, 'with his back to the spectator'; and in the case of Giorgione, by mirroring his own strengths and weaknesses in an ambivalent self-portrait as David. The purchaser's close ties to the event or the character in the painting suggest, rather than state, his privileged cultural and social status.

With a more subdued, discreet elegance, *The Tempest* brings a biblical story into the 'writing room' of a noble Venetian merchant,

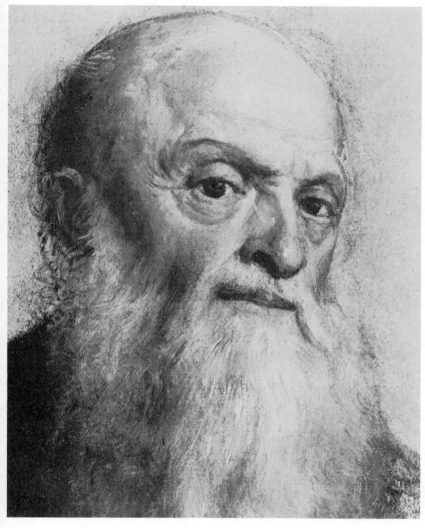

69 Titian, Portrait of Gabriele Vendramin (detail from
The Vendramin Family)

complete with 'hieroglyphs' and subtle allusions to his knowledge
of classical, secular literature. Though in no way a portrait, this
utterly contemporary Adam is nevertheless a means of stimulating
the patron, whether Gabriele Vendramin or someone else, to identify
emotionally with the picture. The voice of God reaches from the
beginning of history, down to this last Adam. But in the painting

the heavenly message has been shrouded under the same mystery that Horapollo created: for it is directed to a single Adam, both modern and Venetian, rather than to the whole of the human race.

At the beginning of the new century, the 'young' Venetians seemed to challenge the 'old' with a more daring and confident conception of themselves and the world:[37] this was the generation of Taddeo Contarini, Gabriele Vendramin, Giorgio da Castelfranco. At one extreme of the new aristocratic yet 'modern' trend was the cult of rediscovered antiquity, and at the other was an intimate and personal form of religious devotion.

Inherently opposed to the superficial nature of religious practice, this new type of individual piety had taken shape as the natural consequence of the meditations on knowledge, God and the world that had already been circulating among the scholars of Europe from the Platonic circles of Florence. Questions on divine knowledge were inextricably bound up with precepts of self-examination, and each illuminated the other with the bold and authoritative light of rediscovered classicism.

At the same time, the private devotion of the artistocrats and the language of the ancients shared the fate of being common only to a few; thus both cults could be considered to be *mysteria* that should be preserved within the select cliques of the elite. Erasmus was reproved by many humanists when, with the publication of his *Adages*, he disseminated the wisdom and spirit of Greece and Rome: 'Erasmus, you have revealed *our* mysteries!'[38] Conrad Muth (1470–1526) was another scholar who derived the underlying criteria of his philosophy from Italian neo-Platonic humanism, visible in the utterly 'Italian' cadence with which, in a letter to a friend, he praised the practice of private and individual communication with God, and inner devotion; and to his disdainful rejection of public shows of penitence and worship, he adds: 'but we know well that these are *mysteries* that we should not divulge but should rather suppress with silence, or, if we do wish to divulge them, they should be veiled in a story or a riddle: let us not cast pearls before swine'.[39] The words of these northern humanists clearly demonstrate their consciousness of belonging to a small and exclusive world of 'initiated' men. The 'swine' of the Gospel are identified as the multitude ignorant of the classics and incapable of an entirely inner faith in God.

In the search for its own reflection in classical mythology, this new awareness of self and the world would in some instances assume the face of Prometheus. It was in this sense that Pietro Pomponazzi

'tells us of the fettered sage who lifts his rebellious brow to the god
who punishes him for the good he has done: but the sage does
not tremble before the thunderbolt that will annihilate him.'[40]
'Prometheus is truly the philosopher who is tormented by ceaseless
cares and thoughts in his search for understanding the mysteries of
God; he knows neither hunger nor thirst, nor sleep, he neither eats
nor spits, he is ridiculed by everyone . . . to the common people he
is a figure of fun.' In stealing the fire of the gods and making men
of clay Prometheus provided a proud image of man, as discoverer
of nature and demi-god.

The figure of Prometheus encapsulated the 'pagan' dimension of
man's primordial existence and as such became naturally linked to
the figure of Adam. Conversely, Augustinian doctrine on original
sin and grace had painted an image of the latter that was not bound
by guilt and divine punishment but, on the contrary, exuded free
and untainted humanity and promises of salvation. In a *Quaestio*
upon Adam and Eve that was widely known and read (not least
because it was falsely attributed to St Augustine), the name of the
Progenitor is associated with ideas of inner renewal (*renovari,
reformari, renasci*), defined as the return 'to the pristine state of
Adam'. Thus, as the archetype of uncorrupted human nature before
the fall – free, noble and wise – Adam could simultaneously be
considered a model for the *homo spiritualis* whom not only God's
grace but his own strength of mind had renewed with a higher
wisdom. For the same reasons he was *homo interior*, in contrast to
the outward demonstrations of the common people.[41]

The finest testament to these ideas and reflections on Adam is
without doubt a passage from the oration *De hominis dignitate* by
Giovanni Pico della Mirandola (1487), first published in Bologna in
1496 and in Venice two years later. God himself addresses the first
man:

> We have given thee, Adam, no fixed seat, no form of thy very own,
> no gift peculiarly thine, that thou mayst feel as thine own, have as
> thine own, possess as thine own seat, form, the gifts which thou
> thyself shalt desire. A limited nature in other creatures is confined
> within the laws written down by Us. In conformity with thy free
> judgement, in whose hands I have placed thee, thou art confined by
> no bounds; and thou wilt fix limits of nature thyself. I have placed
> thee at the center of the world, that from there thou mayst more
> conveniently look around and see whatsoever is in the world. Neither
> heavenly nor earthly, neither mortal nor immortal have We made
> thee. Thou, like a judge appointed for being honourable, art the

molder and maker of thyself: thou mayst sculpt thyself into whatever shape thou dost prefer. Thou canst grow downward into lower natures which are brutes. Thou canst again grow upward from thy soul's reason into the higher natures which are divine.[42]

The Adam who listens to these words is not just the first man of the human race: for Pico, by giving this noble, resonant speech to God himself, was asserting the dignity of all men, of every Adam. The knowledge that grace was restored by the redemption allows him to keep silence on the question of original sin. More mischievous though far less daring than Pico, Erasmus's Cain addressed the angel who guards the gates of Eden in the words of a good-natured Prometheus:

Do you find it pleasant to stand there by the gate with a big sword? We have just begun to use dogs for that sort of work. It is not so bad on earth and it will be better still; we shall learn, no doubt, to cure diseases. What that forbidden knowledge matters I do not see very clearly. Though, in that matter too, unwearied industry surmounts all obstacles.[43]

Man, then, is the 'molder and maker of himself', a Prometheus engaged in exploring the world and shaping his own inner life. But the Adam of *The Tempest*, as in Pico's vision, does not raise his eyes to God's thunderbolt in rebellion. Instead, in this portrait of the beginning of human history, after the expulsion from Paradise, he is surrounded with 'hieroglyphs' that map out the boundaries of his destiny – work, suffering, sin and death. Listening to the burning voice from heaven, consciousness of self seems to translate above all into a meditation of man's place in the world. We can imagine the voice of God addressing Pico's words to this pensive Adam, seemingly lost in a noble melancholy: for his clothes make him contemporary with Pico and Giorgione. His meditative expression leads the observer to search out the hidden presences in the light and shadow of the painting, and seems to express the unshakeable weight of the rebuke set down in the Bible. It arouses not terror but a lingering, elegiac sadness, in which yearning for heaven mingles in equal measure with a love for the world.

VII

Many of the younger Venetians of this period were to conform to this image of piety, which placed spiritual renewal firmly at the centre of every form of active life: a few of them were the

Camaldolensians Paolo Giustiniani and Pietro Querini, the future cardinal Gasparo Contarini, and Niccolò Tiepolo.[44] Intellectual debate among these young Venetians was quickened by heated comparisons between contemplative and active life, between avid reading of the classics and meditation on the Scriptures, between an inherited image of the world and a spate of new and unexpected discoveries. This is particularly evident in the letters of Gasparo Contarini, which are well known from about 1511. Their tone is one of dignified respect mingled with intense affection; taken together, the letters give a sense of a 'courtly', aristocratic intimacy that also displays the unerring self-awareness of an 'elect' society. Thus, be it a discussion of religion or of a personal decision, the analysis of himself and his friend is clear and contained; and his profound self-awareness gives rise to that austere yet tolerant view of the world that was to bring them to the fore in the years of disputes with the Protestants.

Among the forgotten papers of Robert Eisler – 'outsider' to the academic world – is the fascinating suggestion that *The Three Philosophers* was 'probably painted for Gasparo, card. Contarini (1483–1542), named *Gasparo* after one of the three Magi'.[45] We would like to be able to believe this hypothesis, despite the fleeting and unsubstantiated way it was proposed.

'He was called Gasparo through his mother's piety; for seeing that none of the sons she had born until that time had lived, she made a vow on the instruction of some other women to call her next born by one of the three Magi who came from Persia to pay homage to Jesus Christ born in Judea'.[46] Moreover, according to Carlo Ridolfi, in a canvas begun by Giorgione and finished by Titian that hung in the hall of the *Maggior Consiglio*, one of the figures in the train of Pope Alexander III was Gasparo Contarini (the painting was lost in the great fire of 1577).[47] If Eisler's hypothesis is to be believed, we would recognize the 'seated philosopher' (for by tradition Caspar is consistently the youngest of the Magi) as the young Contarini 'whose heart and mind were full of philosophy', as one contemporary described him.[48] We would envisage him during the years as a student at Padua (1501–9) (interspersed with frequent return journeys to Venice, especially after his father's death in 1502) where he was a pupil of Pomponazzi, of Federico Crisogono, teacher of astrology, and of the mathematician Benedetto Tiriaca; and where he shared a bench with Copernicus, ten years his senior. These years saw the beginning of his close friendships with Gerolamo Fracastoro and the Veronese astronomer Battista della

Torre, with whom he was later to correspond on questions of astronomy.[49] And at this time too he laid the foundations of the knowledge of astronomy that he exhibited in 1522, as Venetian ambassador to the court of Charles V. The first witness to this occasion was the official historian of the Council of the Indies, Pietro Martire d'Anghiera:[50] the *Victoria*, one of Magellan's five ships, had returned from a three-year voyage around the world. As they came on shore, the decimated crew realized with astonishment that they had 'lost one day': *'diem fuisse Mercurii arbitrantur, Iovis esse repererunt'* (they thought that the day was of Mercury [Wednesday] and discovered it was of Jove [Thursday]). The phenomenon was studied for the first time in history: and it is not difficult to imagine how the scholars who were summoned to explain it used all their powers of persuasion to convince the sailors that there was an error in their reckoning, or at the very least they had forgotten to make allowance for the leap-year of 1520. But given the unanimous agreement of the superstitious sailors, who had kept their eyes constantly on the calendar so as to observe the year's religious precepts and festivals, there had to be another explanation. The man who found it was none other than Gasparo Contarini, *'omni litterarum genere non mediocriter eruditus'* [provided with a good culture in every field]: it was that 'since the ship followed the course of the Sun around the World [i.e. since it followed a westerly course], in three years it must have done the same circuit that the Sun does in twenty-four hours'.

Given the attributes of this Gasparo, astronomer and philosopher, Eisler's proposition is certainly very tempting: the patron's emotional identification with one of the protagonists in the painting seems more tangible and direct; and, in the light of his later deeds, his many writings and his substantial personal fame, Giorgione's painting would be an early testament to the heart and mind of a man who in other respects is already a very real figure. Those interpreters who see a Copernicus in the figure of the youngest philosopher may be given the simple riposte that he was a fellow student.

But the fact that Gasparo belonged to the same family as the Taddeo Contarini who housed the painting in 1525 is certainly not a definitive argument in support of Eisler's hypothesis. The Contarini family was perhaps the largest and most diversified of all the Venetian nobility, and at that time the various branches were already so separate that in most cases they may be said to be connected by a common surname rather than by kinship. After disentangling the complex genealogies, the first question to ask is therefore: who was

Taddeo Contarini? Everyone supports Ferriguto's theory (1926) as though it were the only possible answer – a young noble of that name born in 1478.[51] But Sanudo's *Diarii* list three if not four Taddeo Contarini in Venice in the same years as Giorgione. Of these, Taddeo son of Andrea appears with some regularity between 1503 and 1509, but he died in 1510 and was therefore off the scene in 1525, when Michiel saw *The Three Philosophers*.[52] Taddeo son of Sigismondo (suggested by Ferriguto to be the owner of the painting in 1525) was castellan of the port of Legnago in 1509, which he left with the arrival of the imperial armies (VIII, cc. 276, 366, 442). He became a 'gentleman stripped of his status, that is to say, of his regiment' in the war (VIII, c. 465), and attempted to gain some sort of position in the defence of the *terrafirma* (IX, c. 561; X, c. 796; XVII, c. 391; XXIII, c. 259: years 1510–16). In 1524 his fortunes were in such dire straits that he decided to 'defer payment of (his) debts for two years' (XXXVI, c. 618); he died in 1527.[53]

Far more interesting and varied was the career and indeed the character of another Taddeo Contarini: this was Taddeo son of Nicolò, son of Andrea *dal naso*, 'of the nose' (X, c. 44), nicknamed *el richo*, 'the rich', in a document of the very year 1525 (XXXVIII, c. 153) (perhaps to distinguish him from the debt-ridden Taddeo son of Sigismondo). His life followed a typical, though not especially brilliant, *cursus honorum: Procurator di le biave in padoana*, 'Procurator of Fodder in the Paduan region' in 1497 (I, c. 508), member of the *Consiglio dei Pregadi* in 1510 (X, c. 57), Administrator of Trade in 1517 (XXV, c. 110). In 1527 he took part in the *Scrutinio di tre Savi del Conseio di Zonta*, the 'examination of three learned men of the *Consiglio di Giunta*' (XLV, c. 451) and was so much in the public eye at that time that twice Marin Sanudo expressly records his presence at the *Maggior Consiglio*, because 'he did not usually attend' (XLV, cc. 483, 560: year 1527). Listed among 'four from Ca' Contarini, all of great wealth', his riches were founded on trade by sea, with Syracuse, Corfu, Cyprus, Jaffa and Syria (V, c. 441; VI, c. 23; cfr. X, c. 644; XXXIII, c. 612). His ships carried wood (XIX, c. 357), 'cloth of gold, and silk, of great value' (XXVII, c. 237) and also pilgrims to the Holy Land.[54] He also had an interest in the wheat trade (XXIX, c. 495) and meat supplies (XXXVIII, c. 153; XLI, cc. 74 and 628; XLIII, cc. 79 and 377), and his name appears on several occasions in the registers of compulsory loans to the Venetian Republic, next to considerable sums of money.[55] Between 1511 and 1519 he was one of a group

of Venetian nobles who pledged themselves as guarantors to Agostino Chigi for the sale of an enormous consignment of Tolfa alum to the Republic.[56] In the Fondaco dei Tedeschi in 1514 he came upon a letter, brought by a merchant from beyond the Alps, containing details of the movement of the imperial army (XVII, c. 506), and immediately warned the Signoria; the same thing happened again in 1524, when a letter from Syracuse warned him that the Turks were approaching Valona (XXXVII, c. 375). In 1523, the inaugural ceremony of the new Doge Andrea Gritti provided a public showing of his immense wealth and high social standing: Taddeo Contarini, son of Nicolò, appeared among 'the relations of the Doge, dressed in silk, velvet, damask and scarlet' (XXXIV, c. 159), as was Gabriele Vendramin (though not the other Taddeo). But he must have been a closer relation to the Doge than Vendramin, since, in 1527, he was removed from the list of eligible Venetians by a commission 'who wished to humiliate the Doge' (XLVI, c. 26).

If there was a Taddeo Contarini to talk about in Venice in 1525, it can only have been this one. And the paintings that Michiel saw in his house (two by Giorgione, two by Giovanni Bellini, two by Palma il Vecchio, one by Romanino and one by a Milanese painter) were by no means the only objects to provide him with 'rest and quiet for the soul' among his frequent public services and his trading affairs. The entry in the 'Registri delle Terminazioni della Procuratia de Supra' on 1 August 1524 shows that Taddeo Contarini, son of Nicolò, borrowed four manuscripts from the Marciana: two by Galenus, Appian's *History*, and Philo Judaeus.[57] They were collected by his son Pietro Francesco, who later became *Riformatore* of Padua University, and was Patriarch of Venice for just over a year (1554–5).[58] A letter written in 1517 from Pietro Bembo to the librarian at St Mark's, Andrea Navagero, records that a 'book of Homer, with the commentary all around the text, old but of good paper' had been lent to 'Hieronymous son of Thadius Contarino'.[59] Titian must have visited his house, if he took the *St Francis* by Giovanni Bellini (18) that hung there, for his own Pesaro altarpiece, painted between 1519 and 1526 (64).

Taddeo son of Nicolò Contarini was probably born around 1466 and died on 11 October 1540.[60] Sadly, his will has not survived, but we know the site of his grave from the will of his son Dario: 'I wish to be buried in the church of Madonna Santa Maria dei Miracoli where my father was buried before me . . . and I wish my tomb to be made in front of the altar that my father once had made in this church'.[61] The altar and the tomb no longer exist in Santa Maria dei Miracoli. But by far the most surprising revelation among

the documents of Venice's State Archives is the marriage, in 1495, of Taddeo Contarini with Maria, daughter of Leonardo Vendramin, and sister of Gabriele.[62] The owner of *The Tempest* and the owner of *The Three Philosophers,* described in Michiel's notes, were not only 'relations of the Doge', and among the wealthiest and most influential of the Venetian nobility, but were closely related to each other as well.

We know from an addendum to the tithes of 1514, as well as from the *Necrologio dei Nobili,* that Taddeo Contarini lived until his death in the parish of Santa Fosca. His house was therefore the gothic Palazzo Contarini, afterwards Correr, that stood on the Strada Nuova (Cannaregio 2217).[63] A little way on, crossing the *rio* of Santa Fosca by the bridge of the same name or by the bridge that is still called Vendramin, is a *palazzo* in a graceful Lombard style (Cannaregio 2400), the abode of Gabriele and *The Tempest.* Close by is the now deconsecrated church of Santa Maria dei Servi, burial place of the Vendramin.[64] Thus Giorgione's two most certain works are united in an even stronger relationship: *The Three Philosophers* and *The Tempest* dwelt with Taddeo Contarini and Gabriele Vendramin in neighbouring *palazzi.* And we can more easily imagine the 'meetings of noble persons' that Vasari refers to, with Giorgione, Gabriele Vendramin and Taddeo Contarini; Taddeo had only to go a short way to visit Gabriele in the house that was the 'meeting place of the flower of the city'.

Of all the various branches of the Contarini family, the future cardinal Gasparo belonged to the same line as Taddeo, though their relationship was only that of distant cousins. His house stood in the same *sestiere* of Cannaregio, though in a different parish.[65] But although he bore the name of one of the Magi, and despite the attraction of his extraordinary personality – astronomer, philosopher and theologian – there is not sufficient evidence to connect him with Giorgione of *The Three Philosophers.* The hypothesis that the painting was done for the young Gasparo and then, once his brilliant diplomatic and ecclesiastical career took him from Venice, given or sold by him to Taddeo, is too uncertain to be acceptable. It is more likely that Taddeo Contarini son of Nicolò – brother-in-law and neighbour of Gabriele Vendramin, merchant and humanist, interspersing his responsibility for a powerful family business with readings of Homer and Philo, and bringing up his sons on classical literature – was not only the owner of *The Three Philosophers* in 1525 but also the man who commissioned the painting.

Perhaps we may simply call on the young Gasparo Contarini as a witness to that state of inner apprehension that was aroused, with

Figure 2 Map of Venice, detail (drawing by Mario Epifani)
1 House of Gabriele Vendramin, owner of *The Tempest*; 2 House of
Taddeo Contarini, owner of *The Three Philosophers*; 3 House of Gasparo
Contarini; 4 Former parish church of Santa Fosca; 5 Former church and
convent of Santa Maria dei Servi. A: House of Gerolamo Manfrin (known
today as Palazzo Venier), where *The Tempest* was kept from the end of
the eighteenth century until 1875; B: Palazzo Giovanelli, where *The Tempest*
was kept from 1875 until 1932

a passionate sincerity, by the call of secular culture in opposition to
the ideal of religious life. In letters written in 1511 and just
afterwards, to his friend Paolo Giustiniani who had just entered the
monastery at Camaldoli, he wrote:

> My life and being are now immersed in study, for I am trying to finish
> with these worldly studies so that I may move on to those to which I
> propose to dedicate myself forever . . . But I find my soul often troubled
> with different anxieties, now of one kind and now of another, and my
> thoughts cannot formulate a way of living that appears to give me
> peace, or at least less anxiety. In this way of life I find one kind of
> anxiety and in another a different one, so that I am afraid.[66]

But so strong is the pull of the 'worldly study' that the proposition to dedicate himself to the Scriptures is not realized: 'I am finally persuaded that [the Highest God] has given my soul an inclination *to descend*, as though I am unworthy of His greatness, and I think that I must be content with *that morality that gave the philosophers to see with a natural light*, which is also God's great gift'.[67]

VIII

Giorgione, writes Vasari in the first edition of the *Lives* (1550), 'had learned without the modern style' from Giambellino; but in the second edition (1568) he says he 'competed with the Tuscan masters, the authors of the modern style';[68] yet in his *Life* of Sebastiano del Piombo he attributes Giorgione with introducing Venice to 'a more modern style, more harmonious and the colours better toned'.[69] Giorgione, then, had *his own* 'modern style', which was somehow different from that of Tuscany and surpassed the 'hard, dry and laboured' style of Giovanni Bellini that was explained by his 'not having studied antiquities'.

The fame of Titian, and a new consciousness that Venetian painting was developing its own characteristics, stimulated critics to find a definition for Giorgione's style. Perhaps the most lucid statement on this by Vasari is contained not in the *Life* dedicated to Giorgione but in his 'Description of the works of the painter Titian of Cador'.[70] 'Being dissatisfied with the methods then in use [Giorgione] began to give his pictures more softness and greater relief. Despite his development of a fine style, however, Giorgione still used to work by setting himself in front of living and natural objects and reproducing them with colours applied in patches of harsh or soft tints according to life; he did not use any initial drawings.' The principal feature of Giorgione's style is indicated as the contrast between 'harsh' and 'soft', rearranged in a balanced colour scheme of both 'softness' and 'relief', where 'living and natural objects' are introduced into the painting with no initial drawings. Nature, seen through Giorgione's eyes, was colour; and by dispensing with the drawing stage his paintings acquire 'a tremendous impression of movement achieved through the finely handled use of shadow'. For this reason, 'many of the great artists of his time admitted he had been born to infuse life into painted figures';[71] 'it must be admitted that those brush strokes of his are *pure flesh and blood*, but so easy and mellow that they are no longer an invention of art but true life'.[72]

Encapsulating the essence of reality with a blend of colours that is immediately true; removing the outline which would 'fix' his figures to the background and instead suspending them among delicate, moving shadows: Giorgione's style was also a way of shaping the painting to suit the sophistication of his ideas – 'for which I would certainly number him among those few men who can express their thoughts through painting'.[73] 'All the Ideas of this Painter are grave, and lofty and full of many considerations . . . the true Idea of men's actions'. 'It can well be believed that to painting Giorgione was as a new John Gutenberg, the inventor of the letter Press which eased the long and wearisome labour of writing . . . On the brow of Painting he has placed such a pure and shining diamond that it dazzles all who see it.'[74] 'He knew how to give light to shadows which would naturally be sharply defined, and above all he handled objects in shadow with· great freedom, sometimes using his ingenuity to give them greater force than in real life; and sometimes making them softer and lighter by melting them together and shading them, so that parts of these areas would hover between the seen and unseen, and *this would create a certain greatness of style in the eyes of each observer, though the reasons were understood by only a few*.'[75] In Zanetti's appraisal, which eloquently condenses all previous critical judgements on Giorgione, the chief characteristic of the artist's style is its aristocratic exclusiveness of the general observer. His paintings might appear natural, though vivid, but they had a richness and brilliance that was 'greater than real life'; rather than a 'new Gutenberg', inventor of an 'easy' method, he was a tireless hunter of *his own* personal way of translating grave and lofty ideas into painting. The '*sfumato*', the 'tremendous impression of movement' and the 'life of the painted figures' in his works drew applause and admiration from everyone – but were only understood by a few; and certainly not by the 'coarse painters and the foolish crowd, who until then had only seen the dead, cold paintings of Giovanni Bellini, Gentile and Vivarino'. This was why 'Giorgione had not yet had public commissions for his oil paintings; and mostly he did nothing but half-length figures and portraits'.[76]

The 'ideas' which Giorgione translated into such masterly blends of colours were not entirely his own. Occasionally, at least, his patron would choose the subject and at the same time would instruct him to render it in a way fitting to his own feelings – veiled; as though from modesty, by almost imperceptible allusions. Drawing upon the 'secret' language learned through the discoveries of antiquity

and a new strain of laical piety, the artist's invention could reflect the wishes of his client: and, by evoking a more direct emotional response to the theme of the painting, endow them with a contemporary significance. The Brunswick David is less a David than a portrait of Giorgione, not just for the force of his expression but for the tone of austere reserve, his refusal to celebrate the victory. The Three Philosophers have less in common with the Magi of the Gospels and medieval tradition as they are more akin to Ficino, Pomponazzi and Pico in their discussions of astrology. The Adam of The Tempest is made rather less Adam by his contemporary dress; or else he is Adam to the same extent that we all are. Updating the story is one way of concealing the subject.

On the other hand, the client's wish to change the inherited iconography faced the painter with a far more difficult and challenging task. Giorgione could give greater rein to his inventiveness in arranging the figures on his canvas within a new framework, or in illuminating them with a natural light that would still reveal the presence of God in the world. And it must have been a great challenge to the painter's ingenuity to make the colours of that light full of life and movement and shading, 'more than in real life'. The figures are set in a landscape that is no longer merely a frame for the 'story' but an object complete in itself: for once the relationship between background and protagonists was altered, the background took on a significance of its own. The patron's desire to veil the subject effectively created a gap between the proposed theme and the painting itself, which the artist had to fill.

By paring it down and placing it, as it were, at the very back of the painting Giorgione hid the subject of The Tempest from general view and wrested it away from manuscripts and frescoes, from the heritage of the Church and its people. For his solitary, mysterious figures seem to be drawn from the imagination of his patron, recording the private piety of a man who rejected the accepted canons of self-expression and who fused the remembrance of God with his own experience of the world.

Notes

1 SUBJECT AND NOT-SUBJECT

1 G. Reitlinger, *The Economics of Taste*, I–III, London, 1961–70, especially I: *The Rise and Fall of Picture Price*.
2 E. Wind, *Art and Anarchy*, London, 1963, p. 137. Venturi is quoted from his *Storia della critica d'arte*, 2nd edn, Turin, 1964, p. 232. (English translation C. Marriott, New York, 1936, p. 345.)
3 Walter Benjamin, *Angelus Novus. Saggi e frammenti*, Turin, 1962, p. 148. Originally published in German: Walter Benjamin, *Schriften*, Suhrkamp, Frankfurt, 1955, pp. 415–16.
4 For iconographic tradition in advertising, some initial suggestions are in J. Berger, *Ways of Seeing*, London, 1971, especially pp. 129–30.
5 From C. Gilbert, 'On Subject and Not-Subject in Italian Renaissance Pictures', in *Art Bulletin*, XXXIV, 1952, pp. 202–16, especially p. 202 as a mere curiosity, though of course it is much more than this.
6 Cf. E. Panofsky, 'Three Decades of Art History in the United States: Impressions of a Transplanted European' in *Meaning in Visual Arts*, Garden City, NY, 1955, pp. 321–45.
7 E. H. Gombrich in *Gazette des Beaux-Arts*, series VI, XLI, 1953, p. 360; E. Battisti, *Rinascimento e Barocco*, Turin, 1960, pp. 148–9; C. Ginzburg in *Studi Medievali*, series III, VII, 1966, p. 1042.
8 An account can be found in A. Reinach, *Recueil Miliet. Textes grecs et latins relatifs à l'histoire de la peinture ancienne*, I, Paris, 1921, nos 491, 500 and 501. Giovio's source was identified by Gombrich (by the latter cf. also *Norm and Form*, Oxford, 1966, pp. 113–14).
9 Cf. E. Battisti, *Piero della Francesca*, Rome, 1971, I, pp. 318–30; II, pp. 49–52; Gilbert adjusted his theory in *Change in Piero della Francesca*, Locust Valley, NY, 1968, pp. 105–6.
10 The question of the relationship between the study of meanings and the study of style has been discussed by a series of authors, culminating in E. H. Gombrich: see C. Ginzburg's important essay, 'Da A. Warburg a E. H. Gombrich', in *Studi Medievali*, series III, VII, 1966, pp. 1015–65.
11 A. Ronen, 'A Detail or a Whole?', in *Mitteilungen des kunsthistorischen Instituts in Florenz*, X, 1961–3, pp 286–94.

12 'The Renaissance Theory of Art and the Rise of Landscape', in Gombrich, *Norm and Form*, pp. 107–121.
13 G. Vasari, *Le Vite*, IV, ed. Milanesi, Florence, 1879, pp. 96–7. (English translation by G. Bull, *Lives of the Artists*, I, London, 1987, pp. 274–5.
14 E. Wind, *Giorgione's Tempesta, with Comments on Giorgione's Poetic Allegories*, Oxford 1969, pp.12–13; M. Muraro, 'The Political Interpretation of Giorgione's Frescoes on the Fondaco dei tedeschi', in *Gazette des Beaux-Arts*, series VI, LXXXVI, 1975, pp. 177–84.

2 THE THREE PHILOSOPHERS

1 Taken from text edited by T. Von Frimmel in *Beilage der Blätter für Gemäldekunde*, II, 1907, p. 54.
2 An account of these findings is given by F. Klauner, *Kunsthistorisches Museum in Wien. Katalog der Gemäldegalerie*, I, 2nd edn, Vienna, 1965, pp. 62–3, n. 551.
3 Cf. K. Garas, 'Die Enstehung der Galerie des Erzherzogs Leopold Wilhelm', in *Jahrbuch der kunsthistorischen Sammlungen*, LXIII, 1967, pp. 39–80; on *The Three Philosophers*, pp. 53–4, 76; ibid., LXIV, 1968, p. 210, n. 128.
4 *Die Kaiserlich–königliche Gemäldegalerie in Wien*, Vienna, 1886, p. 15.
5 'Les Écoles italiennes au Musée impérial de Vienne', in *Gazette des Beaux-Arts*, LXXII, 1893, 1, pp. 5–6; 'Giorgiones Bilder zu römischen Heldengedichten', in *Jahrbuch der königlichen preussischen Kunstsammlungen*, XVI, 1895, pp. 34–43.
6 The bibliography has been collected and summarized very adequately by L. Baldass and G. Heinz, *Giorgione*, Vienna, 1964, pp. 131–34. Only studies published after this book, or not recorded in it, will be quoted at length.
7 'Die Söhne des Noah bei Brizio und Giorgione', in *Berliner Museen*, n.s., VI, 1956–7, pp. 31–3.
8 'De Giorgione au Titien: l'artiste, le public et la commercialisation de l'oeuvre d'art', in *Annales ESC*, XV, 1960, pp. 1060–75, especially pp. 1065ff.
9 'I "tre filosofi" del Giorgione', in *Emporium*, XIII, 1935, pp. 253–6.
10 *Il Mondo*, 23 August 1955 (and afterwards in *Saggi sulla cultura veneta del Quattro e Cinquecento*, Padua, 1971, pp. 111–20). This interpretation closely follows the ideas of Janitschek: the philosophy of the Ancients (Tolomeus), of the Middle Ages (al-Battani), and the Renaissance (Copernicus). But the characters are astronomers, not philosophers. I do not have detailed knowledge of the thesis that P. Meller put to a conference in 1965, quoted by O. Goetz, *Der Feigenbaum in der religiösen Kunst des Abendlandes*, Berlin, 1965, p. 172, n. 77a. The one detail that is mentioned here is the identification of the grotto with Plato's Cave; it is not therefore difficult to imagine that it was inspired by Bembo's *Asolani*.
11 'Chi sono "I tre filosofi"', in *Arte lombarda*, X, 1965, pp. 91–8.
12 'La "morte di bacio". Saggio sull'ermetismo di Giorgione', in *Storia dell'Arte*, II, 1970, nos. 7–8, pp. 180–233, especially pp. 223ff.

13 E. Waterhouse, *Giorgione*, (W. A. Cargill Memorial Lectures in Fine
 Art, 4), Glasgow, 1974, p. 19.
14 C. Gamba, 'La *Venere* di Giorgione rintegrata', in *Dedalo*, ix, 1928–9,
 pp. 205–9; H. Posse, 'Die Rekonstruktion der Venus mit dem Cupido
 von Giorgione', in *Jahrbuch der preussischen Kunstsammlungen*, lii,
 1931, pp. 29–35. The painting's more recent attributive history is
 summarized by T. Pignatti, *Giorgione*, Venice, 1969, pp. 107–8, n. 24.
15 J. Wilde, 'Ein unbeachteter Werk Giorgiones', in *Jahrbuch der preussi-
 schen Kunstsammlungen*, lii, 1931, pp. 91–100, especially p. 98, n. 1
 (on p. 100 *Nachtrag*, quoting Hourticq's book which Wilde only
 discovered when his article was already at the proof stage). L. Hourticq,
 Le problème de Giorgione, Paris, 1930, pp. 61–2 and 81: 'personne
 n'a songé à reconnaître ces figures si familières . . .'.
16 'Röntgenaufnahmen der "Drei Philosophen" Giorgiones und der
 "Zigeunermadonna" Tizians', in *Jahrbuch der kunsthistorischen
 Sammlungen in Wien*, vi, 1932, pp. 141–54.
17 H. Kehrer, *Die heiligen drei Könige in Literatur und Kunst*, ii, Leipzig,
 1908, pp. 223ff. (introduction of the Moorish king; also differentiation
 of ages; the Magi could thus also represent the 'three ages of man').
 In Italy, the Moorish king became current particularly in Venice:
 N. Hamilton, *Die Darstellung der Anbetung der hl. drei Könige in der
 Toskanischen Malerei von Giotto bis Lionardo*, Strasbourg, 1900,
 p. 85.
18 F. R. Shapley, 'A note on "The Three Philosophers" by Giorgione', in
 Art Quarterly, xxii, 1959, pp. 241–2.
19 L. Baldass, 'Zu Giorgiones "Drei Philosophen"', in *Jahrbuch der
 kunsthistorischen Sammlungen in Wien*, l, 1953, pp. 121–30.
20 'Röntgenaufnahmen der "Drei Philosophen"'. The discussion is taken
 up and developed in a useful article by F. Klauner, 'Zur Symbolik von
 Giorgiones "Drei Philosophen"', in *Jahrbuch der kunsthistorischen
 Sammlungen in Wien*, li, 1955, pp. 145–68.
21 For a complete account see U. Monneret de Villard, *Le leggende
 orientali dei Magi evangelici*, Rome, 1952, pp. 6–7.
22 Available in English as *The Three Kings of Cologne: An Early English
 Translation of the 'Historia Trium Regum' by John of Hildesheim*,
 edited from the MSS, together with the Latin text, by C. Horstmann;
 Early English Text Society, vol. 85, London, 1886. See also the Italian
 translation, *La storia dei re magi*, edited by A. M. Di Nola, Florence,
 1966. Even in Syria, where the legend was born, iconography differs
 from texts by showing only *three* wise men (Monneret de Villard,
 pp. 62–3).
23 The text is recorded in Di Nola, *La storia dei re magi*, p. 219. Bede's
 text seems to have given Giorgione a loose guide in deciding the overall
 appearance and the *dominant* colour for the clothing of each of the
 three Magi: the *tunica hyacinthia* (bluish-purple) of the old king
 Melchior, the *milenica* (green) tunic of young Caspar and the *rubea*
 (crimson tunic) of Baldassar; *fuscus, integre, barbatus* [dark, tall,
 bearded], may be translated respectively into the colours of Melchior's
 hood, Caspar's cloak and Baldassar's gown. The old man's oriental
 head-dress of the earlier composition may be derived from Bede's

curious expression *pro mitrario*, conjuring an image of a kind of peculiar and exotic mitre (see text and commentary, especially in Kehrer, *Die heiligen Drei Könige*, pp. 66–7).

24 Following the interpretation of O. Goetz, *Der Feigenbaum*, p. 100f.

25 R. Eisler, *The Royal Art of Astrology*, London, 1946, p. 264. The interpretation of the signs on Melchior's parchment is transcribed from the printer's proofs of a letter (unedited) from Eisler to the *Times Literary Supplement* that was only published in part (see also pp.149–50): 'The white-bearded Magian of the right side holds a chart showing the loops in the apparent orbit of Jupiter (♃) standing next to the sign of (♑) Capricorn and below a cogwheel with cogs numbered 2, 3, 4, 5, 6, 7 – the strange contraption inserted by the Arabic Astronomer Tebit ibn Qurrah (836–901) between 'the sphere of the fixed starts' and the 'crystalline sky' supposed to contain the zodiacal signs for the purpose of explaining the alleged oscillatory movement (*nutatio* or *trepidatio*) of the tropical points eight degrees forward and backward. This movement . . . is meant to connect with the watch for the heliacal rise of the star heralding the birth of the Saviour child.'

26 F. Boll, 'Der Stern der Weisen', in *Zeitschrift für neutestamentliche Wissenschaft*, XVIII, 1917, pp. 40–8; *Kleine Schriften zur Sternkunde des Altertums*, Leipzig, 1950, pp. 135–42; E. Garin, in G. Pico Della Mirandola, *Disputationes adversus astrologiam divinatricem*, I–VI, Florence, 1946, pp. 665–6.

27 H. Toubert, 'Une fresque de San Pedro de Sorpe (Catalagne) et le thème iconographique de l'arbor bona – Ecclesia, arbor mala – Synagoga', in *Cahiers archéologiques*, XIX, 1969, pp. 165–89, especially pp. 168–9.

28 L. Baldass, *Giorgiones Drei Philosophen*, Vienna, 1922, pp. 9–12; M. Auner, 'Randbemerkungen zu zwei Bildern Giorgiones und zum Brocardo-Portrait in Wien', in *Jahrbuch der kunsthistorischen Sammlungen in Wien*, LIV, 1958, pp. 151–72, especially p. 155.

29 L. Réau, *Iconographie de l'art chrétien*, II, 2, Paris, 1957, p. 232.

30 R. Berliner, *Denkmäler der Krippenkunst*, 7, Augsburg, 1927, table VII, 3.

31 P. Francastel, *La Figure et le lieu: L'ordre visuel du Quattrocento*, Paris, 1967, especially pp. 92–3. On the tradition of artificial caves in stage scenery, W. Jobst, *Die Höhle im griechischen Theater*, Vienna, 1970; G. Cohen, *Geschichte der Inszenierung im geistlichen Schauspiele des Mittelalters in Frankreich*, German translation, Leipzig, 1907, pp. 10ff.

32 On this and similar clocks with the same scene, see R. Berliner, *Die Weihachnachtskrippe*, Munich, 1955, pp. 65–7. On the fate of the Play of the Nativity in the Italian Quattrocento, C. Musumarra, *La Sacra Rappresentazione della Natività nella tradizione italiana*, Florence, 1957, pp. 101–2.

33 H. Anz (ed.), *Die lateinische Magierspiele*, Leipzig, 1905, p. 130; cf. M. Böhme, *Das lateinische Weihnachtsspeil*, Leipzig, 1917.

34 The first scholar to notice that the mystery plays led to important changes in iconography was E. Mâle, 'Le Renouvellement de l'art par les mystères à la fin du Moyen-Âge', in *Gazette des Beaux-Arts*, series

III, xxxi, 1904, pp. 86–101, 215–301 and 379–94; also *L'Art religieux de la fin du Moyen-Âge en France*, Paris, 1908, pp. 3–74. See also the discussion in A. Rapp, *Studien über den Zusammenhang des geistlichen Theaters mit der bildenden Kunst im ausgehenden Mittelalter*, degree thesis, Munich (published in Kallmüntz), 1936, and Francastel, *La Figure et le lieu*.

35 P. Hofer, *Die italienische Landschaft im 16. Jahrhundert*, i, Bern, 1946, p. 94, n. 9.

36 L. Venturi, 'Giorgione', in *Enciclopedia universale dell'arte*, vi, 1958, p. 214. Two of the examples that I will discuss here (Gentile da Fabriano and G. F. Caroto) have already been mentioned by J. Wilde in *Jahrbuch der kunsthistorischen Sammlungen in Wien*, vi, 1932, pp. 150–1.

37 Mâle, *L'Art religieux*, p. 36.

38 Vasari, *Le Vite*, v, p. 280 (English translation by A. B. Hinds, iii, 2nd edn, London, 1963, p. 27).

39 M. T. Franco-Fiorio, *Giovan Francesco Caroto*, Verona, 1971, pp. 82–3.

40 See Monneret de Villard, *Le leggende orientali*, pp. 61–2.

41 G. Millet, *Recherches sur l'iconographie de l'Evangile*, Paris, 1916, pp. 139–40; G. Vezin, *L'Adoration et le cycle des Mages dans l'art chrétien primitif*, Paris, 1950, pp. 94–5. It is not possible here to go into the controversy over the date of the columns of the ciborium of San Marco; on the latter see especially A. Venturi, *Storia dell'arte italiana*, i, Milan, 1901, pp. 232ff; a most detailed description can be found in H. von der Gabelentz, *Mittelalterliche Plastik in Venedig*, Leipzig, 1903, pp. 1–61; O. Demus, *The Church of St Marco in Venice*, Washington DC, 1960, pp. 166–70.

42 H. Aurenhammer, *Lexikon der christlichen Ikonographie*, i, Vienna, 1959–67, p. 109.

43 G. Wilpert, *I sarcofagi cristiani antichi*, iii, Rome, 1936, p. 54. On gestures, see S. Settis, 'Images of Meditation, Uncertainty and Repentance in Ancient Art', in *History and Anthropology*, i, 1984, pp. 193–237. Originally published in Italian as 'Immagini della meditazione, dell'incertezza e del pentimento nell'arte antica', in *Prospettiva*, i, 1975, 2, pp. 4–18.

44 E. Kirschbaum, 'Der Prophet Balaam und die Anbetung der Weisen', *Römische Quartalschrift*, xlix, 1954, pp. 129–71. For further early representations of the Magi watching the star, see Vezin, *L'Adoration et le cycle des Mages*, pp. 94–5. In a third-century mosaic, two figures point to a star denoting the birth of Severus Alexander: J. Gagé, '*Basiléia*'. *Les Césars, les Rois d'Orient et les 'Mages'*, Paris, 1968, pp. 248ff., and tables I, II.

45 A. Boeckler, *Die Bronzetüren des Bonannus von Pisa und des Barisanus von Trani*, Berlin, 1953, pp. 12–13.

46 Réau, *Iconographie*, ii, 2, pp. 242–3.

47 Garin, *Disputationes*, pp. 665–6. (See also p. 12.)

48 *Opera Omnia*, i, Basileae, 1576, pp. 489–91. Ficino's contradictory position on astrology is outlined by E. Cassirer, *Individuo e cosmo nella filosofia del Rinascimento*, 2nd edn, Florence, 1950, pp. 160–1.

English translation E. Cassirer, *The Individual and the Cosmos in Renaissance Philosophy*, translated with an introduction by Mario Domandi, Oxford, 1963.

49 *Disputationes*, IV, 15, pp. 512–13. Gilbert has a reference, albeit rather brief and confused, to the debate on the Magi's star (*On Subject and Not-Subject*, p. 216); but the *De astrologica veritate* by Lucio Bellanti, first published in Venice in 1502, which he cites as being of some importance to Giorgione's work, deals with the question very briefly and follows the arguments set out by Pico (I have studied the Basle edition of 1554, p. 195). The ideas of Ficino and Pomponazzi, which Gilbert does not quote, are of greater significance.

50 Cassirer, *Individuo e cosmo*, pp. 165–6.

51 Ibid., p. 186.

52 A. d'Ancona, *Origini del teatro italiano*, I, Turin, 1891, pp. 343–4; Rapp, *Studien*, table opposite p. 56; cf. Mâle, *L'Art religieux*, pp. 527–8. The 'rite of the star' has survived in the Veneto and Lombardy to the present day: G. Sanga and P. Sordi, 'Il rito della "Stella" nel Bresciano', in *Quaderni di documentazione regionale*, 5–6, Milan, 1972.

53 K. Garas, in *Jahrbuch der kunsthistorischen Sammlungen in Wien*, LXIII, 1967, p. 53, has found another presumed companion to *The Three Philosophers* in a *Story of the Amazons*, taken from the inventory of Bartolomeo della Nave's collection. There is no evidence to support such a hypothesis.

54 The phrase is taken from the summary of a conference held in Vienna by Wilde (in *Zeitschrift für Kunstgeschichte*, I, 1932, p. 184).

55 Venturi, *Giorgione*, p. 214.

56 Waterhouse, *Giorgione*, p. 19 (cf. G. Tschmelitsch, 'Die doppelte Bedeutung der "Drei Philosophen" in Wien', in *Speculum Artis*, XIV, 1962, 4, pp. 14–18; humanists and the Magi). Calvesi's first theory is set out in *Commentari*, XIII, 1962, pp. 252–3; the second is in *Storia dell'arte* V, 1970, pp. 223–4. It is difficult to accept Calvesi's claim that Giorgione would have known the *Occulta Philosophia* by Agrippa of Nettesheim before 1509–10, 'even from Dürer himself' since the earliest manuscript of this work is dated at exactly 1509–10: G. F. Hartlaub, in *Zeitschrift für Kunstwissenschaft*, VII, 1953, p. 67. In the catalogue of the 1955 Giorgione exhibition (*Giorgione e i giorgioneschi*, Venice, 1955, p. 35), P. Zampetti writes that Klauner supposed the figure of the infant Jesus to be in the cavern, transforming the painting into an Adoration. Klauner actually says nothing of the kind, but the misunderstanding has persisted, repeated by Calvesi (in his article of 1962), by Pignatti (*Giorgione*, p. 105) and again by Zampetti himself (*Giorgione*, Milan, 1968, p. 15).

57 The tradition of the Magi's royal status arose through the fusion of St Matthew's words with Psalm 72.10, 'The kings of Tarshish and the isles shall bring presents: the kings of Sheba and Seba shall offer gifts,' and with Isaiah 60.6, 'all they from Sheba shall come: they shall bring gold and incense,' where the identity of the two gifts seemed to prefigure the homage of the Magi described by St Matthew.

58 M. Meiss, 'Giovanni Bellini's *St Francis*', in *Saggi e memorie di storia*

dell'arte, III, 1963, pp. 9–30; Meiss, *Giovanni Bellini's* St Francis *in the Frick Collection*, New York, 1964.

59 'The Little Flowers of St Francis'; English translation by T. W. Arnold, Chatto and Windus, London, 1908, p. 185.

60 On the iconography, M. Levi d'Ancona, *The Iconography of Immaculate Conception in the Middle Ages and Early Renaissance*, New York, 1957, pp. 63–5.

61 National Gallery of Ireland, *Concise Catalogue of the Oil Paintings*, Dublin, n.d., p. 40, no. 390. There are many genre paintings by Teniers in N. F. Smolskaya's book, *Teniers*, Leningrad, 1962.

62 See examples collected by A. Ottino della Chiesa, *Leonardo*, Milan, 1967, p. 105.

63 Petrus Comestor, 'Historia Scholastica', in Migne, *Patrologia Latina*, 198, *c*. 1541.

3 THE INTERPRETERS' WORKSHOP

1 G. D'Annunzio, *Il Fuoco*, Verona, 1959, p. 67.

2 'Imaginifico' is a sobriquet for D'Annunzio.

3 'Note su Giorgione e la sua critica', in *Il Convito*, 1895, pp. 92ff., republished as 'Dell'arte di Giorgio Barbarelli', in *Prose di ricerca, di lotta, di comando*, 3rd edn, III, Verona, 1962, pp. 325–52 (source of quotations here).

4 A. Conti, *Giorgione*, Florence, 1894. On Conti, G. Petrocchi, in *Enciclopedia italiana*, Appendix II, Rome, 1948, I, p. 682. The idea of 'Giorgionesque fire' was also passed from Pater to Conti (p. 75) and to D'Annunzio: see below, p. 57.

5 Conti, *Giorgione*, p. 28. As early as 1913, L. Venturi rightly observed (*Giorgione e il giorgionismo*, Milan, p. 330) that 'in his discussion of *The Tempest* Conti demonstrates his lack of a sense of history by putting himself, an amateur philosopher of the nineteenth century, in place of a painter of the sixteenth'.

6 Conti, *Giorgione*, p. 42.

7 See the entry on the latter (unsigned) in *Enciclopedia dell'arte antice*, VII, Rome, 1966, pp. 522–3.

8 J. Strzygowski, *Dürer und der nordische Schicksalshain*, Heidelberg, 1937, pp. 114–21. By the same author see also *Spuren indergermanischen Glaubens in der bildenden Kunst*, Heidelberg, 1936, p. 88.

9 G. F. Hartlaub, *Giorgiones Geheimnis: Ein kunstgeschichtlicher Beitrag zur Mystik der Renaissance*, Munich, 1925.

10 Ibid., p. 48.

11 A bibliography of Ferriguto's works on Giorgione can be found in *Venezia e l'Europa: Atti del XVIII Congresso internazionale di storia dell'arte, 1955*, Venice, 1956, pp. 246–9. Of his many works on *The Tempest*, the most important is *Il significato della Tempesta di Giorgione*, Padua, 1922, later reprinted in *Attraverso i misteri di Giorgione*, Castelfranco Veneto, 1933; the debate with Hartlaub and other interpreters is contained in this last book. On the same lines as Ferriguto, see A. Stokes, *Art and Science*, London, 1949.

12 G. Tschmelitsch, *Harmonia est Discordia Concors: Ein Deutungversuch zur Tempesta des Giorgione*, Vienna, 1966 (in German and Italian). This is the book that M. Calvesi (in *Storia dell'arte*, ii, 1970, p. 189, n. 24) cites on several occasions as a work by 'Von Günther Tschmelitsch'.

13 Calvesi, 'La *Tempesta* di Giorgione come ritrovamento di Mosè', in *Commentari*, xiii, 1962, pp. 226–55, especially p. 229.

14 Calvesi, 'La "morte di bacio": Saggio sull'ermetismo di Giorgione', in *Storia dell'arte*, ii, 1970, 7–8, pp. 180–233.

15 But the evidence is that Palestrina's mosaics were not yet known in the sixteenth century; the passage in *Poliphilo* that Calvesi quotes as proof of an early and widespread knowledge of these mosaics (p. 203 in the edition by G. Pozzi and L. A. Ciapponi, Padua, 1963: 'the pavement of Praeneste in the temple of Fortune') is taken straight from Pliny (*Nat. Hist.* xxxvi, 189: 'lithostrata ... exstat hodieque quod in Fortunae delubro Praeneste fecit') and does not in any way imply that he was acquainted with the monument.

16 Calvesi, 'La "morte di bacio"', p. 196.

17 Ibid., p. 202.

18 Ibid., p. 233.

19 I am quoting from the edition with a commentary by T. Frimmel, in *Beilage der Blätter für Gemäldekunde*, ii, 1907, pp. 37–78, especially p. 58 and p. 75.

20 This reading, which is supported by some persuasive examples, was given by Ferriguto in *Atti del R. Istituto Veneto di Scienzae, Lettere ed Arti*, xcviii, 1983, part II, pp. 281–90 ('La "cingana" di Giorgione e l'anonimo morelliano').

21 'Another painting of a gypsy, a shepherd in a landscape with a bridge, in a walnut frame with intagli and gilt paternostri, by the hand of Giorgio of Castelfranco': A. Ravà, in *Nuovo Archivio Veneto*, xxxix, 1920, p. 177.

22 J. Burckhardt, *Der Cicerone: Eine Anleitung zum Genuss der Kunstwerke Italiens*, ed. Stuttgart, Kröner, n.d., p. 910: 'Das Bild im Pal. Manfrin als "Familie Giorgiones" bezeichnet, ist ein eigentliches und zwar frühes Genrebild in reicher Landschaft'.

23 For a full account, see M. Calvesi, in *Commentari*, xiii, 1962, pp. 227–8, n. 2.

24 London, 1912 (identical to the previous edition, apart from the additional notes by T. Borenius), iii, p. 18.

25 A. Michel, 'Le paysage chez les maîtres vénitiens', in *Revue des deux mondes*, series V, lxxii, 1902, 10, pp. 808–44, especially p. 824, n. 2. The statue is reproduced in P. Zampetti, *L'opera completa di Giorgione*, Milan, 1968, p. 84, and in *Castelfranco Veneto: Guida breve della città e dei dintorni*, Treviso, 1973, p. 33.

26 F. Leitschuh, *Das Wesen der modernen Landschaftsmalerei*, i, Strasbourg, 1898, quoted in Michel, 'Le Paysage', pp. 823–4. In the opinion of U. Monneret de Villard, *Giorgione da Castelfranco*, Bergamo, 1904, the woman and child in *The Tempest* are a hallucination of the man; for Giorgione (evidently identified as the man in the painting), painting the scene was an 'act of liberation and domination' over the world of

reality, 'over the world of pain and anguish'. D. Phillips, *The Leadership of Giorgione*, Washington DC, 1937, gives it the title 'Thunderstorm at Castelfranco', and seems to be in no doubt that it is a 'scene of his [Giorgione's] childhood memories' (p. 24).

27 'The School of Giorgione in the Renaissance' appeared in the *Fortnightly Review* of 1877 and was later reprinted in *The Renaissance: Studies in Art and Poetry*, 3rd edn, London, 1893, pp. 132–62. Quotes here are from W. Pater, *The Renaissance*, 5th edn, London, 1901, pp. 135–51.

28 Ibid., p. 141. But I have not been able to trace (at least in the *Lives*) the passage where Vasari talks of 'Giorgionesque fire', as Pater puts it. But cf. A. M. Zanetti, *Varie pitture a fresco de' principali maestri veneziani*, Venice, 1760, p. 5: 'the great fire of Giorgione in the deep shadows'.

29 In an article of 1908, later in *Méditations esthétiques* (1st edn 1913: I quote from *Les peintures cubistes*, Paris, 1965, p. 46.)

30 *Aspetti dell'umanesimo nella pittura veneta dal 1455 al 1515*, Rome, 1964, pp. 85–6. On *The Tempest*, Bonicatti takes up Calvesi's first interpretation (1962), see above, pp. 53–4. But one need only consider the *Concerto Bentivoglio* by Lorenzo Costa (see below, p. 142) to surmise that Giorgione's 'inclination' for music was not so remarkable.

31 Venturi, *Giorgione e il giorgionismo*. On *The Tempest*, pp. 82–7. On p. 331, Venturi defines D'Annunzio's work as 'magnificent interpretative writing on *The Tempest*'. See also L. Venturi, *Come si comprende la pittura*, Turin, 1975 (Roma 1947[1]), pp. 61–2.

32 Venturi, *Giorgione*, Rome, 1954, p. 16; on *The Tempest*, p. 14 (a similar text can be found in the entry on Giorgione by the same author in the *Enciclopedia universale dell'arte*, vi, 1958, pp. 207–29, especially p. 214).

33 K. Clark, *Landscape into Art*, London, 1949, p. 58. Perhaps the most perceptive attempt to read *The Tempest* as a painting with no subject is to be found in a work by Adrian Stokes, *The Image in Form*, London, 1972, pp. 184–93.

34 U. Ojetti, 'Il soggetto e la Tempesta', in *Corriere della Sera*, 17 August 1939, p. 3.

35 The article by Ojetti on the Cremona Prize is in *Corriere della Sera*, 29 July 1939, p. 3. On the prize and its themes, cf. F. Tempesti, *Arte dell'Italia fascista*, Milan, 1976, p. 227; some of the paintings are reproduced in U. Silva, *Ideologia e arte del fascismo*, Milan, 1973, figs. 5–7.

36 This is repeated again by A. Morassi, *Giorgione*, Milan, 1942, p. 87.

37 On the latter, see the entry by R. Bianchi Bandinelli, in *Enciclopedia dell'arte antica*, vii, pp. 1218–19. The first of Wickhoff's two articles only discusses *The Three Philosophers* ('Les écoles italiennes au Musée impérial di Vienne', in *Gazette des Beaux-Arts*, lxxii, 1893, 1, pp. 5–6), while the second also treats *The Tempest* ('Giorgiones Bilder zu römischen Heldengedichten', in *Jahrbuch der königlichen preussischen Kunstsammlungen*, xvi, 1895, pp. 34–43, especially pp. 39–40). Wickhoff never fulfilled his plan to write a monograph on Giorgione; M. Dvořák gives an account of the project in *Kunstchronik*, xxi, 1910, p. 34.

38 Among the supporters of this theory, L. Justi, *Giorgione*, Berlin, 1908,
 I, pp. 55–6 (not in the later editions, 1926 (2nd) and 1936 (3rd),
 p. 121) and H. Cook, *Giorgione*, London, 1900, p. 11; among its
 opponents especially G. Gronau, 'Kritische Studien zu Giorgione', in
 Repertorium für Kunstwissenschaft, XXXI, 1908, pp. 403–36 and
 503–21, especially pp. 516–21.
39 In *Kunstchronik*, XXVI, 1915, *c.* 573. This interpretation is only recorded
 by A. Morassi, *Giorgione*, p. 86, though he does name the author.
40 L. Hourticq, *Le problème de Giorgione*, Paris, 1930, pp. 55–68.
41 F. Hermanin, *Il mito di Giorgione*, Spoleto, 1933, p. 70; R. Eisler,
 New Titles for Old Pictures, quoted by Richter as being published in
 London in 1935, though in fact never was published (see below pp. 177–8
 n. 45). Eisler's hypothesis only appears in a letter to the *Times Literary
 Supplement*, XLV, 1946, p. 66, where it is no more than a summary.
42 G. M. Richter, *Giorgione da Castelfranco*, Chicago, 1937, p. 241.
43 Morassi, *Giorgione*, p. 87; G. F. Hartlaub, 'Arcana Artis', in *Zeitschrift
 für Kunstgeschichte*, VI, 1937, pp. 289–324, especially p. 318, n. 25;
 and most of all, 'Der Paris-Mythos bei Giorgione', in *Zeitschrift für
 Aesthetik und allgemeine Kunstwissenschaft*, XXXII, 1938, pp. 252–63,
 especially pp. 257–8.
44 T. Pignatti, *Giorgione*, Venice, 1969, p. 143, n. c3.
45 G. F. Hartlaub, 'Zu den Bildnismotiven des Giorgione', in *Zeitschrift
 für Kunstwissenschaft*, VII, 1953, pp. 57–84, especially pp. 78–80.
46 R. Paribeni, 'La Tempesta di Giorgione alle Regie Gallerie di Venezia',
 in *Bollettino d'arte*, series III, XXVI, 1932–33, p. 145. Parpagliolo's
 article appears in the next issue of this review, p. 282 ('L'argomento
 della "Tempesta" di Giorgione').
47 *La Tempesta di Giorgione e l'Amore profano di Tiziano nello spirito
 umanista di Venezia*, Milan, 1939.
48 I quote from the most recent edition: *Il motivo della "Tempesta" di
 Giorgione*, Padua, 1955.
49 In *Jahrbuch der kunsthistorischen Sammlungen in Wien*, LI, 1955,
 p. 165, n. 80.
50 L. Baldass and G. Heinz, *Giorgione*, Wien–München, 1964, pp. 136ff.
51 The essay first appeared in *Emporium*, November 1957, and was
 reprinted in *Rinascimento e Barocco*, Turin, 1960, pp. 144–56;
 quotations have been taken from this edition.
52 M. Calvesi, in *Commentari*, XIII, 1962, pp. 238–9.
53 'De Giorgione au Titien: l'artiste, le public, et la commercialisation de
 l'oeuvre d'art', in *Annales ESC*, XV, 1960, pp. 1060–75, especially
 p. 1063.
54 Quoted by Ferriguto, *Attraverso i misteri*, p. 278.
55 Quoted by Ferriguto, *Attraverso i misteri*, p. 281. This is the last story
 of the *Decameron*. English translation London, Penguin, 1981, p. 20.
56 A. Stange, *Die Welt als Gestalt*, Cologne, 1952, p. 198 (made known
 to me via a quotation in H. von Einem, 'Giorgione der Maler als
 Dichter', in *Abhandlungen der Akademie der Wissenschaften in Mainz*,
 1972, 2, p. 14).
57 Meller's statement to the XXI International Congress on Art History
 (Bonn 1964) was not published; for a brief summary, ibid., p. 14.
58 G. Künstler, 'Landschaftdarstellungen und religiöses Weltbild in der

Tafelmalerei der Übergangsepoche um 1500', in *Jahrbuch der kunsthistorischen Sammlungen in Wien*, LXII, 1966, pp. 103–56, especially pp. 146–50.

59 E. Wind, *Pagan Mysteries in the Renaissance*, 2nd edn, London, 1967, p. 143, n. 7.

60 E. Wind, *Giorgione's 'Tempest' with Comments on Giorgione's Poetic Allegories*, Oxford, 1969.

61 G. Pochat, 'Giorgione's Tempesta, Fortuna and Neo-Platonism', in *Konsthistorisk Tidskrift*, XXXIX, 1970, pp. 14–34, takes up Wind's interpretation and specifies the meaning of the painting more precisely: 'what is natural in Man is dependent on Nature, what is spiritual on God. Man is immersed in nature, and if the tempest should symbolize the "good" kind of fortune, it comes from the same source of providence, which is God', whereas the thunderbolt is symbolic of divine revelation. Among the reviews of Wind's book, see G. Robertson, in *Burlington Magazine*, CXIII, 1971, 821, pp. 475–7; J. Bialostocki, in *Zeitschrift für Kunstgeschichte*, XXXIV, 1971, pp. 248–50; P. Marandel, in *Revue de l'Art*, XI, 1971, pp. 105–6; E. Verheyen, in *Kunstchronik*, XXIV, 1971, pp. 269–73. Lastly, see W. Tresidder, 'New Evidence in Support of Wind's Interpretation of "La tempesta"', in *Burlington Magazine*, CXVII, 1975, pp. 599–600.

62 See especially the objections raised by Calvesi, 'La "morte di bacio"', p. 1902; and by N. T. De Grummond, 'Giorgione's Tempest: the Legend of St Theodore', in *L'Arte*, XVIII–XIX–XX, 1972, pp. 5–53.

63 In *Horizon*, XIII, New York, 1971, pp. 94–103.

64 *Culture and Society in Venice 1470–1790*, London, 1972, pp. 165 and 229.

65 De Grummond, 'Giorgione's Tempest', pp. 5–53.

66 H. A. Noë, 'Messer Giacomo en zijn "Laura"', in *Nederlands Kunsthistorisch Jaarboek*, XI, 1960, pp. 1–35; E. Verheyen, 'Der Sinngehalt von Giorgiones "Laura"', in *Pantheon*, XXVI, 1968, pp. 220–7.

67 De Grummond, 'Giorgione's Tempest', especially pp. 6 and 47, n. 4.

68 *La Nazione*, 14 September 1976.

69 A. Morassi, 'Esame radiografico della Tempesta di Giorgione', in *Le Arti*, I, 1939, pp. 567–70.

70 Venturi, *Giorgione*, pp. 14–15.

71 In Morassi, 'Esame radiografico', p. 570.

72 A. Ferriguto, 'Del nuovo su "La Tempesta" di Giorgione (Raggi e personaggi)', in *Misura* (journal published in Bergamo), November 1946, pp. 207–300. Of all those who have studied *The Tempest*, Battisti is the only scholar to show any knowledge of this article; the rest report Morassi's views alone.

73 See article quoted in note 51 above for discussion of this exegesis.

74 G. Fiocco, *Giorgione*, Bergamo, 1941, p. 33.

75 Gilbert, 'On Subject and Not-Subject', p. 211.

76 M. Meiss, in *Frescoes from Florence*, London, 1969, pp. 60–5. On iconographic formulae for the Annunciation and their theological meaning, see especially M. Baxandall, *Painting and Experience in Fifteenth Century Italy*, 2nd edn, London, 1974, pp. 49–56.

4 INTERPRETING *THE TEMPEST*

1 *Monumenta Germaniae Historica, Legum Sectio III, Concilia,* II, supplement, ed. H. Bastgen, Hanover–Leipzig, 1924, p. 213, Cf. A. Freeman, 'Theodulf of Orleans and the Libri Carolini', in *Speculum,* XXXII, 1957, pp. 663–705.

2 For a full account see C. Settis-Frugoni, *Historia Alexandri elevati per griphos ad aerem: Origine, iconografia e fortuna di un tema,* Rome, 1973.

3 A. Meli, *Bartolomeo Colleoni nel suo mausoleo,* Bergamo, 1966, pp. 40–1. The complete series of the Bergamo *formelle* is reproduced by F. Malaguzzi in *Gio. Antonio Amadeo,* Bergamo, 1904, pp. 52–3. On Amadeo, see E. Arslan in *Dizionario biografico degli italiani,* II, 1960, pp. 601–17. On the close contact between Bergamo artists and Venice, see G. Ludwig, 'Die Bergamasker in Venedig', in *Jahrbuch der preussischen Kunstsammlungen,* supplement, 1903, pp. 1–2.

4 A. Mazure, *El tema de Adán en el arte,* Paris–Barcelona s.d.; J. B. Trapp, 'The Iconography of the Fall of Man', in *Approaches to "Paradise Lost",* London, 1968, pp. 223–65; see also L. Réau, *Iconographie de l'art chrétien,* II, 1, Paris, 1957, p. 76ff.: H. Aurenhammer, *Lexikon der christlichen Ikonographie,* I, Vienna, 1959–67, pp. 46ff.; L. Reygers in *Reallexikon zur deutschen Kunstgeschichte,* I, 1937, pp. 126ff.; H. Schade in *Lexikon der christlichen Ikonographie,* I, 1968, pp. 54ff. Some further subdistinctions are introduced in the *Art Index* of Princeton (the copy I consulted was in the Vatican Library).

5 O. K. Werckmeister, 'The Lintel Fragment Representing Eve from Saint-Lazare, Autun', in *Journal of the Warburg and Courtauld Institutes,* XXXV, 1972, pp. 1–30.

6 E. Guldan, *Eva und Maria, eine Antithese als Bildmotiv,* Graz–Cologne, 1966, pp. 13ff., especially pp. 18ff.

7 This terminology has been used quite differently by S. Ferri, 'Fenomeni di prolessi disgenativa nell'arte antica', in *Opuscula,* Florence, 1962, pp. 42–59. On the 'proleptic' nature of representations of Eve with a child, as an *anticipatio* that serves to connect with following scenes of Cain and Abel, see H. L. Kessler, 'Hic Homo Formatur. The Genesis Frontispiece of the Carolingian Bibles', in *Art Bulletin,* LIII, 1971, pp. 143–60, especially pp. 150–1.

8 I. Hueck, *Das Programm der Kuppelmosaiken im Florentiner Baptisterium,* dissertation, Munich, 1962, pp. 130ff.; K. Koshi, *Die Genesisminiaturen in der Wiener 'Histoire universelle' (Cod. 2576),* Vienna, 1973, especially p. 12.

9 O. Pächt, in the *Burlington Magazine,* CIII, 1961, pp. 166–75.

10 On this chest: P. Schubring, *Cassoni,* Leipzig, 1915, p. 235, n. 77 and table xi; a similar engraving by Robetta is reproduced by M. Pittaluga, *L'incisione italiana nel Cinquecento,* Milan, 1920, p. 85, fig. 22; drawing: *Corriere della Sera,* 14 August 1976, and F. Zeri in *Antologia*

di Belle Arti, 6, 1978, p. 152. Cf, the 'bucolic' representation of Adam and Eve in Eden in a painting by Veronese: F. Muthman, *Mutter und Quelle*, Basle, 1975, p. 24 and tables 6 and 3.

11 G. Pochat, 'Giorgione's Tempest, Fortuna and Neoplatonism', in *Konsthistorisk Tidschrift*, xxxix, 1970, pp. 14–34, especially, on lightning, pp. 29–31; *Figur und Landschaft*, Berlin–New York, 1973, pp. 400–6.

12 H. Homann, *Studien zur Emblematik des 16. Jahrhunderts*, Utrecht, 1971, pp. 24–40. M. Praz's book, *Studies in Seventeenth Century Imagery*, i, London, 1939 and ii: *A Bibliography of Emblem Books*, London, 1947, has awakened new interest in these neglected works.

13 On the norms of composition of the 'emblem', see A. Schöne, *Emblematik und Drama im Zeitalter des Barocks*, Munich, 1964, pp. 17ff.; on the earlier use of the word, Homann, *Studien*, pp. 38ff.

14 E. Iversen, *The Myth of Egypt and its Hieroglyphs in European Tradition*, Copenhagen, 1961.

15 Migne, *Patrologia Latina*, 210, col. 579A. The connection between emblem books and medieval tradition is particularly emphasized by B. Tiemann, *Fabel und Emblem*, Munich, 1974.

16 K. Giehlow, 'Die Hieroglyphenkunde des Humanismus in der Allegorie der Renaissance', in *Jahrbuch der kunsthistorischen Sammlungen in Wien*, xxxii, 1915, pp. 1–232; L. Volkmann, *Bildschriften der Renaissance*, Leipzig, 1923.

17 *Hypnerotomachia Poliphili*, ed. Pozzi–Ciapponi, Padua, 1964, p. 125; on the *ruminatio Scripturae*, texts quoted by J. Leclerc, *L'amour des lettres et le désir de Dieu*, Paris, 1957, p. 72.

18 G. Pozzi, *Francesco Colonna. Opere*, Padua, 1959, pp. 153–4.

19 Volkmann, *Bildschriften der Renaissance*, pp. 34–5.

20 From the Authorised Version. The text is: 'I will open my mouth in a parable; I will utter dark sayings of old; Which we have heard and known, and our fathers have told us. We will not hide them from their children, showing to the generation to come the praises of the Lord'. On the work of Pierio Valeriano, see Volkmann, *Bildschriften der Renaissance*, pp. 35ff.; Iversen, *The Myth of Egypt*, pp. 70ff.

21 Republished by Johann Georg Graeve, *Thesaurus Antiquitatum Romanorum'*, v, Venetiis, 1732, coll. 591–618. The extracts from the *Hieroglyphica* quoted in the text are on pp. 324ff. of the Basle edition of 1575.

22 Giehlow, 'Die Hieroglyphenkunde des Humanismus', pp. 172ff. On Dürer's sampler of the *Hypnerotomachia* he acquired in Venice, M. T. Casella, *Francesco Colonna. Biografia*, Padua, 1959, p. 101.

23 F. Picinelli, *Mondo simbolico*, Milan, 1653, book II, ch. xv, pp. 50ff.

24 I have consulted the excellent collection of the Kunsthistorisches Institut at Bonn University. A summary of these emblems can be seen, for example, in the *Teatro d'imprese* by Giovanni Ferro (Venice 1623), ii, pp. 235–7, though it does not include all of them; also the *Mondo simbolico* by Picinelli, pp. 415–17. Cf. W. Haftmann, *Das italienische Säulenmonument*, Berlin, 1939, pp. 55–61.

25 Ferro, *Teatro d'imprese*, p. 236 (I have not been able to find information on Cesare Turetini); Picinelli, *Mondo simbolico*, p. 416; Philothei, *Symbola christiana*, Francofurti, 1667, p. 9.

26 G.F. Hill, *A Corpus of Italian Medals of the Renaissance before Cellini*, London, 1930, p. 24, n. 86.

27 *Hypnerotomachia Poliphili*, p. 230; cf. pp. 14–15 and 23–4.

28 Full indications of these can be found in H. van de Waal, *Iconoclass: An Iconographic Classification System*, I–III; *Bibliography*, Amsterdam–London, 1973, pp. 174–5.

29 Praz, *Studies in Seventeenth Century Imagery*, II, pp. 424–5, only mentions one edition of Mercier's book, in quarto, in 1592. But in Bonn I was able to consult a small edition in octavo, with no indication of date or place of publication, where this emblem bears n.VI (pp. 10–11). On Vredeman de Vries' engraving see E. Forssmann, *Saüle und Ornament*, Stockholm, 1956, p. 159 and fig. 133; cf. H. Mielke, *Hans Vredeman de Vries*, dissertation, Berlin, 1967, pp. 51–2. Two further examples of emblem books: Dionysii Lebei Batillii, *Emblemata*, Francofurti ad Moenum, 1596, embl. XLV; Othonis Valerii, *Q. Horatii Flacci Emblemata*, Antverpiae, 1607, p. 177.

30 W. Messerer, in *Lexikon der christlichen Ikonographie*, IV, 1972, p. 54. The example of 1568 is a stele in Vienna, noted by J. Stryzgowski in *Dürer und der nordische Schicksalshain*, Heidelberg, 1937, p. 10 (drawing) and 177 (commentary), which he compared with the broken pillars of *The Tempest*, albeit within a generalized and misconceived interpretation (see above p. 0). On the broken pillar in sepulchral art see especially P. A. Memmesheimer, *Das klassizistische Grabmal*, dissertation, Bonn, 1969, p. 117. M. Lurker, *Symbol, Mythos und Legende in der Kunst*, Baden–Baden, 1958, p. 60, points to Adam and Eve with two pillars in a medieval fresco and tries to find an interpretation; but in this fresco (thirteenth century) the pillars are only part of the scene's architectural frame, as can be seen from the reproduction in W. Frodl, *Die romanische Wandmalerei in Kärnten*, Klagenfurt, 1942, p. 47, or in W. Myss and B. Posch, *Die vorgotischen Fresken Tirols*, Vienna, 1966, p. 93.

31 Cf. C. De Mandach, 'Le symbolisme dans les dessins de Jacopo Bellini', in *Gazette des Beaux-Arts*, LXIV, 1922, 2, pp. 39–60, especially pp. 50–1; and see also the broken pillar on fol. 24a next to the Baptism of Christ: V. Goloubew, *Die Skizzenbücher Jacopo Bellinis*, II, Brussels, 1908, table xiv.

32 E. Arslan, *I Bassano*, Milan 1960, table 28 (cf. tables 71, 127, 130, 131, 132 and 133), and tables 178 and 179. On Ghirlandaio's painting, A. Warburg, *Gesammelte Schriften*, I, Leipzig–Berlin, 1932, pp. 155–6; *La rinascita del paganesimo antico*, Florence, 1966, p. 243. Choosing a different line of interpretation, G. Bandmann, 'Höhle und Saüle auf Darstellungen Mariens mit dem Kinde', in *Festschrift für Gert von der Osten*, Cologne, 1970, pp. 130–48, read the broken column as the end of the Old Pact, in opposition to Mary 'columna novae legis'.

33 A. Tenenti, *Il senso della morte e l'amore della vita del Rinascimento (Francia e Italia)*, Turin, 1957, especially pp. 278ff.

34 D'Essling, *Le livre à figures venitien*, I, Florence–Paris, 1907, p. 169, records seven certain editions and possibly two further ones between 1470 and the end of the century; also one ms. in 1454, ibid., p. 119. On an illuminated edition belonging to Gianfrancesco Asolano, brother-in-law of Aldo Manuzio, see ibid., pp. 139–40.

35 *De omnium gentium omniumque saeculorum insignibus memoriaque dignis factis et dictis, Exemplorum libri X*; I quote the Basle edition of 1563, p. 229 and also 237–8 and 369.

36 St Ambrose in the *Liber de Paradiso* (Migne, *Patrologia Latina*, 45, col. 276B).

37 Procopius of Gaza, in the commentary to Genesis, (Migne, *Patrologia Graeca*, 87, col. 225D). See also the *Legenda aurea: [God] hominem exsulem fecit . . . et ante paradisum habitare fecit*, 3rd edn, (ed. Graesse, 1890, p. 847).

38 For a general account, L. I. Ringbom, *Paradisus Terrestris. Myt, Bild och Verklighet*, Helsinki, 1958, pp. 21, 225 ff. and 407. See also a painting by Jacopo Bassano in the Galleria Doria: Arslan, *I Bassano*, I, p. 175.

39 Werckmeister, 'The Lintel Fragment'.

40 The Octateuch is an old name for the first eight books of the Old Testament (cf. Pentateuch) [Tr.].

41 Again I would recommend the work of E. Guldan, *Eva und Maria: Eine Antithese als Bildmotiv*, Graz–Köln, 1966, where these points are treated in full (though obviously without reference to *The Tempest*); cf. H. Schmerber, *Die Schlange des Paradies*, Strasbourg, 1905.

42 'Vita Adae et Evae', 6–8, (ed. W. Meyer, in *Abhandl. der Akad. zu München*, XIV, 1879, 3); *Physiologus Latinus*, ed. Carmody (University of California Publications in Classical Philology, XIII, 1933–4), XX, 26, p. 118.

43 H. Vollmer, *Ein deutsches Adambuch*, Hamburg, 1908, fig. opposite p. 50; L. Reygers, *Reallexikon zur deutschen Kunstgeschichte*, I, 1937, pp. 144–5; Aurenhammer, *Lexikon der christlichen Ikonographie*, p. 50; H. Schade in *Lexikon der christlichen Ikonographie*, I, 1968, p. 68; cf. L. Réau, *Iconographie de l'art chrétien*, II, 1, p. 91. Also L. Pillion, *Les Portails de la cathédrale de Rouen*, Paris, 1907, p. 179 and figs. 56 and 58 (for an interpretation, Réau, *Iconographie de l'art chrétien*, II, 1, p. 94).

44 E. Arslan, *Das gotische Venedig*, Munich, 1971, p. 171, n. 52. See the study quoted by Arslan in A. N. Didron and W. Burges, 'Iconographie du Palais Ducal di Venice', in *Annales archéologiques*, XVII, 1857, pp. 68–88 and 193–216, though it is little more than a careful description. After this I only know of one reference, by B. Rackham in *Journal of the Warburg and Courtauld Institutes*, XXIII, 1960, pp. 308–9. The decoration of the interior of the Palazzo after the fire of 1574 has excited rather more interest (for the most recent work, S. Sinding-Larsen, *Christ in the Council-Hall: Studies in the Religious Iconography of the Venetian Republic*, Rome, 1973, Acta Instituti Romani Regni Norvegiae, V).

45 G. Fogolari, *Il Palazzo Ducale di Venezia*, Milan, n.d., table 2 and commentary. See also C. Semenzato, *Il Palazzo Ducale di Venezia*, Turin, 1971, pp. 13ff.

46 Ibid., pp. 204ff. and 207–8.

47 F. Zava Boccazzi, *La Basilica dei Santi Giovanni e Paolo in Venezia*, Venice, 1965, pp. 131–9.

48 Ibid., pp. 117–23.

49 M. Brunetti, 'Il Fondaco dei Tedeschi nell'Arte e nella Storia', in *Il Fondaco nostro dei Tedeschi*, Venice, 1941, p. 77.
50 *Notizia d'opere di disegno*, p. 56.
51 G. Mariacher, *Palma il Vecchio*, Milan, 1968, respectively p. 57, n. 26 and pp. 50–1, n. 13.
52 *Notizia d'opere di disegno*, p. 58; cf. H. E. Wethey, *The Paintings of Titian*, I, London, 1969, p. 171. On the kinship of Gabriele and Andrea Vendramin, see the family tree obtained by Ferriguto, *Attraverso i misteri di Giorgione*, p. 195.
53 *Notizia d'opere di disegno*, p. 53. On Lotto's painting, see G. Mariano Canova, *L'opera completa del Lotto*, Milan, 1975, table IL and catalogue, n. 175; on Titian's painting, Wethey, *The Paintings of Titian*, I, pp. 104–5, n. 59, who does not link the painting to Michiel (there are six well-known variations on this: ibid., p. 105); on Savoldo's 'nude', A. Boschetto, *Giovan Gerolamo Savoldo*, Milan, 1963, table 3 and commentary.
54 Wethey, *The Paintings of Titian*, I, pp. 76–7, n. 16.

5 THE HIDDEN SUBJECT

1 In Cant. 67, 7 (Migne, *Patrologia Latina*, 183, col. 1106B).
2 G. Swarzenski, 'Bermerkungen zu Palma Vecchios "Verführung der Calisto"', in *Kunstgeschichtliches Jahrbuch*, II, Vienna, 1908, pp. 54–66. Cf. G. Mariacher, *Palma il Vecchio*, p. 47, n. 6.
3 E. Herzog, *Die Gemäldegalerie der Staatlichen Kunstsammlungen Kassel*, Hanau, 1969, p. 82, n. 24.
4 S. Settis, 'Citarea su un'impresa di bronconi', in *Journal of the Warburg and Courtauld Institutes*, XXIV, 1971, pp. 135–77, especially pp. 143 and 176–7. On Augurelli, R. Weiss, in *Dizionario biografico degli italiani*, IV, 1962, pp. 568–71.
5 E. H. Gombrich, *Norm and Form*, p. 48.
6 P. Giovio, *Dialogo dell'imprese militari et amorose*, Lione, 1574 (Lione 1555[1]), p. 12, (English translation by Samuel David, London, 1585).
7 M. Baxandall, *Painting and Experience in Fifteenth Century Italy*, 2nd edn, London, 1974, p. 41.
8 Venezia, 1648, I, p. 249.
9 F. Heinemann, *Giovanni Bellini e i belliniani*, Venice, 1962, p. 73, n. 260. On the various exegeses, see especially G. Robertson, *Giovanni Bellini*, Oxford, 1968, pp. 99–103. N. Huse, *Studien zu Giovanni Bellini*, Berlin–New York, 1972, pp. 82–6 has tried to identify the *Allegoria sacra* with the *fantasia* painted by Giovanni Bellini between 1503 and 1504 for the study of Isabella d'Este.
10 V. Goloubew, *Die Skizzenbücher Jacopo Bellinis*, II, fols. 32 and 29.
11 C. Gould, 'The Pala of S. Giovanni Crisostomo and the Later Giorgione', in *Arte Veneta*, XXIII, 1969, pp. 206–9; C. Hornig, 'Giorgiones Spätwerk', in *Annali della Scuola Normale Superiore di Pisa*, series III, IV, 1976, pp. 877–927, especially pp. 913–17.
12 S. Sinding-Larsen, 'Titian's Madonna di Ca'Pesaro and its Historical

Significance', *Acta Instituti Romani Regi Norvegiae*, ɪ, 1962, pp. 139–69.

13 This passage is taken from F. Bologna, 'Il Caravaggio nella cultura e nella società del suo tempo', in *Caravaggio e i Caravaggeschi*, Rome, 1974 (Accademia Nazionale dei Lincei, *Problemi attuali di scienza e di cultura*, n. 205), pp. 149–87, especially p. 156. On the trends and formulae suggested more directly by the Church, see G. Labrot, 'Un type de message figuratif: l'image pieuse', in *Mélanges de l'École Française de Rome*, ʟxxvɪɪɪ, 1968, pp. 595–618. More generally, the discussion by M. Schapiro, 'Frontal and Profile as Symbolic Forms', in *Words and Pictures*, 's Gravenhage–Paris, 1973, pp. 37ff.

14 L. Venturi, *Giorgione e il giorgionismo*, Milan, 1913, p. 289.

15 G. M. Richter, *Giorgio da Castelfranco*, Chicago, 1937, p. 256; Gilbert, 'On Subject and Not-Subject', p. 215.

16 *Notizia d'opere di disegno*, p. 54.

17 Ibid., p. 54. Above, pp. 123–5.

18 Venturi, in *Enciclopedia universale dell'arte*, vɪ, p. 214.

19 Ferriguto, *Attraverso i misteri di Giorgione*, pp. 428–9, drew attention to this passage in connecting it with *The Sleeping Venus*. But most scholars after him do not seem to have noticed it.

20 'Untersuchungen über Giorgiones Selbstbildnis in Braunschweig', in *Mitteilungen des Kunsthistorischen Instituts in Florenz*, vɪɪɪ, 1957–9, pp. 13–24.

21 See the comparison of passages from the two editions of the *Lives* in Venturi, *Giorgione e il giorgionismo*, pp. 295–6.

22 C. de Tolnay, *Michelangelo*, ɪ, Princeton, 1947, p. 183, n. 93; ibid., pp. 205ff., on the lost bronze David; C. Seymour Jr, *Michelangelo's David: A Search for Identity*, New York, 1974, especially pp. 7ff.

23 T. Borenius, *The Picture Gallery of Andrea Vendramin*, London, 1923, table 3.

24 Ferriguto, *Attraverso i misteri di Giorgione*, pp. 181ff.; for the extract from Vasari, see above, n. 21 (English translation by A. B. Hinds, 2nd edn, London, 1963, ɪɪ, p. 168).

25 D. Von Hadeln, 'Das Bentivoglio-Konzert von Lorenzo Costa', in *Pantheon*, xɪɪɪ, 1934, pp. 338–40.

26 F. Sansovino, *Venetia città nobilissima, et singolare*, Venice, 1581, p. 144.

27 M. Sanudo, *Diarii*, xxɪv, c. 556 (1517). For further information on Gabriele Vendramin, ibid., cc. 557 and 558; xxv, c. 567 (1518); xxvɪɪɪ, c. 290 (1520); xxxɪv, c. 162 (1523); E. A. Cicogna, *Inscrizioni veneziane*, vɪ, Venice 1860–61, p. 596.

28 M. Foscarini, *Delle letteratura veneziana ed atlri scritti intorno ad essa*, Venice, 1854 (1st edn, Padua, 1752), p. 410.

29 E. Vico, *Discorsi sopra le medaglie de gli antichi*, Venezia, 1555, pp. 16 and 88; H. Goltz, *Iulius Caesar, sive Historiae imperatorum Caesarumque Romanorum ex antiquis numismatibus restitutae*, Bruges, 1563, p. bbiv of the additional letter which can be found in some editions (I consulted the edition in the British Library).

30 *I Marmi*, Venezia, 1552, pp. 40–1 (ɪɪ, pp. 35–6 of the version edited by E. Chiorboli, Bari, 1928).

31 H. E. Wethey, *The Paintings of Titian*, ii: *The Portraits*, London, 1971, p. 147, n. 110. The painting is listed in the house of Gabriele Vendramin in the 1569 inventory: A. Ravà, 'Il "camerino delle antigaglie" di Gabriele Vendramin', in *Nuovo Archivio Veneto*, new series, xxxix, 1920, p. 177: this fact, together with his personal friendship with Titian and the weight and authority given to his figure, leaves no reason to doubt his identity as the painting's principal character; the gesture of the gentleman on his right, 'presenting' his seven sons, identifies him clearly as Andrea Vendramin.

32 S. Moschini-Marconi, *Gallerie dell'Accademia di Venezia. Opere d'arte dei secoli XIV e XV*, Rome, 1955, p. 63, n. 63.

33 J. Fletcher, 'Marcantonio Michiel's Collection', in *Journal of the Warburg and Courtauld Institutes*, xxxvi, 1973, pp. 383–5.

34 *Italienische Forschungen* (ed. Kunsthist. Inst. Florenz), iv, 1911, pp. 72–5.

35 Ravà, 'Il "camerino dell antigaglie"', pp. 155–81; G. Gronau, 'Venezianische Kunstsammlungen des 16. Jahrhunderts', in *Jahrbuch für Kunstsammler*, iv–v, 1924–5, pp. 8–34, especially pp. 27–34: E. Jacobs, 'Das Museo Vendramin und die Sammlung Reynst', in *Repertorium für Kunstwissenschaft*, xlvi, 1924, pp. 15–38, especially pp. 15–17; L. Beschi, 'Collezioni d'antichità a Venezia ai tempi di Tiziano', in *Aquileia nostra*, xlvii, 1976, cc. 1–44.

36 V. Scamozzi, *Dell'idea dell'architettura universale*, Venezia, 1615, p. 305. See also, with reference to 1561, the passage from Sansovino quoted above on p. 114. The earliest sale of a painting from Gabriele Vendramin's collection for which we have certain information was probably Titian's *Vendramin Family*, sold to Van Dyck between 1636 and 1641: C. Gould, *The Seventeenth Century Italian Schools*, National Gallery, London, 1975, p. 286.

37 See contemporary accounts reported by M. Muraro in *Gazette des Beaux-Arts*, series VI, lxxxvi, 1975, pp. 177–84, conclusions.

38 Erasmus, *Epistolae*, i, ed. Allen, Oxford, 1906, p. 67.

39 *Epistolae*, ed. Krause, Kassel, 1885, p. 13.

40 E. Garin, *Medioevo e Rinascimento: Studi e ricerche*, Bari, 1954, p. 209, with no reference to the extract from Pomponazzi. There is a similar, though not identical, text in the *De fato, de libero arbitrio et de praedestinatione*, iii, 7.25 (ed. Lemay), Lugano, 1957, p. 262: the quote that follows in the text is taken from here.

41 For a full account, see especially K. Burdach, *Riforma–Rinascimento–Umanesimo*, Florence, 1935, pp. 135–6; Cassirer, *Individuo e cosmo*, pp. 149–50.

42 Ed. B. Cicognani, Florence, 1943, pp. 7ff.; cf. Cassirer, *Individuo e cosmo*, pp. 138ff. (English translation by P. J. W. Miller, New York–Kansas City, 1940, pp. 4–5).

43 J. Huizinga, *Erasmus*, Turin, 1941, pp. 56–7. (English translation by F. Hopman, London, 1952, p. 32).

44 H. Jedin, *Gasparo Contarini e il contributo veneziano alla riforma cattolica in La civiltà veneziana del Rinascimento*, Venice, 1958, pp. 103–24.

45 It is impossible not to feel a certain sympathy for this scholar

(1882–1949), who never taught and never managed to publish his book *New Titles for Old Pictures*, part of the which was devoted to Giorgione. (After Richter dated it with a reference 'London 1935' it was quoted by a long line of scholars as though it were a published work!) After various adversities, one of which was a long imprisonment in Nazi camps, Eisler discovered that some of his ideas on Giorgione were beginning to circulate through Richter's book and attempted to draw attention to this fact in a letter to the *Times Literary Supplement* (1946). He corrected the proofs but only a third of his letter was finally published (see above, p. 169, n. 41), regarding *The Tempest*, while the rest, on *The Three Philosophers*, is still unedited (see also above pp. 163, n. 25). The proposition quoted here is not included in the typescript of the book, and is only formulated in the letter to the *Times Literary Supplement*. (The Eisler papers are preserved in the Warburg Institute, where I was permitted, with a customary perfect courtesy, to examine them at my leisure.)

46 Written by Contarini's contemporary biographer Ludovico Beccatelli, *Vita del cardinale Gasparo Contarini*, Brescia, 1746, p. 2. Gasparo was a family name (for example, the register of wills in the Archivio di Stato di Venezia – referred to from now on as ASV – mentions one Gasparo Contarini in 1325 and another in 1423): but both Beccatelli and the other biographer, Giovanni della Casa, preferred to claim that Contarini was the first to be given this name, in order to link him more closely to the 'piety of his mother' and to the Magi.

47 *Le Maraviglie dell'arte* (1648), ed. von Hadeln, I, Berlin, 1914, p. 157. On the portrait of Contarini: *Regesten und Briefe des Cardinals Gasparo Contarini*, ed. F. Dittrich, Braunsberg, 1881, pp. 83 and 246–7; W. C. Lane and N. E. Browne, *A. L. A. Portrait Index*, Washington DC, 1906, p. 338; H. W. Singer, *Allgemeiner Bildniskatalog*, III, Leipzig, 1931, p. 18; *Neuer Bildniskatalog*, I, Leipzig, 1937, p. 280; G. J. Fontana, *Cento palazzi di Venezia*, 2nd edn, Venice, 1934, pp. 11 and 112.

48 *Regesten und Briefe*, p. 9. For Caspar as the youngest Magian see Kehrer, *Die heiligen Drei Könige*, I, pp. 67ff.

49 G. Contarini, *Opera*, Paris, 1571, pp. 244ff.; *Regesten und Briefe*, pp. 258ff.; F. Dittrich, *Gasparo Contarini*, Braunsberg, 1885, pp. 14ff., 210, 273ff.: *Contarini als Astronom*.

50 *De orbe novo . . . decades*, Compluti (Alcala de Henares) 1530, pp. LXXX r–v; cf. Beccatelli, *Vita*, pp. 6–7. On Anghiera, cf. R. Almagia, *Dizionario biografico degli italiani*, III (1961), pp. 257–60.

51 'I committenti di Giorgione' was published in the *Atti del R. Istituto Veneto di Scienze, Lettere e Arti*, LXXXV, 1925–56, pp. 399–410, before being published in *Attraverso i misteri di Giorgione* (1933).

52 Cf. the numerous instances recorded in the indices of vols. V, VI, VII, VIII, IX. The index of vol. VI lists another two Taddeo Contarini, who have no patronymic but are nevertheless clearly identifiable through their public functions (lawyer and ?). The fourth Taddeo Contarini, di Alvise, is only registered in the index of vol. XX, c. 436, though in fact he is not mentioned there. I have taken the year of the death of Taddeo di Andrea Contarini from M. Barbaro, *Genealogie delle famiglie patrizie venete*, ms. Marc. It. cl. VII, 925 = 8594, p. 274r. P. Burke,

Venice and Amsterdam, London, 1974, pp. 27–8, has observed the frequent repetition of the same names in the great Venetian families.

53 M. Barbaro, *Genealogie*, p. 278*v*.

54 xxiv, cc. 269, 342, 356; xxv, cc. 71 and 79; xxvi, c. 17.

55 x, c. 44; xii, c. 336; xx, cc. 539–40; xxi, c. 174; xxii, cc. 521 and 678; xlviii, c. 566. Further scattered pieces of information on the same person: ii, c. 109, 114, 372; xiii, c. 487; xv, c. 45; xx, c. 459; xxi, cc. 172, 493, 444; xxiii, cc. 185 and 413; xxviii, c. 490; xxxiii, cc. 311 and 612; xxxv, c. 470; xxxvi, c. 350; xliv, c. 26; xlv, c. 627; lv, cc. 36, 322, 552.

56 *I libri commemoriali della Repubblica de Venezia Regesti*, vi, Venice, 1903, pp. 109–10, 156, 162.

57 G. Coggiola, 'Il prestito di manoscritti alla Marciana deal 1474 a 1527', in *Zentralblatt für Bibliothekwesen*, xxv, 1908, pp. 47–70, especially pp. 54 and 64–5.

58 On the latter, Foscarini, *Della letteratura veneziana*, pp. 344–5, n. 6; cf. Doni, *I Marmi*, i, p. 68. I. Colesi, *Uominiillustri per dignità ecclesiastiche e Procuratori de S. Marco della stirpe Contarini*, ms. in the library of the Museo Correr, Cicogna 3382=3416/2°, mentions that he wrote 'some comments on Aristotle's books on hearing'. Agostino Valier (later cardinal) wrote an oration for his election to the patriarchate (ms. Marc. Lat. Z 499=1942, fol. 190 f), and dedicated his work *De tempore* to him (P. O. Kristeller, *Iter italicum*, i, London, 1963, p. 322); his friendship with Vittore Fausto is recorded in the dedicatory letter by Paolo Ramnusio, 'Petro Francisco Contareno Thadei f', in the preface to the Aldine edition of Fausto's *Orationes quinque* (Venetiis, 1551).

59 The letter is recorded by E. A. Cicogna, *Inscrizioni veneziane*, vi, 1, Venice, 1853, p. 307. Girolamo was one of the four sons of *this* Taddeo Contarini (the others were Pierfrancesco, Andrea and Dario, as is shown by the family tree in Barbaro, *Genealogie*, i, p. 274*r*. M. E. Costanza, *Biographical and Bibliographical Lexicon of Italian Humanists*, ii, Boston, Mass., 1962, p. 1086, s.v., attributes the translation of St Cyprian's *Orazione sulla pestilenza*, published in Padua in 1577, to this Taddeo Contarini, whereas it is in fact the work of Tommaso Contarini 'of the Count of Jaffa' (Bibl. Marciana, Misc. 361).

60 On the year of his death: ASV, Avogaria di Comun, *Necrologio dei Nobili*, 159, on that date; his date of birth can be calculated from his entry into the Balla d'oro in 1484 (ASV, register of the Balla d'oro).

61 ASV, *Testamenti*, 1203/59 (signed original) = 1205/II/56 (notary's copy). The will is dated 24 August 1556. The same burial place was chosen by Nicolò, son of Girolamo and grandson of Dario, who died in 1652, the last male descendant of Taddeo Contarini: ASV, *Testamenti*, 180/1010 (by his hand) = 183c/812 (notary's copy).

62 ASV, Avogaria di Comun, *Cronaca di Matrimoni*, 107.2, f.63*r*.

63 ASV, Savi sopra le Decime, 1514, Santa Fosca. On the *palazzo* and the change of ownership in the second half of the seventeenth century from the Contarini family to the Correr, see E. Bassi, *Palazzi di Venezia*, Venice, 1976, p. 460.

64 An engraving of Palazzo Vendramin in Santa Fosca can be seen in

V. M. Coronelli, *Singolarità di Venezia e del suo serenissimo Stato*, Venice, 1700 (no enumeration of tables), with a caption stating that it was also the abode of cardinal Francesco Vendramin, patriarch of Venice between 1605 and 1619. P. Selvatico, *Sulla Architettura e sulla Scultura in Venezia . . .*, Venice, 1847, p. 252, provides an engraving of the carved portal; cf. G. Tassini, *Curiosità veneziane*, 8th edn, Venice, 1970, pp. 251–2. On Santa Maria dei Servi as the burial place of the Vendramin of Santa Fosca, G. Cappelletti, *Storia della chiesa di Venezia*, i, Venice, 1849, p. 521. Gabriele Vendramin too wished to be buried with 'modest obsequies': see the will in *Italienische Forschungen*, p. 72.

65 On the kinship between Taddeo and Gasparo Contarini, see the family trees in Barbaro, *Genealogie*, p. 274r and G. A. Capellari-Vivaro, *Il Campidoglio Veneto . . .*, ms. Marc. It. cl. VII 15 = 8304, I, p. 304r. On Gasparo Contarini's *palazzo*, G. Tassini, *Curiosità veneziane*, p. 737; Capellari-Vivaro (*Il Campidoglio Veneto*) states that Gasparo's father Alvise was the 'owner of the Palazzo at Santa Maria dell'Orto'. I received invaluable assistance in researching Venetian documents from Dottoressa M. F. Tiepolo and Professor G. E. Ferrari.

66 Published by H. Jedin, 'Contarini und Camaldoli', in *Archivio Italiano per la storia della pietà*, ii, 1959, pp. 51–117, especially p. 68.

67 Ibid., p. 77.

68 The two extracts are compared in Venturi, *Giorgione e il giorgionismo*, pp. 294–5 (English translation of the 1568 extract by A. B. Hinds, p. 169).

69 Vasari, *Le Vite*, v, p. 565. (English translation by A. B. Hinds, iii, p. 112. The two quotes that follow are from iv, p. 199.)

70 Ibid., viii, p. 427 (English Penguin translation, p. 443).

71 The first extract is from the preface to Part III of the *Vite*, iv, p. 11 (Penguin translation, p. 252); the second is from the first edition of the *Vita* of Giorgione (in Venturi, *Giorgione e il giorgionismo*, p. 296) (Penguin translation, pp. 252 and 273).

72 M. Boschini, *Le ricche miniere della pittura veneziana*, Venice, 1674, c. b2 (the extract is reported by Venturi, *Giorgione e il giorgionismo*, p. 316).

73 Vasari, in the first edition of the *Life* of Giorgione (in Venturi, *Giorgione e il giorgionismo*, p. 300).

74 Boschini, *Le ricche miniere*.

75 A. M. Zanetti, *Della pittura veneziana e delle opere pubbliche de' veneziani maestri*, Venice, 1771, pp. 89ff. (the extract is reported in Venturi, *Giorgione e il giorgionismo*, pp. 319–20).

76 L. Dolce, *Dialogo della Pittura intitolato l'Aretino*, Vinegia, 1557, p. 54.

Index

RITTER LIBRARY
BALDWIN-WALLACE COLLEGE

9677